Fashion Flair for Portrait and Wedding Photography

Lindsay Adler

Course Technology PTR

A part of Cengage Learning

COURSE TECHNOLOGY
CENGAGE Learning™

Australia, Brazil, Japan, Korea, Mexico, Singapore, Spain, United Kingdom, United States

COURSE TECHNOLOGY
CENGAGE Learning

Fashion Flair for Portrait and Wedding Photography

Lindsay Adler

Publisher and General Manager, Course Technology PTR: Stacy L. Hiquet

Associate Director of Marketing: Sarah Panella

Manager of Editorial Services: Heather Talbot

Marketing Manager: Jordan Castellani

Acquisitions Editor: Megan Belanger

Project/Copy Editor: Karen A. Gill

Technical Reviewer: Gary Meek

Interior Layout Tech: Judy Littlefield

Cover Designer: Mike Tanamachi

Indexer: Sharon Shock

Proofreader: Gene Redding

For product information and technology assistance, contact us at **Cengage Learning Customer & Sales Support Center, 1-800-354-9706.**

For permission to use material from this text or product, submit all requests online at **cengage.com/permissions.** Further permissions questions can be emailed to **permissionrequest@cengage.com.**

Adobe, the Adobe logo, Lightroom, and Photoshop are either registered trademarks or trademarks of Adobe Systems Incorporated in the United States and/or other countries. All other trademarks are the property of their respective owners.

All images © Lindsay Adler.

Library of Congress Control Number: 2010943123

ISBN-13: 978-1-4354-5884-0

ISBN-10: 1-4354-5884-2

Course Technology, a part of Cengage Learning
20 Channel Center Street
Boston, MA 02210
USA

Cengage Learning is a leading provider of customized learning solutions with office locations around the globe, including Singapore, the United Kingdom, Australia, Mexico, Brazil, and Japan. Locate your local office at: **international.cengage.com/region.**

Cengage Learning products are represented in Canada by Nelson Education, Ltd.

For your lifelong learning solutions, visit **courseptr.com.**
Visit our corporate Web site at **cengage.com.**

Printed in the United States of America
1 2 3 4 5 6 7 14 13 12 11

This book is dedicated to the people who took a chance on me as an up-and-comer. Without the support of my publisher, sponsors, and fans, I wouldn't have the success I enjoy today. By believing my future would be a bright one, you helped it to become true.

Contents

PART I
CONCEPTS OF FASHION FLAIR

Chapter 1
Prepare to Flair 5

Chapter 2
Shoot on Location 21

Chapter 3
Get Style: Wardrobe, Hair, Makeup, and Props 37

Chapter 4
Strike a Pose 61

PART II
TECHNIQUES FOR FLAIR 82

Chapter 5
Tools of the Trade: Basic Equipment 85

Chapter 6
In-Camera Flair 101

PART III
SEE THE LIGHT

Chapter 7
Analyze the Light

Chapter 8
Ambient Light: All Natural

Chapter 9
Studio Light: Complete Control

Chapter 10
Flash on Location: Taking Control 187

PART IV
THE POWER OF POST:
PHOTOSHOP AND OTHER TOOLS 200

Chapter 11
Retouching for Perfection 203

Chapter 12
Stylized and Creative Effects 231

PART V
MAKE FLAIR YOUR BUSINESS. 256

Chapter 13
Flair Products and Services 259

Chapter 14
Making Fashion Flair Work for You 277

Index 299

Introduction

Fashion photography is all about fantasy. It is about creating an alternate reality, even if that reality is just a perfected version of what already exists.

Fashion photography can be whatever you want it to be:

- It can be Zen-like and peaceful, or it can be rebellious and in your face.
- It can be delicate and refined, or it can be tough and gritty.
- It can be quiet and muted, or it can be bold and colorful.

Fashion is about fantasy—whatever fantasy you envision. As a photographer, this freedom is truly rewarding.

The ability to create fantasy appeals to many clients. Most people don't want to just look like themselves in a portrait; they want to look like the "perfected" version of themselves, or better yet the version of themselves they see in their mind. People usually don't desire the reality; they desire the fantasy. They can have the reality any day, but they come to you to create what they wish they could be or experience what they wish they could have.

In fashion photography, you allow your subjects to become part of a piece of art. There are no restrictions and no right answers. I love fashion photography because of the freedom it allows. I can envision anything I want and make it come to fruition through photography. If I want to create an image of a girl wearing a huge wig with rain and fog surrounding her, nothing is stopping me. In fact, I have done that very shoot, as seen in Figure I.1. I had a vision, and I wanted to bring the vision of this beauty to life. That type of creativity and freedom is liberating. Fashion photography has no restrictions.

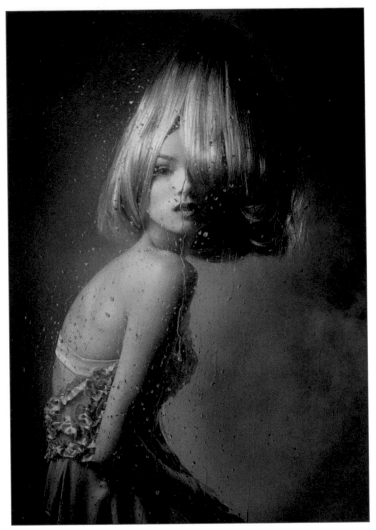

Figure I.1

In this shoot, I was able to create bizarre hair in an unusual scene purely for the sake of enjoyment and creativity.

If you can imagine it, you can create it. You are not limited by what exists, because you can modify your subject or environment in Photoshop. You can put subjects on an entirely different background, change the color of the clothes they are wearing, make them skinnier, and do pretty much anything you can imagine.

Why This Book

Tens of thousands of people want to become fashion photographers. There are even TV shows about them. But the field is just not practical for most people. It is extremely competitive, with unrealistic career demands for most individuals. You have to be willing to travel a lot, live in a big city, work odd hours, and often put up with a lot of stress.

The concepts of fashion photography, however, are applicable to any portrait or wedding photographer. That's where this book comes in. Other books instruct people on how to become fashion photographers, including getting established in the industry or working with models. This book introduces you to the concepts of fashion photography and shows you how to put these concepts to work in your wedding and portrait photography. This book is practical and geared at making you money. It doesn't just focus on the career path of a fashion photographer or the creative process. It covers everything from fashion poses to essential fashion lighting techniques to important ways to retouch your clients to achieve the fashion look. You can take these skills to the bank now by offering your clients unique fashion flair in their portraits.

This book opens by discussing the preparation required to add a fashion twist to your images, including location and styling, and then the poses, lighting, and equipment needed on the day of your shoot. It then covers in-camera techniques, fashion lighting essentials, Photoshop techniques, and a variety of other tricks to achieve the fashion flair aesthetic. The book would not be complete without the final section on business tips that will really make the fashion flair approach work for you. Marketing, social networking, products, and services can all be found in Part V.

Your Clients and Fashion Flair

My clients love my fashion flair approach to photography. Many young men and women want to feel like models, even if that is not their career—in fact, *especially* if that is not their career. With shows like *America's Next Top Model*, people are craving the chance to look or at least feel like a model. You can give your clients the opportunity to fulfill this desire.

The fashion flair approach turns a portrait from a chore into a great experience. People no longer just show up at a studio in plain clothing, smile, and pose. Instead, they prepare clothing, maybe get their hair and makeup done, and show up at an exciting location. The shoot becomes their own. You make the shoot an experience to remember and the images something to brag about.

My clients know that with me as their photographer, they can express something about themselves. Whether it's in their clothing or in their location, we work together to create a piece of art. People don't want to hang a boring picture of themselves on the wall. But when a photo becomes a piece of art that the client is incorporated into, it becomes something to be proud of. This book will show you how to do that.

Your Business and Fashion Flair

Each photographer has a different style of shooting and desired aesthetics, but no true photographer wants to be boring or typical. The point of photography is to have a unique vision, which can translate into your portrait and wedding photography.

People can go to Wal-Mart to get boring headshots. But if they want unique quality imagery, they need to go to a professional photographer. If they want imagery with a fashion twist, they need to come to you.

By distinguishing yourself with your fashion flair approach, people won't seek out your services for boring portraits. You won't be expected to stick someone in front of a background and snap a few static, formal portraits. Instead, they'll seek you out for striking and powerful imagery—imagery that says something about them or stands out as a piece of art. The image in Figure I.2 is a piece of art that tells a story, captures a moment, and would look stunning as a huge print on a wall. This image is what fashion flair is all about.

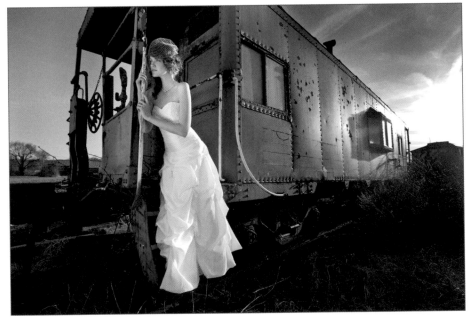

Figure I.2

I took this image in a train yard at sunset. It embodies the fashion flair approach of photography through its use of location, lighting, styling, and posing.

Distinguishing yourself with fashion flair can be invaluable to your bottom line. Because you will offer boutique and high-end services, you can ask a much higher price for your photography. This boutique approach will bring clients your way who already have a passion for photography and often a budget to invest in it.

Don't be ordinary. Be extraordinary . . . and charge for it. Be couture.

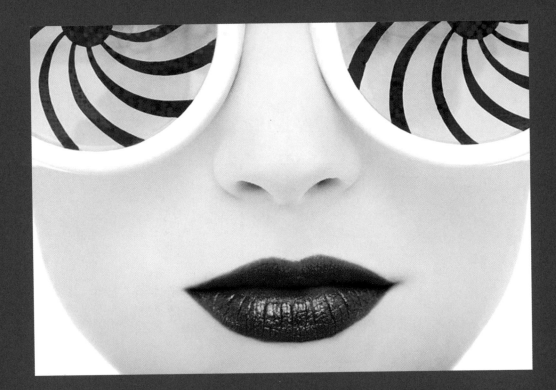

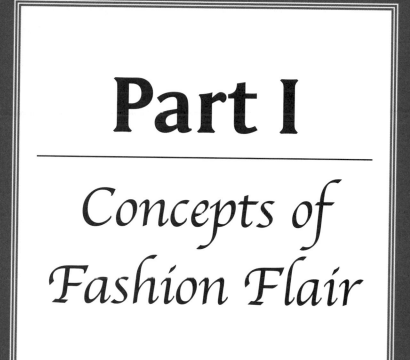

Part I

Concepts of Fashion Flair

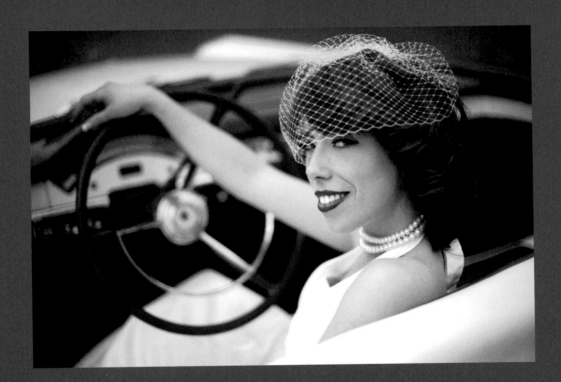

1

Prepare to Flair

Fashion photography involves a great deal of preparation. It's what separates basic portraits from fashion or conceptual portraiture.

For a typical portrait session, you show up, meet the subject, and take pictures. There is often little discussion of location, hair, clothing, props, and lighting. There is seldom a concept behind the portrait except to make a flattering image of the subject.

Fashion photography often produces striking imagery because of all the preparation involved, most of which takes place before the actual day of the shoot. It involves organizing a location, determining the shoot concept, selecting the model, choosing the wardrobe, and communicating the concept to the hair and makeup team. A high-end, single-day shoot may involve weeks of preparation.

To give your portraiture a distinct fashion flair, you must begin to consider some of the steps you can take to make your images stand out. Ask yourself what elements will contribute to a strong image.

For example, Figure 1.1 has a distinct fashion flair primarily from the pose and post processing. It was part of a boudoir shoot to be given as a wedding gift. Rather than doing a glamour shoot, we made the shoot high fashion by using rich colors, purposefully selected makeup, and a fashion pose. This did not take a great deal of time or preparation, but the client and I did discuss beforehand the final look we were trying to achieve.

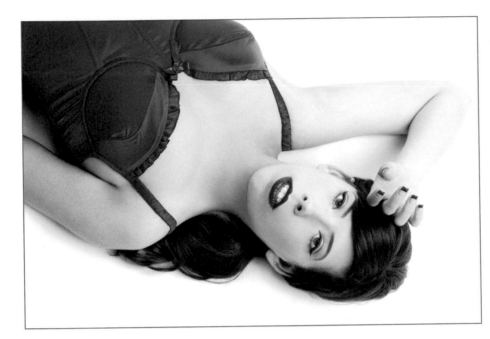

Figure 1.1
We used a fashion pose, choice makeup, and Photoshop effects to create a high-fashion look that was classy and striking for this boudoir shot.

What are you trying to communicate about your subject? Is there a particular concept or visual aesthetic you'd like to convey?

There are several essential elements to consider when preparing for a shoot with a strong fashion influence. Breaking down a shoot into these elements allows you to see the various areas of the shoot you can affect and the myriad results you can achieve. Here are elements to consider:

- Concepts
- Location
- Styling: hair, makeup, wardrobe, props
- Posing
- Lighting
- Post-processing (Photoshop, retouching, and more)

These elements allow you to take a portrait beyond just a pretty picture of an individual. You will no longer be *taking* a person's portrait; you will be *making* a person's portrait. You cannot expect to just show up and create an image that looks like it was taken from the pages of a fashion magazine. You should begin to think of your portraits as mini-productions. You subject is your model, and as the producer of the shoot you must consider all elements within your control.

Control is one of the great gifts of fashion photography. As a photographer, you are in control of every aspect of the image. You determine the composition, lighting, model, and posing. You have no excuses if the image doesn't achieve your goals, because you have complete control.

Get Inspired

Inspiration can come from anywhere. It can come from a dream, a song, a TV advertisement, or other artists and photographers. Learn to keep your eyes open and digest what you see. Photographers learn to view things differently, such as light and shadows. We see unique angles that are naturally apparent.

Look out for interesting locations or unique props. When you watch television, find the interesting visuals or styling. Following are a few good places or sources of inspiration.

Tear Sheets

Keep a collection of images or *tear sheets* (pages pulled from magazines) that inspire you. If you see a pose you really like in a magazine, tear out that page for future reference. If you catch a glimpse of lighting you really like in an online editorial, save that image to your desktop. I have hundreds of images saved for inspiration. Whether inspired by a location, pose, concept, clothing, or something else, I save these images for future use. I have a folder in my studio where I keep the collection of magazine images I have torn out. I have several folders on my computer where I save images I've found online, organized in a way that indicates what about the image inspired me. If I'm looking for inspiration for avant-garde makeup, I visit the Makeup folder. If I am looking for a different lighting scheme, I visit the Lighting folder.

These tear sheets are invaluable. Not only can I use them for inspiration, I can use them to communicate my concept to others. If there is a hairstyle I want for a shoot, I just pull out a photo. That's so much easier than explaining it to a stylist! Or perhaps I have a particular concept in mind; instead of struggling to explain it to my client, I show her a sample image to illustrate the direction I want to take the shoot.

Keep and organize tear sheets. They will save you time and inspire you.

Locations

Sometimes a particular location will inspire me for a shoot. A location may encourage a certain composition, or it might have a particular time in history that it reminds me of. For example, if there is a 1950's diner in your area, you

might be inspired to do a couple's engagement session with a 1950's theme. Or perhaps a rich, green forest will inspire you to do a bridal image with the pure white dress against the bright green tones.

If a location inspires you to create a certain image, all you need to do is wait for the right client to come around who fits that environment.

I had seen the falls in Figure 1.2 in my hometown and photographed them as landscape photography. I knew that this would make a striking scene for a fashion image, so when I found a bride willing to pose near them, I was able to catch this image.

Figure 1.2

The falls make a beautiful and elegant backdrop for this bride.

Props

An interesting chair, an old clock, or a unique pair of glasses can inspire an entire shoot. When browsing eBay or a local antique shop, you are certain to come across treasures that will inspire a shoot concept. Keep these props in mind if you have an opportunity to fit a concept you have developed, or focus an entire shoot around an interesting prop.

Clothing

A shirt, a dress, or any piece of clothing may inspire you. A long and flowing dress may inspire an elegant and ethereal shoot in a field at sunset. A black leather jacket may inspire a *Rebel Without a Cause*–themed shoot. If you're working with a wardrobe stylist on a shoot, be sure to consult with him about interesting or inspiring pieces of clothing he has access to. Several of my most successful images have resulted from my asking a stylist to tell me about any outstanding pieces of clothing he is interested in working with.

Your Creative Team

A *creative team* refers to the individuals you work with during a fashion shoot. They include the hair stylist, makeup artist, wardrobe stylist, prop stylist, and any other people who take part in making your concept a reality. If you choose to work with hair stylists, makeup artists, or wardrobe stylists, chances are they are brimming with ideas for shoots. They are artists like you and have their own ideas and visual goals. Many will keep their own collection of tear sheets for inspiration. If you are short on ideas or just looking for a different perspective, turning to your creative team can be a great way to come up with something unusual.

In Figure 1.3, for example, I had a college fashion major approach me and ask me to photograph her work. From there I simply needed to find a client or model who would be appropriate for the styling she provided. She created the clothes and the headpiece and even helped direct the hair and makeup.

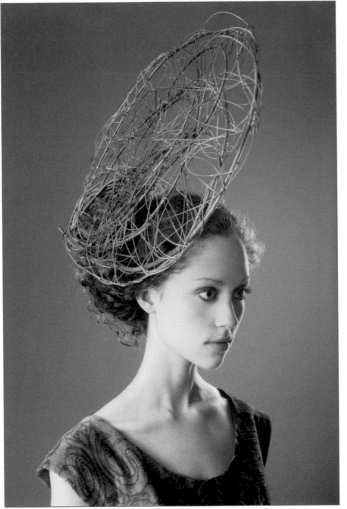

Figure 1.3
Sometimes people on your creative team (whether hair, makeup, or wardrobe) provide the inspiration needed for a shoot.

Client or Model

Sometimes your client or model will inspire a shoot because of a particular look. A subject with big, soft eyes might inspire a gentle beauty shoot with a wreath of wildflowers on her head. A subject with a strong jaw line and short spiky hair would inspire an entirely different shoot.

If you find a client who is a muse for you, consider shooting her free of charge (after the first session) to help you build your fashion portfolio. Photographing someone like this is a great way to push your creativity and try new fashion flair techniques.

Sometimes a client will inspire a shoot because he approaches you with a particular idea. Maybe he is an equestrian and tells you he's always wanted an image of himself riding into the sunset with his horse. He provided you with the inspiration; now it's your job to perfect the details for an amazing image.

In Figure 1.4, my client wanted to do a pin-up style shoot. We passed around (through email) various inspirational shots, including poses, hair, makeup, and clothing. She was a perfect fit for this styling. She even provided the clothing.

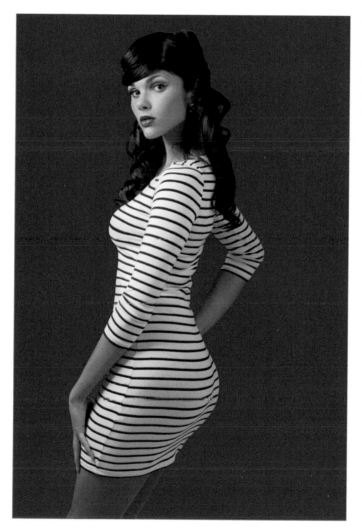

Figure 1.4

With this fashion flair pin-up shoot, my client and I discussed all the styling before the shoot to achieve our desired final look.

Music Videos

Even if you aren't a big fan of MTV or pop music, music videos are an incredible source of inspiration. Most of them are like 3-minute moving fashion editorials. Many are highly stylized with great lighting, props, and locations. If you have a favorite band or a genre of music you like, take some time to watch music videos and see if any of the visuals grab your attention.

For example, in Figure 1.5, I was watching a music video in which the lead singer danced in front of a car in fog during the last few shots of the video. The image was striking, so I wanted to do something similar.

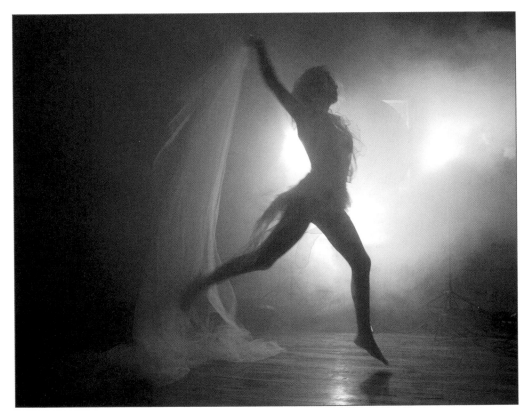

Figure 1.5 This image was inspired by a visual in a music video of the singer dancing in front of car headlights on a foggy night.

Movies

Movies are a great source of inspiration because every aspect of the scene is planned. The speech, the blocking, and the props are carefully selected. Check out the clothing and lighting for inspiration. You can get some good ideas, especially by watching movies set in another period.

Songs, Poems, and Books

When you close your eyes and listen to a song, visuals may come to mind. Perhaps you try to envision what you would do if you were asked to create the music video for that song. Or perhaps there is a favorite lyric in a song or a poem that speaks to you. How would you put those words into a single image? If you are struggling for inspiration, pick a song and try to imagine what type of portrait or fashion image would best illustrate what that song conveys or how you feel when listening to it.

Fashion Photographers Who Inspire

I've always found other photographers' work a great place for inspiration. Note that I don't copy their work. What's the point of making an image that's already been made before? Plus, it's just not right ethically.

Yet using the work of truly great photographers for inspiration has helped me achieve fantastic lighting, poses, and more.

This is by no means a comprehensive list of fashion photographers, but if you are new to fashion photography, this is a good place to start looking for inspiration.

Fashion and Conceptual Portrait Photographers

These fashion photographers represent a few of the great masters of the past as well as photographers currently leading the fashion photography industry.

- Cecil Beaton
- Irving Penn
- Richard Avedon
- Helmut Newton

- Herb Ritts
- Paolo Roversi
- Patrick Demarchelier
- Steven Meisel
- Mario Testino
- Mario Sorrenti
- Peter Lindbergh
- Annie Leibovitz
- Albert Watson
- Bruce Weber
- David LaChapelle
- Nick Knight
- Rankin
- Joyce Tenneson
- Jill Greenberg
- Mark Seliger

Photographers' Agencies

Photographers' agencies represent creative individuals, promote their work to potential clients and magazines, and help handle marketing. The few agencies listed here represent some of the most famous photographers today.

- Art + Commerce
- Art Department
- Art Partner
- Creative Exchange

Consider checking other photographer and artist sites to find great work. If you search a certain keyword on Flickr or Google Image, you might find an image to help you complete your concept or give you a tear sheet to communicate with your creative team. You might search Getty Images (a stock photo agency) or try an artist social networking site like DeviantArt. When searching such general sites, you are sure to come across a lot of visual noise, but once in a while you will find exactly what you are searching for.

Visualize Your Concepts

Once you've found your source of inspiration, you need to put together a cohesive concept.

For example, you've decided to go with the 1950's diner as a location for an engagement session. What hair would look best for this shoot? What type of clothing should the couple be wearing?

If you have a creative team, they will be able to come to you with ideas for hair, makeup, and clothing. If not, now is time for more research. Go online to find the appropriate styling necessary. How do you want the bride-to-be to style her hair? What should the groom-to-be wear?

In fashion photography, the photographer is often telling a story. The story doesn't have to be logical in the traditional sense but should provide a way to bring the viewer into the image and explore the story within.

For the concept of the engagement shoot in the diner, you can work a story into images of the two flirting, having a milkshake, and riding home in his old-fashioned convertible. You can enhance the experience for the viewer and client alike. From a business standpoint, telling a story with images gives you the opportunity to sell more prints, sell client books, and make the shoot more of an experience.

You have probably seen fashion editorials in the back of fashion magazines. They are frequently 6–15 pages in length and based around a cohesive theme. While maintaining this theme, the photographer often tells a story through his images.

- The story may be based on fantasy, with the model in a world filled with fantastic props and surreal fairytale environments like the work of fashion photographer Tim Walker.

- The story may be about consumerism and sexuality in society, like the work of David LaChapelle.

- The story may be about beautiful doe-eyed subjects—quiet, almost mourning, appearing to be plucked from the Victorian era, like the work of Paolo Roversi.

 Or, quite simply, the images can tell a story of a girl (or guy) in a unique environment in unique clothing.

■ Not all editorials tell a complex story, but many of the most successful editorials invite the viewer in to explore the world that the photographer has created.

Not only does storytelling make the images more interesting, it gives your images a direction. The story you are trying to tell will help inform your choices of location, lighting, and styling. Furthermore, you will keep your viewers engaged and entertained. The images don't need to read like a book with a beginning, middle, and end. Instead, their cohesive theme should help draw viewers into the images and make them crave more.

Figure 1.6 was part of a bridal fashion shoot, done before the day of the wedding. Together we created a 1950's fantasy setting using vintage styling and a vintage car as a prop. I took a number of shots of her driving the car, fixing her makeup in the mirror, and playing the role of this 1950's bride. The hair, makeup, styling, and props reinforced this theme to convey the story.

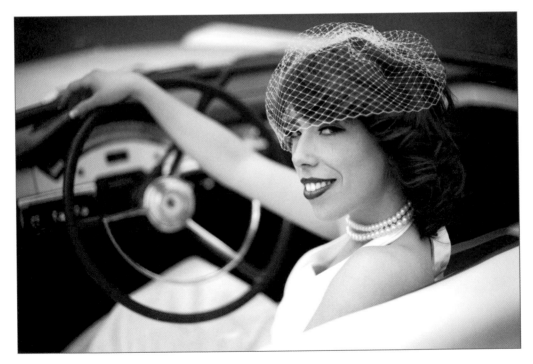

Figure 1.6 Your images can tell a visual story. For this shoot, I was able to create a 1950's vintage fantasy for my bridal client.

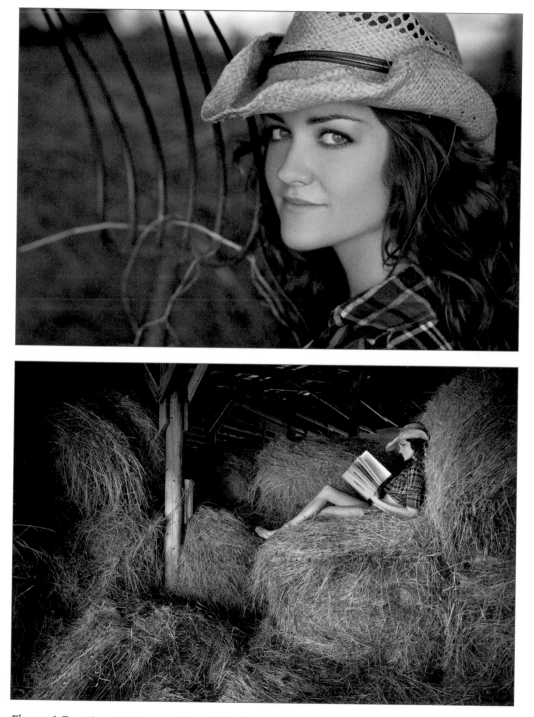

Figure 1.7 These two images, although basic, can begin to paint a detailed story in your viewer's mind.

Obviously, in most situations, you won't have your portrait or wedding client in a truly bizarre environment or telling some extravagant story. Instead, the interest in the image's content can allow the viewer's mind to explore the possibilities of the story within the image.

The images in Figure 1.7 involve storytelling at the most basic level. I took a series of portraits of this young lady at a local farm. In one shot she held a pitchfork to show her as a working farm girl. Another shot showed her reading a book in a haystack. The story in the images depicts a beautiful farm girl expected to help run the family farm. She works in and around the farm, handling chores, but her heart is not necessarily in it. What she truly enjoys is escaping into the haystacks, hiding from her duties, and diving deep into a book. Here she can escape and pass the hot summer days in her thoughts, dreaming of far-off places or a different time in history.

This reading into the images may be a bit exaggerated, but that's the idea of storytelling. You invite the reader to finish the story you have begun in his mind and engage him with your images. These two basic images begin to paint a detailed story.

Consider Logistics

Although the majority of this chapter has been dedicated to the challenge of finding inspiration and communicating an idea, you also have to be practical when preparing for your fashion flair shoots.

You must consider many logistics before your shoot:

- Can the client do the hair and makeup herself, or do you need to hire someone?

- If shooting on location, how can you get permission to shoot on the location, and do you need extra insurance? Do you have to pay to rent the location? (See Chapter 2, "Shoot on Location.")

- Will you need studio lighting, an extra assistant, or special tools?

- Is styling props and clothing something you are comfortable doing yourself, or do you need to get advice or hire a stylist?

- Do you need to buy or rent extra props to communicate your idea?

- Is there a specific time of day you must shoot to get a certain lighting effect?

As with all things in life, you live and you learn. You will figure out the questions to ask, and there are sure to be unexpected complications or costs at some point. With more experience, you'll learn to anticipate what could go wrong and take steps to compensate. Remember that at some point, things will go wrong, but that's just another opportunity to learn.

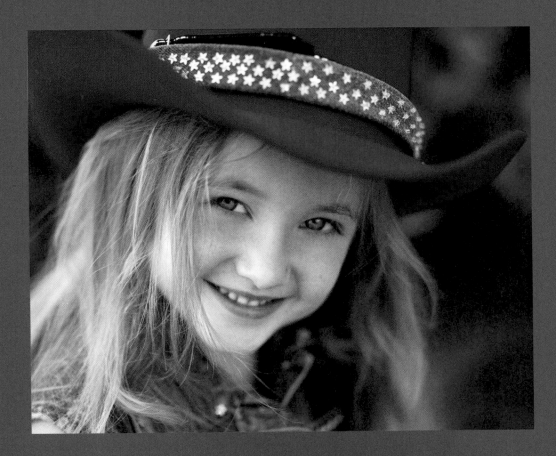

2

Shoot on Location

Some locations are set in the studio using specialized backgrounds or elaborate set design. Rather than building sets or sticking with plain backgrounds, I often prefer to venture outside the studio to find an interesting location. Adding compelling locations to your portrait and wedding shoots is a great (and relatively easy) way to add interest to your photography. In fashion photography, shooting outside the studio is referred to as *shooting on location*, and it's used for a specific purpose. Sometimes locations help to further a story, sometimes they match a particular theme, sometimes they are bizarre, and sometimes they simply complement the clothing on the model.

By photographing subjects in an interesting, extravagant, or even bizarre environment, you help them feel that they are living the fantasy of fashion photography. As stated before, fashion photography is often about fantasy and surrealism. When you take clients out of their usual surroundings and place them somewhere more exciting, you are creating a fantasy world achieved through your images.

Figure 2.1 certainly creates an air of fantasy and surrealism. I was able to get permission to photograph inside a botanical garden to get this striking setting.

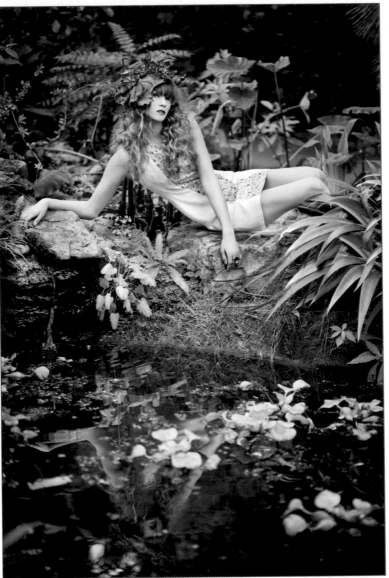

Figure 2.1
Utilizing visually striking
locations is a great way to
make your fashion flair
photography more interesting.

Interaction

Some of the best locations are those that your subject can interact with. Because you are dealing with clients who aren't models, it is much easier for them to pose if you provide them some sort of environment to interact with. Whether it's a rock to sit on or a doorway to lean in, if there is a natural way for clients to interact with the environment, they will feel calmer and cooler.

When clients are just standing in front of the environment, it draws a great deal of attention to their clothing and pose, whereas if they are interacting with the environment, there is great emphasis placed on the story and surroundings.

Also, when subjects are able to interact with the environment, it is a bit like assuming the mindset of a character in a play. They begin to transform into the character they are playing. They are better able to enter the role they envision and pose when they feel they have entered another realm.

In Figure 2.2, the subject climbed on top of a train at noon. The light was not perfect, but the contrast of the sky and train created this graphic image. The subject was able to interact with the location by sitting or standing on different parts of the train. If the subject had simply stood in the foreground with the train in the background, it would have been a less interesting image.

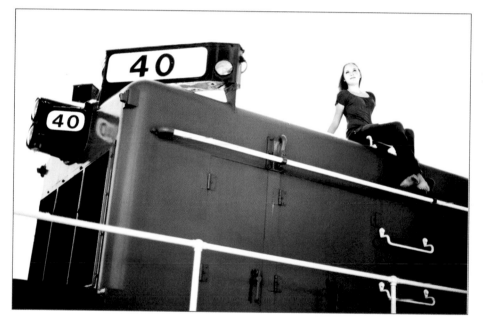

Figure 2.2

Your images will become more interesting if you find ways for your clients to interact with interesting environments.

To learn more about posing and interacting with the environment, see Chapter 4 "Strike a Pose."

As talked about in the previous chapter, you should try to tell stories with your images to engage your viewer and create compelling images. Locations can be one great way to tell a story. In Figures 2.3 and 2.4, the location helps to create a cute wedding narrative. These images, from a trash the dress session, tell the story of a wedding couple "gone fishing" on their wedding day. (A trash the dress session occurs after the wedding and often involves the bride posing in

unusual locations or doing unusual things that risk ruining ["trashing"] the dress.) The images are playful, fun, and unusual. Unusual images will be more memorable, so your clients will cherish them more.

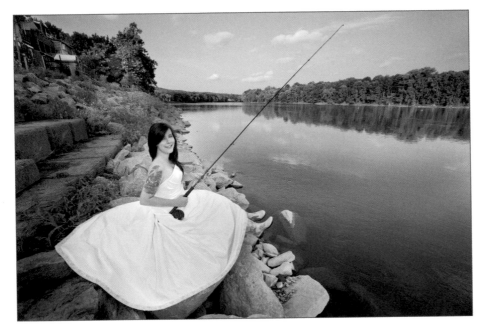

Figure 2.3

The bride sits along a riverbank, fishing in her wedding dress. The location tells a story and makes for an unusual and playful image.

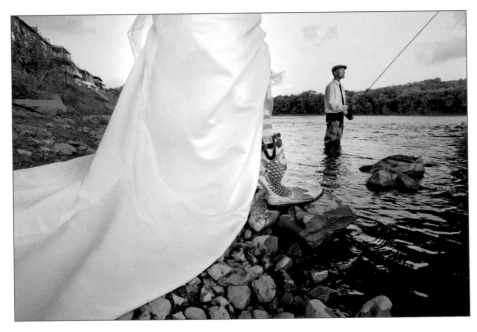

Figure 2.4

I'm sure many die-hard fishermen would love to fish on their wedding day. Making this wish a reality creates a funny and entertaining image.

Composition

When selecting a location, always look at the way you can compose that location within a frame. If the scene is flat overall (like an interesting textured wall), it will affect the way you shoot, compose your image, and pose your client. Ideally, you would look for environments with leading lines and depth.

Leading lines serve as a way to lead viewers' eyes to the center of interest in a photo. The most typical example of a leading line would be a stream in a landscape, guiding viewers' eyes throughout the scene. Leading lines are important compositional elements in fashion photography as well. Although these are not typical leading lines, the two brick walls converge to act as visual leading lines in Figure 2.5.

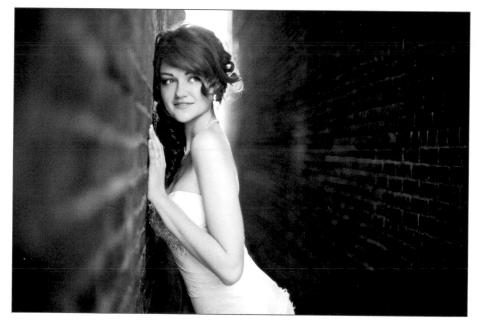

Figure 2.5

Leading lines are a powerful visual tool that can draw viewers' eyes to the subject.

If you are going for a graphic image, you may consider a background with graphic patterns, bright colors, or little depth. This allows you to focus primarily on composition and color theory.

If you are trying to tell a story, you may want to choose an environment with depth. To have depth, you are looking for a foreground, middle ground, and background. By adding depth, you add reality to the scene and allow the viewer to feel as though she is living in the world of this environment, not just an element in front of a background.

With green screen techniques these days, it is relatively easy to fake a subject within a surreal environment if you realistically match the light. In fact, several famous conceptual portrait photographers use green screen with celebrities and models to achieve high-impact conceptual portraiture.

Also, finding unique ways to frame your subject provides for interesting composition. You can frame your subject with a doorway, window, branches, other people, or anything else. Get creative! Using frames within your image focuses the viewer's eye on the subject and helps control the viewer interaction with the image. Furthermore, it makes your photograph more interesting.

Frames do not literally need to be frames within the picture. I have seen this done often, and it is a bit cliché. In Figure 2.6, the subject is framed by the opening in the stairway. She is nicely framed by her environment, and viewers' eyes are drawn to this part of the image.

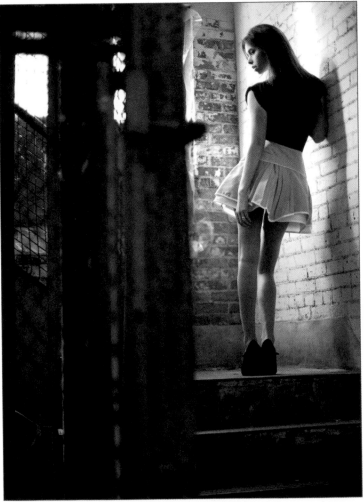

Figure 2.6

Framing is a powerful compositional tool to draw viewers' eyes to the subject and add visual interest.

Color Theory

Color theory involves the way color affects the meaning and feelings behind visual art. For example, we often associate blue as a cool color and red as a hot color. We also know that mixing different colors within a single image can create tension or harmony.

Color theory is pretty broad. You may have learned about primary colors and the color wheel in grade school. You can use many of those concepts in your photography to make stronger images.

The famous fashion and celebrity photographer David LaChapelle is renowned for his use of color theory in images. His imagery is bold and graphic, and it makes exquisite use of color theory. He often uses saturated complementary colors within an image to make a visual impression.

The color wheel, seen in Figure 2.7, is a range of colors displaced in wheel format, including primary colors (red, green, blue) and the subsequent colors achieved by mixing these base colors. You get a continuum of color.

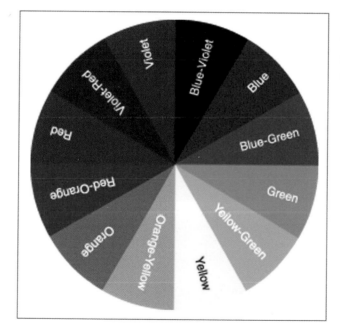

Figure 2.7

The color wheel is a representation of the continuum of colors.

Why should you care about the color wheel?

The color wheel can tell you a few important things. First, the colors opposite each other on the color wheel are complementary colors. Pairs might include red and green, yellow and purple, and so on. Using complementary colors creates a powerful impact in images by using contrast that still conveys unity. When placed next to each other, complementary colors intensify one another.

Second, the color wheel can help you determine colors that would achieve color harmony in use. When you use two or three colors next to each other on the color wheel, it creates visual harmony. It conveys a sense of order, balance, and unity within the image.

Figure 2.8 demonstrates complementary colors in use. The subject's red hat against the green foliage creates strong contrast and intensifies the appearance of each color.

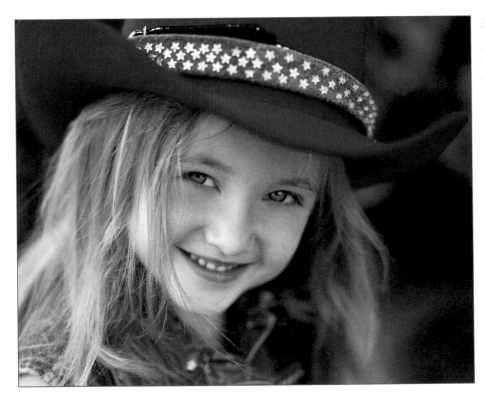

Figure 2.8

Red and green, opposite each other on the color wheel, are complementary colors. The red hat against green foliage creates a strong contrast and pleasant visual effect.

In Figure 2.9, the green in the girl's dress and the background foliage mimic each other, as well as the brown of her dress and the tree. The overall effect is color harmony.

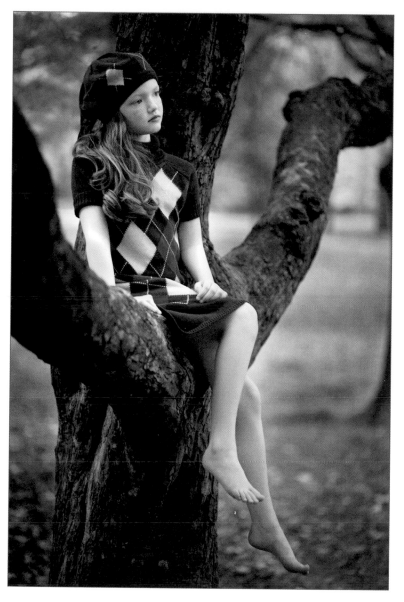

Figure 2.9
The greens and browns in both the environment and the subject's clothing help create color harmony in the scene.

Lighting on Location

When you arrive at a location, after you determine whether the location will fit your concept and determine a likely composition, examine the lighting conditions. Can you illuminate your client using natural light like window light and reflectors? Do you have to bring in artificial lighting like strobes or speedlights?

Although it may seem obvious, you need to make sure there are outlets if you require artificial lighting and determine if you'd need extension cords. If no outlets are available, you may have to utilize speedlights or portable power packs. Nearly all strobe companies have some form of portable power packs that can allow you to use studio lighting on location. The "vagabond" power pack is produced by the Paul C. Buff company. This pack powers a variety of lights that are usually operated without a pack (those that plug into wall sockets). The number of flashes per battery depends on the output of the lights, but you can purchase additional batteries to change in and out.

> **NOTE**
>
> Portable power packs have a limited number of frames per battery charge. Most portable power packs provide fewer than 200 flashes per fully charged battery. If you are planning on doing multiple looks or changing locations, you may need another charged battery or an additional pack. Packs and batteries are often quite heavy; you typically need an assistant to help manage equipment for these shoots.

Take a careful look at existing light. If there are overhead lights, can you turn them off? If the lights are fluorescent or have a color cast to them, make sure you can turn the lights off, or you will have to gel your strobes to match the color cast.

If you're in tight quarters, can you even use artificial lighting or fit a reflector in the space?

In Chapters 8, "Ambient Light: All Natural," and 10, "Flash on Location: Taking Control," you can find instruction on location lighting with natural light, strobes, and more.

Unique Locations

I often ask people on Facebook and Twitter for suggestions on where to shoot. Also, I ask my clients to ask their friends and family for ideas. I have several places near the studio in my town where I shoot regularly. I know these places well, and they reliably produce good images. I know the light, I know what compositions work, and I know they are always great backups.

With each client, however, I try to produce new imagery. If a client can come up with a new and exciting location, I am ready to shoot there. Again, I look for locations that allow the client to interact or have strong compositional elements. Clients often come up with ideas for locations or suggestions of how these locations might fit into the shoot.

In Figure 2.10, my client described herself as an "outdoor-loving country girl," so it seemed obvious to photograph her in a location that represented her down-home personality. In this case, the photography took place in a local field near a large pile of hay bales. The sepia tone of the image emphasized the visual mood, and the client's clothing choice created a cohesive theme.

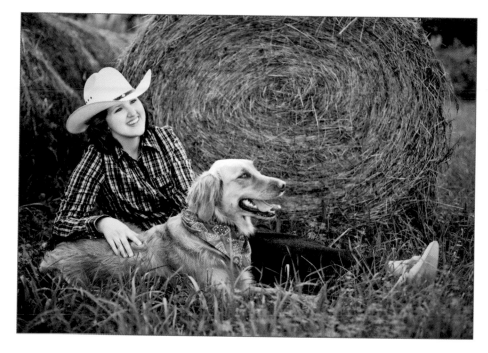

Figure 2.10

Before many portrait sessions, I ask my clients to describe themselves and what type of image would best represent them. In this case, my client expressed a love of the outdoors and life in the country.

When traveling to other cities or countries for a portrait or wedding shoot, particularly if I've never been there, I often use Craigslist to get suggestions on where to shoot. Under Community>Artists, you can create a post asking for suggestions of good places to photograph. I almost always get a few good leads from other artists living in the area who share their favorite places to paint, draw, or photograph.

Be creative in your locations. I often keep my locations relatively simply by shooting in a park or by a river. Yet I have noticed that some of my most memorable images were shot by old, worn trains or beside beautiful waterfalls. Locations like these add impact.

In Figure 2.11, you can see an interesting location I discovered. This image was taken in the spray paint room at Syracuse University. The room was littered in graffiti and made a great background for a portrait or fashion image. I worked with the client to find a dress that mimicked graffiti designs. This image would be interesting regardless of the subject, her clothes, or her pose because the location itself lends visual interest and high impact.

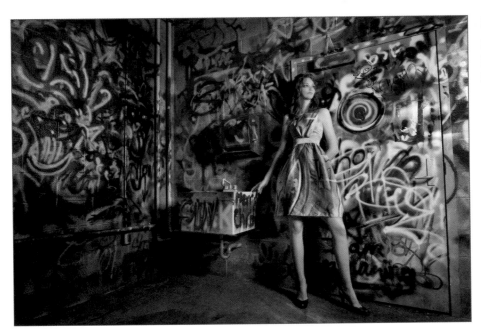

Figure 2.11

Finding bizarre and interesting locations adds impact to your imagery.

I am positive you can find interesting environments near you and your studio. As a passionate photographer, I'm sure you know that if someone says there is nothing interesting to photograph, he isn't looking hard enough. Think about interesting parks in the area, restaurants with beautiful interiors, the gardens of nearby estates, exquisite hotels, funky clubs, old buildings, gnarled trees, or natural attractions.

In the movie industry and in high-end magazine/advertising work, some people are hired solely for the purpose of finding a good location. Although you don't need to hire a professional location scout, you can hire someone to do some research to find different options that meet your visual requirements. If you have a bigger budget, you can use any of the large online location databases.

These databases are primarily used by the motion picture industry. Locations are sorted by descriptive factors like "industrial," "modern," "derelict," or "gardens." Some of the more well-known location companies have private homes and gardens all over the country and world. What's the catch? You have to pay a hefty fee to the location company as well as to the location you are actually renting. If you are making a big-budget movie, no big deal. Or if you happen to land a big-budget client who envisions a certain type of location, these location databases can be invaluable.

> **NOTE**
>
> If a location is listed in a database, it means the company already has prior approval to shoot there. You don't have to worry about convincing the owner of the house, garden, or restaurant to let you shoot. The company has already worked out the terms with the location database company.

Time of Day

When shooting on location, particularly outdoors, lighting varies drastically based on time of day and time of the year. Scout out your location at the same time of day that you will be shooting. If you check out a location at 10 a.m. and the light is great, the lighting may be harsh and horrible at 4 p.m. Timing is key. On a similar note, if you shoot a location at 7 p.m. in June, the light will not be the same if you go back to shoot at 7 p.m. in November. Just keep these factors of changing light in mind when selecting a location or time to shoot.

Figure 2.12 is a successful image because of the direction of light (evening light), the composition, and the starburst coming through the foliage. If it had been shot earlier in the day, the light would have been too harsh overhead, and there would have been no starburst. If it had been shot later in the day, the light would have fallen beneath the nearby hills, and there would have been no direction of light. Time of day is essential to many locations.

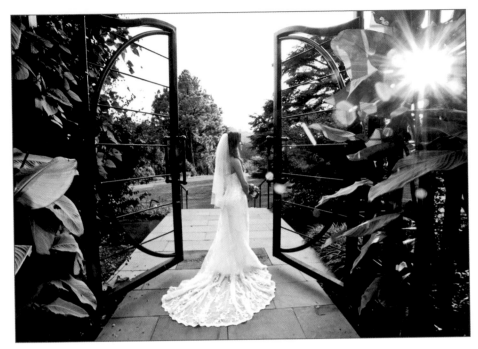

Shooting at Noon

Photographers often hear that shooting midday when the sun is high and harsh is terrible for portrait lighting. The subjects have harsh shadows on their faces, squinted eyes, and often undesirable highlights in the background.

Yet I have found that shooting at noon can be one of the best times of day to shoot. If you are not shooting in direct sunlight, noon shoots can produce great qualities of light.

You can use a large diffuser to soften the sunlight and create an equivalent to a large softbox. (See Chapter 9, "Studio Light: Complete Control.") If you stick the subject in the shade and bounce this midday sunlight into the shadows, you can have crisp and flattering light for your subject. (See Chapter 8.) In other words, depending on where you are shooting on location, you don't need to shoot during a golden hour or with special equipment to achieve the best lighting results. Watch and control the light!

Permissions

Shooting in certain locations requires permission. Sometimes obtaining permission is as easy as asking. Other times you may need to do a little more convincing.

If you have liability insurance (see the next section), it's definitely going to help you convince a landowner or business owner to allow you on his property. If you have insurance and someone is injured, the owner doesn't have to worry about having insurance to cover the damages.

Also, bartering is a great thing. Remember that your images have value. In fact, they have *a lot* of value. Offer the owner of the location images of the location that he can use for promotional purposes, including on a Web site or in a brochure. You can even throw in an image for advertising if the person is difficult to convince. Let the owner know how much your images are worth and how much you would normally charge for creating beautiful images of a location. Also, if you're bartering for images, be clear that the images don't include a model in the photo unless your subject agrees to sign a release for this purpose.

Insurance

As a professional or even aspiring professional photographer, you need some form of insurance. If you don't have it, you could damage your career and financial future.

I often photograph brides at a waterfall nearby my studio. Let's assume I am photographing a bride, and (heaven forbid!) she slips and falls. Without insurance, this bad situation could be even worse.

When you shoot on location, you need to have insurance. Often when you purchase business insurance, you can buy policies that include coverage for shooting on location. At a minimum, you want coverage for your equipment in case of damage and liability coverage for you and your clients in case of injury. A typical liability insurance policy is $1,000,000 of coverage, although you can always purchase additional coverage and even specialized coverage, depending on your needs. Be sure that the type of insurance coverage you have doesn't just cover you within the walls of your studio but will also protect you on location.

Many professional photography agencies offer a form of liability insurance in conjunction with another company, or they recommend a variety of companies. Check the Web sites of Advertising Photographers of America (APA) or Professional Photographers of America (PPA) for current recommendations.

3

Get Style: Wardrobe, Hair, Makeup, and Props

When you think of fashion photography, you probably think of models in beautiful clothing with great hair and makeup. Styling is essential in a fashion image. You are in control of the styling of the wardrobe, hair, makeup, and props. The selection and styling of these elements help you communicate a specific theme or achieve a desired visual result.

In fashion photography, you don't just *take* the picture; you *make* the picture.

In a typical portrait session, a client shows up, poses, and gets her picture taken. To achieve a fashion flair, you must be aware of the different aspects of styling to create your picture. Before your client comes in, you should have already discussed wardrobe, hair, and makeup. You should have already decided upon the main goals and concept of the shoot and how styling different elements including props can help you achieve your visual goals.

Not every shoot has to be a big production, but you need to at least address the different elements of styling that can affect an image.

If you are not very stylish, don't worry. You can achieve a lot of styling by looking at inspirational images or collaborating with other creative individuals.

Fundamentally, all you want is an attractive and interesting image. You don't have to know "what's in" with clothing at the moment. You just need to know what photographs well and what will communicate the goals of your image. If you are uncomfortable with styling, you can start off simple—just don't leave the decisions up to chance. You can accomplish a great deal on your own. Many images in this book were accomplished solely through collaboration between my client and me. Some of my most successful images, however, were the result of working with a creative team.

You can often find clothes and props on your own and help put together an image around a cohesive theme. In Figure 3.1, I found the dress at a local clothing boutique for $20 and the shell necklaces for less than $5 at a crafts store. When you're combining locations, clothing, props, and posing, you can create an inexpensive yet extremely successful image with style. Imagine this same image of the subject in jeans and a t-shirt, just sitting on the rock. It wouldn't have the same impact or mood. The styling and posing make this image what it is.

Figure 3.1 This portrait, taken at Laguna Beach, was not a large production but still was visually successful because of its styling.

Building Your Creative Team

In most cases, creating fashion photography is a group effort. When I am working on a fashion flair portrait, I usually work with a minimum of three other people: the one doing hair and makeup (one person), the client/model, and a photo assistant. Other times I have worked with more than a dozen people on my creative team!

It is not necessary to have a big team, but you will be better able to focus on your job (making amazing photos!) if someone else is concentrating on hair and makeup and your assistant is focused on lighting or clothing. In the beginning of my career, I did everything myself. The images were good, but the shoots were a lot more stressful and generally ran less smoothly. Specialization is the way to go. I now focus on the subject's expressions and posing and leave the rest to someone else.

In some cases it's good to hire a wardrobe stylist (see the "Wardrobe" section that follows), but chances are you can do a lot of styling by yourself.

The following sections discuss ways to develop concepts and gather creative people to help you execute your shoot. One major resource I frequently use is Model Mayhem (http://www.modelmayhem.com/).

Model Mayhem and Other Social Networks

Model Mayhem is a social network for photographers, models, hair stylists, makeup artists, wardrobe stylists, and other industry professionals. As a photographer, you can create a profile of your best work and include your contact information and a brief bio or artist statement.

From there, you can begin browsing the site for other people you'd be interested in collaborating with. Under the Browse section, you can search for people based on city or ZIP code and add them as a friend, as seen in Figure 3.2. You can send personal messages stating your desires to collaborate, or simply "friend" people whose work you admire.

Figure 3.2

Model Mayhem is a social networking site for fashion creatives, including photographers, hair stylists, makeup artists, and wardrobe stylists.

In short, you can use Model Mayhem to find hair stylists, makeup artists, and wardrobe stylists in your area who might be interested in collaborating on your fashion flair (or other fashion photography) shoots.

Model Mayhem allows you to post casting calls, as seen in Figure 3.3. Basically, you are creating an online Model Mayhem ad where you indicate the date of the shoot, the type of person you are looking for (hair, makeup, and so on), the compensation for the shoot (paid shoot or just for practice), and any other related information (like the concept). People who are interested in my shoot and what I have to offer can respond to the post. I then sort through the respondents and choose the people I want to work with. It's as easy as that.

Figure 3.3

Whenever you need to hire hair, makeup, or wardrobe professionals, you can put an ad out (casting call) to see who is interested in fulfilling the position at a predefined rate.

I have used Model Mayhem on many of my fashion flair shoots; it has helped me connect with creatives who later became an essential part of my fashion team. When I travel, Model Mayhem is essential because it allows me to post casting calls in a region so I can find a team in an area I am unfamiliar with.

Although I seldom use Model Mayhem now that I have a steady creative team, it was essential in the beginning for me to make connections with other creatives and find people I could eventually rely on to help me build my fashion flair name.

> **Caution**
>
> The people on Model Mayhem are not held by a code of ethics or rules, which can be problematic. People sometimes cancel at the last minute or may never even show up to a shoot. When using Model Mayhem, be sure to meet the people you are working with beforehand or at least talk to them on the phone a few times to discuss your concepts. I recommend that you have a test shoot (unpaid) before doing any paid work to be sure that the creative team shows up on time and produces quality work. Once I find a team I can rely on, I avoid using Model Mayhem for important paid shoots because of the inherent risk of no-shows.

Model Mayhem is not the only social network of its kind. Several others have similar objectives, including Model Run (http://www.modelrun.com/) and One Model Place (http://www.onemodelplace.com/), but Model Mayhem has the largest active membership and therefore the greatest chance to find someone for your team. In addition to Model Mayhem, I have used more traditional social networking sites like Facebook and Twitter to reach out to creatives I am interested in.

Wardrobe

Your wardrobe choice is often informed by the concept you are trying to achieve. Is there a particular style or visual effect you're after?

Tear sheets become important here. As mentioned in Chapter 1, "Prepare to Flair," *tear sheets* are images you pull out of magazines or save online to use as inspiration.

If you don't have a strong fashion sense, having a tear sheet to demonstrate an idea or clothing style is invaluable. If you have a certain concept for a shoot, you can show the concept to your client or wardrobe stylist to discuss possible outfits. You can even keep tear sheets of the types of clothing you like to best communicate your goals for clothing.

Finding Unique Clothes

For many concepts, you can get away with using the clothes in your client's closet or having her search for particular clothes to purchase for a shoot. But if you and your client are looking for more avant-garde outfits to photograph, you will have to put a bit more effort and research into the search. Here are a few tips for finding this unique clothing.

If you live near a college, check whether it has a fashion design program. If so, you are in luck. These students have no doubt made interesting pieces that they would love to have photographed. In fact, many colleges require students to have their senior collection (final college project) professionally photographed to put together as a portfolio of their work. Figure 3.4 is an example of a high-fashion jacket created by a fashion design student at Syracuse University. Because the piece looked vampire-esque, I chose to illuminate the image with dramatic side lighting.

Figure 3.4

If you are looking for interesting pieces of clothing, consider contacting fashion students at a local college or university.

Keep in mind, however, that most of these students have designed their pieces for models, so they will run small. These unique pieces may only be appropriate for skinny young women, but this might be perfect if you shoot a lot of senior portraits.

You might also consider hiring one of these students as a fashion consultant for your business. If there is a student who has work you like, she can become your wardrobe stylist.

On high-end fashion shoots, an individual is solely in charge of clothing. This person, the wardrobe stylist, is not usually the fashion designer. She doesn't make the clothes. Instead, she helps you select clothing to achieve the concept of your editorial and put together a cohesive look, including shoes and accessories. Believe it or not, many (even most) fashion photographers are not particularly stylish. They are much more concerned with the expression of their idea and concept and treat clothing as one small part of the equation. They hire wardrobe stylists whom they respect and trust to handle all the clothing.

You can consider hiring a fashion student or professional wardrobe stylist to style shoots for you. For example, if you are photographing an engagement portrait with a vintage fashion twist, you might have this stylist go around to local vintage and used clothing stores to help you find clothing that will achieve your stylistic goals. If you are comfortable doing this yourself, even better. Don't worry, however, if you are not much of a stylist; there are people out there willing to help and collaborate.

There are several places to begin looking for clothes:

■ **The client's closet (or her friend's closet).** You can usually find what you need for a shoot right in the client's closet. If your client doesn't have the right look and feel, have her check with her friends. Many of my clients place a request in their Facebook status and soon find someone who has clothing to accomplish the desired look.

■ **Local boutiques and clothing stores.** Local boutiques often have a variety of higher-end and more interesting clothing items. Some boutiques even let you borrow clothes for a shoot in exchange for images. Be sure to show them samples of your work, and let them know the type and number of images they would receive in exchange for borrowing the clothes. Certain boutiques let you borrow the clothes as long as you leave your credit card information in case of damage or your not returning. In Figure 3.5, I was permitted to borrow this beautiful gown for a senior portrait shoot from a local bridal and boutique dress salon.

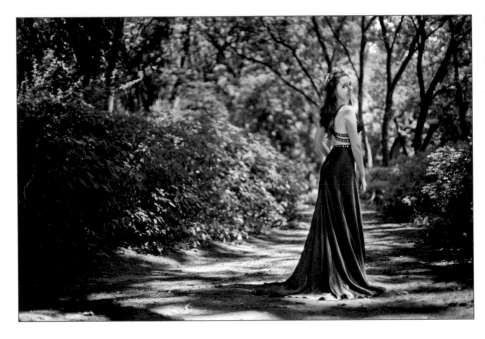

Figure 3.5

Local boutiques and clothing stores may allow you to borrow some of their high-end clothing for your shoots if you provide collateral or images as compensation.

- **Local vintage or used clothing stores.** Vintage stores and consignment shops are like the antique stores of clothing. You never know what you will find, but you just might find a treasure. When I did a lot of shooting in college, I frequently checked out the local consignment shop for interesting finds. It's logical that when I do a vintage-themed shoot, vintage stores are the place to be. If you have a particular concept in mind, you might consider bringing along an inspiration shot to show the store owner. If the owner is friendly, he might help you find just what you are looking for. I found the clothing in Figure 3.6 at a vintage shop in London. The wardrobe stylist created the custom hair piece, and I hired a hair stylist and makeup artist for the shoot. The visual requirements of the shoot would have been too demanding to do myself; they required professional expertise.

- **Fashion design students.** As mentioned earlier, fashion design students are sure to have interesting clothing styles and a strong fashion sense to advise you on styling your clients.

- **Online clothing stores.** Various online clothing stores can help you (and your client) find just the right look. Clothing stores like ShopBop provide hundreds of designer clothing items at less expensive prices.

- **eBay.** Over the years I have found tons of great items on eBay. From hats, to dresses, to furs, this is a great resource for unusual finds.

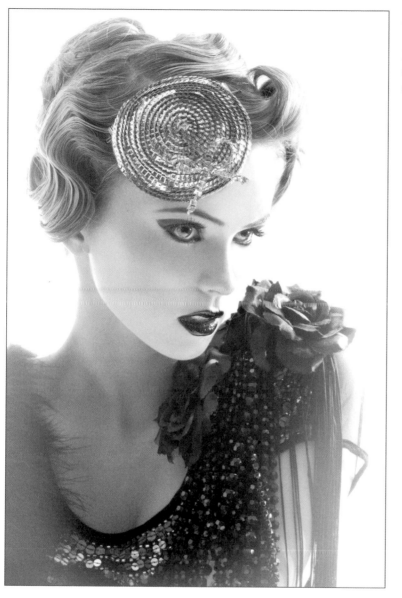

Figure 3.6
For this fashion editorial, I acquired nearly all the clothes and accessories from vintage and used clothing stores.

Following Some Basic Guidelines

There are no rules for styling your client. Everything depends on what you are trying to achieve. If you look in fashion magazines, you'll see that some fashion editorials are based on a concept of the model wearing clashing or unfashionable styles. It all depends on the photographer's vision.

If you are trying to keep it simple, there are a few basic tips to keep in mind. But these tips mean nothing if you have a concept that requires breaking the rules. These are just helpful basic guidelines:

- **Solids.** Typically, it is easier to photograph clients in solid colors. Solid colors are not distracting and usually focus the viewer's eye on the subject. For most shoots, I have my subjects wear dark, solid colors unless there is a particular concept I am expressing with the clothing. However, there will be times when bright tribal patterns or polka dots will be exactly what's needed. In most situations, however, keeping it simple with solids allows you to focus more on pose and location.

- **Words and logos.** Words and logos are distracting and dated. If you are doing a vintage shoot, vintage logos might be appropriate. For the most part, however, logos are restrictive. You particularly want to avoid clothing with brand names like Nike or a rock band's name. Unless including these logos fits exactly within your theme, using them will only create visual noise to your image and distract from your main goal.

- **Sleeves.** The length of sleeves a subject wears helps to convey the season of the image and part of the mood. The most pertinent tip here is to avoid tank tops in most situations. If a female subject is even slightly overweight, the bare skin from a sleeveless shirt makes her look heavier. Sleeveless dresses may be fine at a distance when you're trying to achieve an airy, summery feel, but you'll still want to avoid them for any overweight subjects. You might have guys wear a sleeveless shirt if you are trying to achieve a "muscle man" look, but be sure they have the body to pull it off.

- **Necklines.** Long necks are attractive in women. They're an aesthetic of beauty that fashion and beauty photographers often use in their techniques. In many fashion shots, the models are often craning and extending their necks to make them look almost birdlike and surreal. In most cases, turtlenecks add weight to a man or woman; they're not usually desirable in an image.

Hair and Makeup

Hair and makeup can be a great way to distinguish your images from the competition. Most of the time clients show up with their hair down and makeup low-key as if they are going to work or school. However, you can take extra steps to help your clients look and feel their best. Further, you can better communicate the concept of your image by utilizing unique hair and makeup techniques.

Thinking through the hair and makeup on a shoot may unleash your creativity, because many fashion images are driven by the styling of hair and makeup. These beauty shoots can help you achieve powerful imagery for close-up shots your clients will clamor for.

When I was going through a local crafts store, I found a sheet of felt designs that inspired me to do a beauty shoot. The felt was originally intended to adorn the outside of potted plants. But I carefully affixed these pieces of felt to the subject's face and neck for the image shown in Figure 3.7.

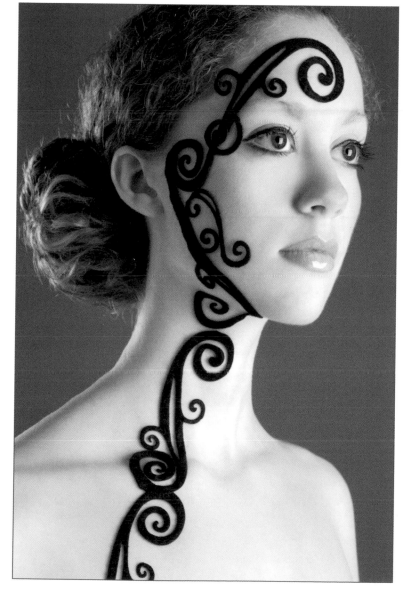

Figure 3.7

Felt designs, found at a craft store, were added to the subject's face to give a high-fashion feel to the image through leading lines and elegant patterns.

The Basics

At a minimum when dealing with a client, you should discuss hair and makeup. Do you want the hair neat and pulled away from the face? Or do you want the hair a bit wild and messy? Do you want the makeup natural and soft? Or do you want the makeup to be dramatic and theatrical?

Depending on the concept, you may need to bring a hair stylist or makeup artist into the shoot to achieve your desired look.

Address whether men should be clean shaven or have a bit of scruff. Which achieves the look you are going for?

> **TIP**
>
> In most cases, you should advise clients not to get a drastic haircut or a major change of hairstyle within two weeks of their appointment if they are styling their hair themselves. Clients need time to figure out styling.

Inspiration

For inspiration in hair and makeup, I keep a lot of tear sheets.

Just as I do for lighting and other aspects of photography, I tear pages from a magazine when I see hair and makeup I might want to use in the future. Furthermore, when looking at the work of other photographers or of models online, I keep a folder on my desktop called Hair and Makeup where I save any inspirational looks.

Another great place for hair and makeup ideas is the portfolios of hair stylists and makeup artists. Many have their own Web sites, and some even have their own creative representatives (agents).

You can find hair and makeup artists on sites like ModelMayhem.com, FTAPE.com, and Dripbook.com. FTAPE.com has a wealth of information, including links to hair stylists and makeup artists, links to many fashion magazines, and links to other photographers.

A creative hair stylist or makeup artist is sure to have begun a collection of inspirational images. If you are looking for ideas, ask if this person has a style she has been wanting to create.

I had once seen an image of a model with a variety of feathers in her hair. I decided to create a portrait that took that natural feather's styling to the next step and placed an entire turkey wing in the model's hair. The image in Figure 3.8 maintains its natural, wild, and elegant feel.

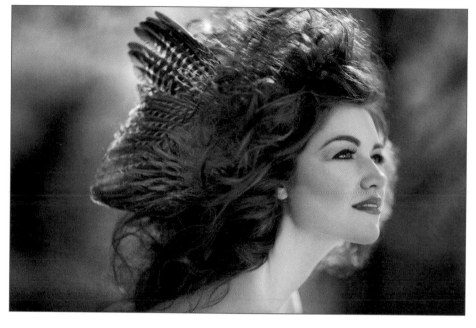

Figure 3.8

This beauty image is focused on the styling of the model's hair and makeup, inspired from another online image.

Collaboration

There may be instances when you decide you need a hair stylist or makeup artist as part of the shoot. If so, you need to find an individual or salon to collaborate with.

It is not usually a good idea to have the client go to a salon to have her hair done before the appointment. Many hair stylists just pile the client's hair up as if they are going to a prom or wedding—usually not what you want when doing a fashion shoot. You need someone you can give more direction to and collaborate with.

I have found a local hair stylist and makeup artist (one person) who is interested in doing fashion-oriented imagery and is available the entire shoot. Her services are included in the cost of my session and are offered as a value-add to my clients. Figure 3.9 is an image from a bridal fashion session I did with a client. Bridal fashion sessions (see Chapter 13, "Flair Products and Services")

can occur before or after the wedding day, but not on the same day. Because of this, a professional must do the hair and makeup. If done before the wedding, it may serve as a practice run on the hair and makeup to be sure it's what the bride wants on her wedding day. It can also be a time to try more exciting or elegant hairstyles than would have been practical on the wedding day. In Figure 3.9, a birdcage was added to the styling to give the image a more vintage feel.

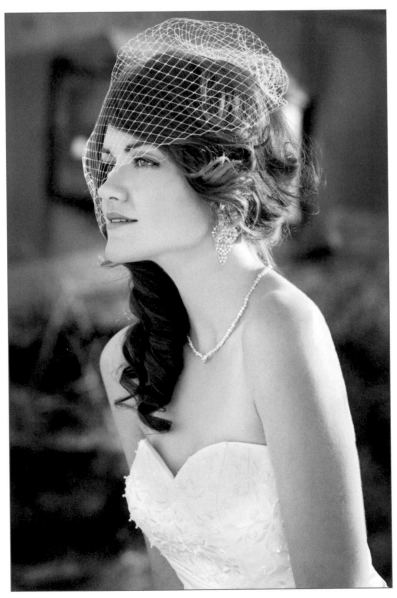

Figure 3.9

Bridal fashion shoots are a chance to try more extravagant hair and makeup.

I suggest working out some sort of bulk or hourly rate with the local salon or hair stylist you work with. For example, you might agree that she will style 15 sessions for a certain amount of money or that she be paid hourly for up to a certain number of hours working. For each shoot, provide at least two retouched images for each different look for the hair stylist or makeup artist to use on her Web site and for promotions.

> **TIP**
>
> Keep in mind that you are helping this hair stylist and makeup artist market themselves. You are introducing them to potential clients and associating them with high-fashion styling. When negotiating prices, be sure to remember that these artists are benefiting from your contract in some ways that aren't directly monetary.

It is always best to find a hair stylist and makeup artist who is interested in fashion imagery and excited to do the shoots. This will give you another creative mind to offer input on how the hair and makeup should be styled, which is invaluable. I seldom know exactly how the hair and makeup should look. Instead, I communicate what I am trying to achieve to the hair styling and makeup artist and let her take it from there. That is her job, and it puts less stress on me. Once you find someone who can help you come up with creative ideas and someone you can rely on, you are well on your way to establishing an essential element of your fashion flair.

Consider looking for young men and women recently out of training from cosmetology school or those who have trained for fashion hair and makeup. They are usually excited and eager to experiment. Furthermore, their services are often more reasonably priced than pros, and they usually have more flexible schedules for collaboration.

> **TIP**
>
> In most cases, look for someone who can do both hair and makeup. If you have to work with two different people, your costs will increase, and sessions will often take more time. Furthermore, the hair stylist and makeup artist might have conflicting visions of what the final look should be.

Also, consider looking on Model Mayhem to find hair stylists, makeup artists, and even wardrobe stylists. It is a social network where models, hair stylists, makeup artists, wardrobe stylists, photographers, and more generate a profile to network with other creatives. You can search by ZIP code, city, and state to see who is interested in collaborating in your area. I have used Model Mayhem dozens of times on fashion shoots and client shoots to find hair and makeup artists to collaborate on my project.

Progression

When you're planning to use multiple looks on a client in a single day, you have some additional considerations when planning hair and makeup. Preparation becomes important. You should have an idea of the hair and makeup required for each look.

Think of the shoot as a progression. Start with the most simplistic hair style and slowly progress toward more intense or avant-garde styling. With makeup, start with lighter colors or simpler makeup and progress toward more dramatic makeup effects.

For example, if you want a shot with the model's hair large and teased out, make it the final shot of the day. It is extremely hard to tame teased hair to achieve another look. The hair would have to be washed and restyled, wasting a lot of time. If you want dark, dramatic eye makeup in a shot, save that for the end so that you don't have to completely remove the makeup for another shot. Lighter colors are easier to remove than darker ones, or you can apply darker makeup on top with ease.

If you don't plan out the progression of the shoot, you will lose a lot of precious time and frustrate the hair stylist and makeup artist you are working with.

Time Management

Hair and makeup aren't achieved with the snap of a finger. Depending on the difficulty and complexity of the look you want to achieve, hair and makeup can take hours. This is something to be aware of. Communicate with your creative team to figure out the timing.

For example, if you want to do a shoot during ideal light, which happens to be at 6 p.m. during a specific time of year, calculate how long hair and makeup will take to complete. If the look you want to create is complex, you may need to have the client arrive 1.5 hours early. If you want just a simple look, the client can show up 15 minutes early to change. This is yet another reason that preparation is important: you figure out what you are trying to achieve and how much time you need to achieve a particular look.

In my experience, initial hair and makeup often take an hour or so, and sub-
sequent looks are achieved in about 15 minutes. This obviously can vary greatly,
depending on what you are trying to accomplish. In Figure 3.10, the initial look
took about 45 minutes. This hairstyle was inspired by an image I found online
in the portfolio of a well-known beauty photographer.

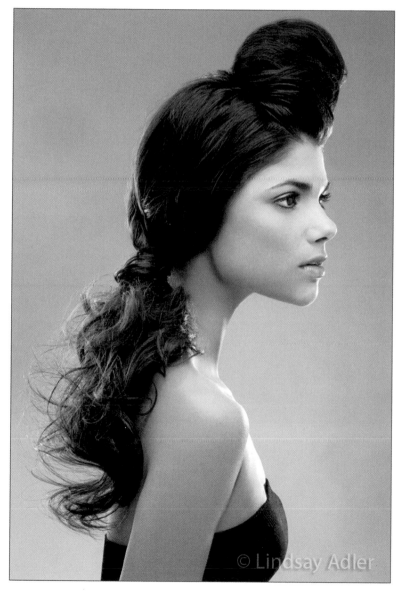

Figure 3.10

For this shoot, we began with
this more bizarre, extravagant
hairstyle and then let the
hair down into loose curls
for a final look. Be sure that
the looks can flow together
without having to do a
complete change of hair
and makeup each time.

Props

Props can make or break a picture. A prop might make for a quaint background element that furthers the concept of a theme, or it might act as the visual centerpiece of the image. A prop may emphasize the mood of a shoot, but it also can easily detract.

If you are just starting off with the fashion flair attempt, avoid using too many props. They're just another element to worry about. You have to worry about finding the prop, using it in the image, and the subject interacting with it. In fashion photography, one person's job is dedicated to gathering and managing props. This individual, the prop stylist, is usually given a budget and a description of the concept and is expected to provide props (purchased, created, or rented) for a specific shoot.

In Figure 3.11, the mirror as a prop adds an extra dimension to the image. Not only does the image have more composition interest (with the mirror framing the subject's face), it has more conceptual interest. The subject now appears to be reflecting upon her life and future.

When you feel comfortable with the basics of fashion flair including location, lighting, hair, makeup, and clothing, consider adding interesting props into the mix. Several of my favorite images have included extravagant props.

Where to Find

Finding props can be an exciting challenge, but it can also be a pain. I have found useful props in the following places.

Client's Own

If you have a prop concept or idea, first ask your client. She may have the perfect prop for the shoot or may know someone with access to it. Furthermore, if the client is excited about your concept, she may take it upon herself to find the prop for you.

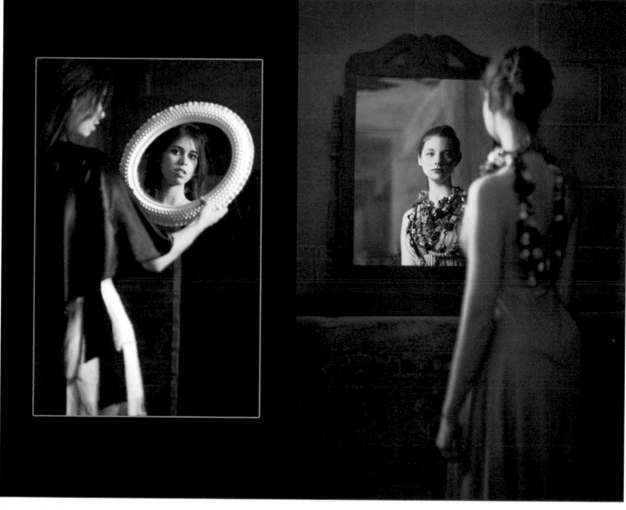

Figure 3.11

Props can add dimensions to an image by improving composition, adding visual interest, maintaining a theme, or making the image more conceptual.

Antique Shops

Antique shops are amazing places to locate props. I've photographed everything from antique phones to antique couches to antique mirrors. Some antique shops allow you to rent or borrow items for a shoot if the props are returned in the condition that you borrowed them. It's normal for the antique shop to ask you to leave an imprint of your credit card in case you don't return the antique or damage it in some way.

eBay or Online

One of my favorite images involved a prop I found on eBay. You can buy any-thing and everything on eBay, from vintage dresses to gothic candlesticks to bright red cyber goggles. Sometimes if I don't have an idea for a shoot, I browse through eBay looking for unusual items. I created the image in Figure 3.12 using red cyber goggles I found on eBay (less than $20), red lipstick (less than $5 at CVS), and Photoshop to white out the subject's skin. This image, one of my most iconic to date, was created with a college friend for less than $25.

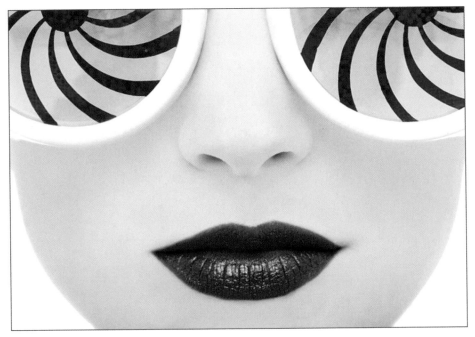

Figure 3.12

eBay is a fantastic place to find unusual or unique props.

Artists

Many artists specialize in creating unique items as art or as props. I have found prop makers through Craigslist and by searching online. Also, if you have a friend who is an artist (particularly one who likes 3D art and sculpture), you may be able to hire him to create the perfect prop. I regularly had one of my photo assistants, who was an artist, create props for me, from wreaths of flow-ers to unusual headpieces. Another place to find artists is on deviantART.com. deviantART is a social network for artists, whether painters, photographers, sculptors, or computer artists. I have borrowed or commissioned props from artists who have created incredible surreal and eye-catching pieces.

What to Look For

You'll be looking for two main types of props:

- **Props that achieve a mood or theme.** Perhaps you want to do a shoot that is earthy and imp like. You might want a prop of a wreath of flowers or wildflowers in the subject's hands, as seen in Figure 3.13. Although the clothing and environment help set the stage for the theme, the props can take it a step further. In Figure 3.13, the flowers on the model's head and in her hands emphasize the imp-like styling and a quiet, natural look. The wildflowers were picked from a nearby field, and the wreath was made from a few fake flowers from a local craft store.

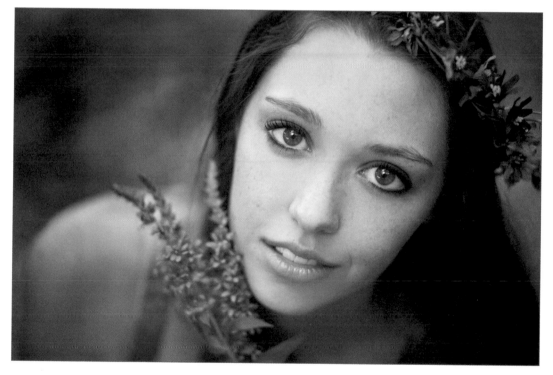

Figure 3.13

This image would not have the same impact and stylistic feel without the addition of the flower props.

■ **Props that are the center of interest.** Suppose you find an amazing pair of glasses online. They don't fit a particular theme, but they are interesting and graphic. These glasses could become the image's center of interest, and the clothing, hair, and makeup could be based off this single prop. I found the steampunk goggles in Figure 3.14 through an artist's online profile. The lighting, styling, and posing are influenced by the goggles alone. The subject made the perfect model for this project.

Figure 3.14

Props can become the center of interest of your image, as in the case with steampunk goggles found online in an artist's profile on deviantART.

CAUTION

When selecting props, be sure they do not dominate the image unless that is the role you want them to take. If you're working with a client who isn't a model, it is easy for visually strong props to pull away from your subject, making her look unnatural and out of place. Be sure that the props make for a strong image but do not overshadow the subject.

(C) Adler Photography

4

Strike a Pose

*P*osing in fashion is an art, not a science, and there are no rules or special guidelines. In fashion photography, poses can be expressive, but they can also be straightforward. When I do a fashion shoot, I often keep my poses relatively simple unless I'm trying to accentuate a certain part of the clothing or my image concept is based on a particular pose. Many fashion photographers prefer strong, simple, and stoic poses in their images.

Other times I specifically aim for a more exotic pose to emphasize the fantasy aspect of the shoot. For example, the bride in Figure 4.1 is in more of a "fashion" pose; her positioning is strong and dynamic instead of traditional. Seldom will you see a bride posed in this unique way that emphasizes the C curve of her body and her long neck.

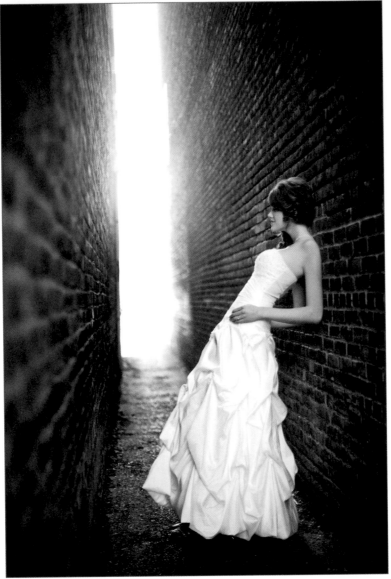

Figure 4.1
Fashion poses do not need
to be overly elaborate and
complicated.

Inspired Poses

When honing your skills for posing, I highly recommend drawing inspiration
from other pieces of artwork. Posing is not easy. In fact, I find it one of the more
challenging aspects of fashion flair. Hair, makeup, and wardrobe are taken care
of before the shoot, but the posing is based on your ideas, your client's abilities,
and your communication skills during the shoot.

Because of the challenges of posing, I recommend that you come prepared with inspiration shots for posing or some concrete posing ideas to use as a starting place. I do this *all* the time for fashion flair shoots. In fact, I often print out a piece of paper with 5–6 different poses that have inspired me for a shoot. This is even more helpful when photographing couples. When doing research, I seek out poses that reflect the theme of the shoot or the personality of the subject and use these poses as a starting point.

Figure 4.2, for example, is an interesting pose that I can honestly say I would not have come up with myself. I found this pose in a fashion and style blog. Finding great poses is easy with professional models, but with regular subjects it becomes more challenging to push the boundaries.

Figure 4.2

Because posing can be challenging, I often bring along inspiration on a sheet of paper to guide the way.

If I had to verbally describe these poses to subjects, it would be challenging. That's why I bring physical printouts of these inspiration shots to the shoot. It helps clients visualize what I'm trying to go for. If this pose isn't working, I can always take the shot and compare the two images side by side to see the differences. In general, though, I am not working that rigidly. I usually find a good pose as a starting point and then go with the natural flow of the shoot or the chemistry of the couple.

> **TIP**
>
> The more fashion photography you do, the more comfortable you will become. As you shoot more, you will find a few poses that are foolproof that you will use as a starting point for nearly every session. In the beginning you may struggle, but rest assured that posing comes with practice.

As discussed in Chapter 1, "Prepare to Flair," I find inspiration from many sources. It's common for me to discover pose ideas online in fashion magazine Web sites and blogs.

When you are gathering inspiration for poses, start by looking for basic poses that look pleasing and might fit your concept. If you find a more complicated pose, feel free to bring the magazine page to the shoot. However, don't begin the shoot with the more complicated pose. Help your clients build confidence by starting easy and straightforward. First, work with your subject until you feel you have a strong basic shot, and then introduce the magazine image for inspiration. Don't try to copy the pose exactly. You can seldom get it quite right. As I stated before, use it as a jumping-off point for your creativity.

Be as specific as possible when directing your subjects. Instead of saying, "Move your head," say, "Move your chin two inches to the right." I frequently use hand gestures to suggest the direction of movement or an axis of rotation. I also frequently find myself posing for the model if he or she can't grasp the pose from my description. I pose, the model imitates me, and then I direct the final adjustments.

When working with clients who are not models, I try to give as much direction as possible, but if a client has an idea for a pose, I run with it. I am happy to let clients take part in the creative process. Some clients (particularly guys) really get into the session and suggest some outrageous poses that add excitement and energy to an image. Women, too, sometimes get into the groove and begin creating striking poses. It all depends on the client's personal comfort level.

The Role of Posing

A pose can be anything you want it to be. It can be static, or it can have a lot of movement. It can emphasize vulnerability, or it can emphasize power and authority. It can emphasize the mood of the image or reveal something about the subject's personality. For example, the pose in Figure 4.3 is anything but exciting. It is quite static and rigid, yet it is perfect for the image. The body and the balloons balance the image and create an interesting visual dynamic.

Figure 4.3

Here the pose is straightforward and static, but it creates an intriguing balance to the image.

If you want to learn basic portrait posing, there are many books out there offering general guidelines. For example, many guides instruct you to turn women to three-quarters, drop their shoulders, place their arms forward on a posing table, and tilt their heads inward to make a C shape. Another typical pose encourages you to place the female form in the shape of an S to emphasize natural curves. You can find these basic poses in any posing guide. Here I have provided some advanced tips for fashion flair posing and how to approach posing in your mind.

In fashion photography, sometimes the entire composition is based on the strength and angles of a pose. An interesting pose can be the center of interest of the image. Figure 4.4 is a great image primarily because of the subject's pose within the window frame. If she were standing rigidly in the center of the window, the image would not be as powerful. Here the dynamic angles of the subject's body emphasize the other lines in the frame and create a powerful graphic composition.

Figure 4.4

Sometimes a strong pose can make an interesting composition within an image.

Also, a pose can reveal something significant about a subject. For example, if you are photographing a dancer, the image should be *about* the pose to show off the dancer's body, poise, and shapes that can be created. Figure 4.5, for example, is clearly about the pose and shape of the body.

Figure 4.5

Here, pose is essential for this fashion flair portrait of someone training to be a professional dancer.

Posing Tips for Different Clients

Each shoot and each client require different poses. Here are some suggestions when working with women, men, couples, and children.

Women

Posing women is both easy and challenging. It is easy because there are so many possibilities. I love posing women because a pose can take on any feeling: it can be dance like, or aggressive, or relaxed, or anything you want it to be. It is challenging, however, because there are so many possibilities, and you must pose in a way that most flatters the woman's face and body. With models, you can easily go with the flow and let them bring inspiration for poses through their movements. With women who aren't models, however, the responsibility of posing is on you.

Posing for portraiture, fashion, and glamour photography varies. It is a continuum with no definite distinctions between the three, but you should still be aware of the general differences.

It is easy to accidentally pose clients in a glamorous way. Glamour poses emphasize the chest, buttocks, and sexuality of a subject. Many attractive young women may automatically pose this way.

Unless you are doing a glamour or boudoir session, you want to avoid too much sexuality. It's not classy or high fashion. There is a balance you must maintain between emphasizing the beautiful parts of someone's body and making the image too sexual.

Figure 4.6 is a balance between a fashion and a glamour pose. The curves of the body are sensual, and the dramatic lighting emphasizes the sexuality of the image. The image is classy, glamorous, and fashionable. I chose this pose for the subject because she indicated that she felt "the sexiest she had ever felt," and we wanted an image that represented her state of mind.

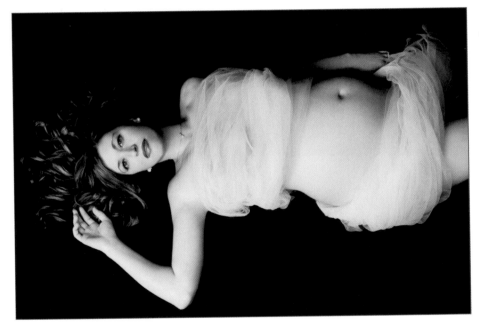

Figure 4.6

This image is classy and glamorous, helping the subject demonstrate how attractive she feels through the curves of her body.

Portrait poses are often uninteresting and nonessential to the image. They are simple and focus on basic, flattering poses. They are not the focus of the image.

Fashion poses can be simple, but they can also be dramatic. They usually emphasize the mood or theme of a photo and can contribute to the mood and feel of a scene. Often, fashion poses complement the clothes and form of the subject. Furthermore, they may create a strong composition and captivating shapes within the composition.

When posing women, there are a few important things you want to look for: curves, separation, and comfort.

■ **Curves.** When posing female subjects, I try to create natural curves. I'm looking for the women's bodies to create leading lines and naturally pleasing curves throughout the image. This can be created by the location of their arms, the way they lean, and so on. A woman does not need to be curvaceous to create elegant curves in her pose. Figure 4.7 is an example of how I have used a subject's arms and hands to create a leading line throughout the image.

Figure 4.7

Try to create compositional curves through your pose selection. Here, the subject's arms give leading lines to pull the subject through the image.

■ **Separation.** Watch for the natural curves of a woman's body. For example, if you put a subject's arms straight at her side, you make her look heavier and wider because you cannot see her natural contours. In Figure 4.8, notice the space between the woman's left elbow and the rest of her body. This shows the natural curves of her hips and waist and gives a slenderizing effect. If her arm were flush with her side, the effect would be much less appealing. This technique generally applies to any subject, whether skinnier or heavier. You don't want the body to be a blob of parts blending together. This is especially true with bulky bridal gowns or less form-fitting clothing.

Figure 4.8

Here the separation between the woman's left elbow and her hip flatters her natural lines and makes her appear more slender.

- **Comfort.** If your subject isn't comfortable, it will show immediately. If you have the subject in an uncomfortable pose, keep it extremely brief, and focus on making it look natural.

Men

Men can be challenging to pose because you must find a pose that fits the mood of the shoot without making them look too feminine or making the pose look too forced. I often pose men in one of three ways. These are not rules, but guidelines for how I work.

- **Show authority.** Men like poses that make them look powerful and authoritative. Often I seek these more aggressive poses. I have the men lean toward the camera (aggressive stance) no matter what pose they are in. Furthermore, I often have them cross their arms or stand rigidly toward the camera. These poses contribute to a feeling of authority.

- **Add movement and action.** Adding action and movement to a pose can make for an exciting image. Depending on the personality of the client, you can get some really interesting action shots. Some of my favorite shots of men have involved all the groomsmen jumping in the air, making crazy expressions after the wedding. Figure 4.9 looks like the subject is deflecting a punch as he leans back and swings his arms. Again, having visual inspiration or giving direction (perhaps saying, "Imagine you are avoiding a punch to the face") can really help in these situations.

> **NOTE**
>
> Here the water in the air was from a spray bottle we misted slightly before and during the shot.

Figure 4.9

Sometimes I pose men in a way that creates a lot of action and movement, such as this subject posing as if he's deflecting a punch.

■ **Catalogue poses.** Catalogue-like poses are classy and typically what you think of when you think "male model." He might have his fist to his chin or be leaning casually on a wall with his arms crossed. I check men's clothing catalogues and advertisements for inspiration in this realm. Figure 4.10 is a catalogue-inspired pose. The clothing is important, and the pose interacts with the garments.

Figure 4.10

Here the client is interacting with the clothing as part of the scene and pose.

NOTE

I try to find environments for men to interact with. If I can find a wall for them to lean against or stairs to sit on, they are often more comfortable because it gives them an environment to direct their movements. Figure 4.11 is an example of how a male subject can interact with his environment. Usually I start with a simple arms-crossed pose, and then I adjust to get just the right look.

Figure 4.11

Men often find posing more comfortable when they have something to lean on or interact with.

Couples

When shooting fashion flair with couples, I typically try to either tell a story through the pose or show an intense emotion and physical connection between the two. One pose might be playful and represent the joy in their relationship. In another pose I might get close and show a tender moment of a kiss. I frequently utilize inspiration images for fashion catalogues (like Abercrombie & Fitch) and fashion editorials I find online.

Poses for couples really depend on what you are trying to achieve in an image. You may have the two laughing and rolling around on the floor, or have the man leaning over the women in a sexually aggressive way, or have them playing piggy back. For fashion shoots, images of couples are typically sexualized. They are not necessarily blatantly sexual, but there is certainly a sexual tension in the air.

For engagement sessions, I try to convey the relationship between the couple. Furthermore, I try to create poses that capture intense emotional moments. In the couple's portrait in Figure 4.12, the man is literally sweeping the woman off her feet. This quiet moment is cinematic as they await a kiss.

Figure 4.12

When shooting couples, I try to capture moments that tell a story.

Similarly, during wedding shoots, I capture a range of poses that represent intimacy. In Figure 4.13, the pose is more high fashion because it's intimate without being overly sexualized. In fashion shoots, the posing can even become erotic, although this is likely not desirable for your client shoot. The type of poses you can achieve really depends on the comfort level of your client. Feel free to send them an inspiration shot beforehand for them "to practice" if a pose is complicated or intimate.

Figure 4.13
Here, the kiss on the neck creates a romantic, intimate moment between the couple.

Children

Children love to dress up. This is why fashion flair with them can be so much fun. They dress up, they have great personalities, and they usually are not shy in front of the camera. The downside of photographing kids is that posing may be limited, depending on the patience and willingness of the child.

Typically with children, I've found that "posed candids" are best. In short, I put kids in the right lighting and environment. Then I try to get them in a general pose (perhaps leaning on a tree or sitting on the ground). From there I let them be themselves, which usually results in a lot of great movement and expressions. I often have kids bring a favorite toy or have a parent helping to get great expressions.

If a child is cooperative and mature, I attempt more complicated fashion poses.

Figure 4.14 is an example of a posed candid. We did hair, makeup, and wardrobe beforehand. Then when we were in the park, I let her be herself with the parasol. She skipped, twirled in circles, and giggled a lot. This candid is one of the giggle shots.

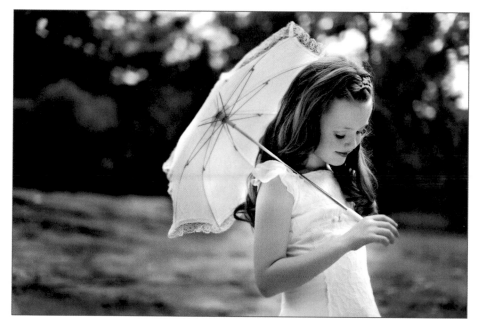

Figure 4.14

In this "posed candid," I put the subject in the right location and general pose and then let her act natural to get this beautiful expression.

Figure 4.15 is an image of the same girl, on the same day, but with a high-fashion twist. I was able to direct the girl's posing to get this much more mature look. If I choose a high-fashion pose for the child, I try to get the pose to match the mood of the shoot. If you can get a cooperative child to do more fashion poses, I am sure you will love the results. Furthermore, this photoshoot was unique and will be eye-catching to anyone who sees it.

CAUTION

Some people are opposed to shots of children looking older in their images. They want children to look and behave like children. This depends on each client. You'll need to discuss the concept beforehand. Communication between client and photographer is really important. If the client really dislikes a concept or styling, chance are she won't purchase many images.

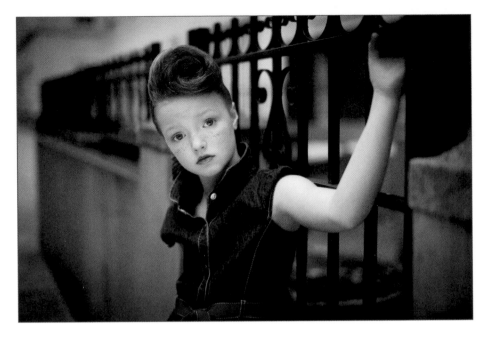

Working with Your Subjects

If you want to get the most out of your client's poses and expressions, you can take some steps to set the right mood and prepare yourself and your clients for a fantastic shoot.

Build a Relationship

On the set of a fashion flair shoot, the most important relationship is between the photographer and the subjects. They must trust you and feel comfortable with you. If this comfort and trust aren't there, it will be apparent in the image. Good communication and comfort will help you get the most out of your subjects. Particularly because your clients aren't professional models, they must be able to trust that you are putting them in good poses and helping them look their best.

Get to Know Your Subject

One of the biggest suggestions I can give you as a photographer when shooting portrait and fashion images is to get to know your subjects. When you meet them, figure out their interests and who they are. What are they passionate about in life? Ask about their children, the college they're attending, or their hobbies. Allow this casual conversation to reveal what drives your subjects. I use this information to help me get the facial expressions I need to achieve a certain visual effect.

For example, if in my conversation I find out that someone is an animal lover, I tell them to think about puppies or their favorite pet to help get a jovial expression. Similarly, if I am trying to achieve a forlorn expression, I ask them to act as though their pet ran away. I'm toying with their emotions to convey a particular mood or emotion within my image.

Another important reason to get to know your subject is that it gives you a way to make downtime more comfortable. For example, when I'm rearranging lighting or we are moving to a new location, I ask my subjects to talk about themselves. If you don't take the time to get to know your subject, the room will be silent and uncomfortable. I keep spirits up and the momentum of the shoot going by allowing the subjects to share their passions. Furthermore, as any good businessperson will tell you, people love to talk about themselves, and one way to get people to show interest in you is for you to show a sincere interest in them.

Offer Positive Reinforcement

During your shoot, you need to give nearly constant positive reinforcement to your subjects. Let them know when they're doing a good job. When they do something right, be specific when you tell them about it. If a pose or a facial expression looks great, tell them. Positive reinforcement not only encourages them and gives them confidence, but it lets them know what to do to look most aesthetically pleasing.

If a shot isn't turning out the way you wanted, don't show your concern in your face or your words, or you'll risk making the clients feel uncomfortable and insecure. They might assume you're unhappy because of them. Instead of saying, "This just isn't working," or "I really don't like this," try saying something more optimistic. For example, you could say, "Okay, that was good, but I'd like to try something else." Make sure they feel like they're doing a good job.

If your models don't appear to be at ease or the shot isn't quite right, take a moment to show them the image at the back of the camera so they can work with you. When they see the result, they might know precisely what to do to fix a pose, expression, or anything else that might be a bit off. Again, you and the models have the same goal: to come out of the shoot with a great product.

Set the Mood

Some photographers play music when photographing models or their subjects. This is completely legitimate, and you might find this helpful. You can use the music to set the mood of the shoot and help your subjects pose more appropriately. If you want really loud, aggressive poses, use loud, aggressive music. Making a shouting or defiant face feels bizarre in a quiet room or in front of other people, but adding music helps subjects get into their part. Don't just play

your favorite music; be sure the music is helping you achieve your artistic goals. In Figure 4.16, for example, I let the client choose his favorite music to play during the shoot. You can see the movement and attitude this gave him to really get into expressive posing.

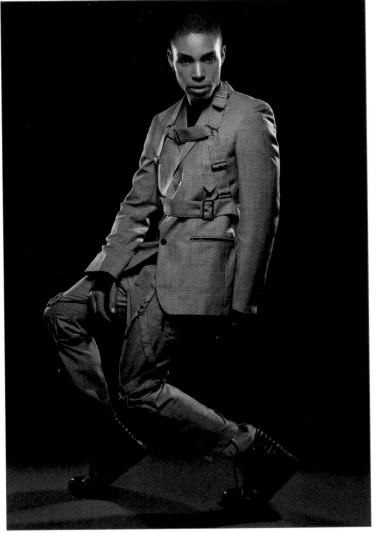

Figure 4.16

Setting the mood on the shoot and in the studio is important to get the most out of a client's poses and expressions.

NOTE

I keep the volume of the music to a minimum. I want to be sure that the clients can hear me when I give them direction or positive feedback. Some photographers blare the music to let the clients just go with the flow.

If you do play music on set, be careful that the music is not something to hide behind. Some photographers are shy and don't take the time to get to know their subjects, so they hide behind music to break the silence. Don't use music as an escape, but as a tool to capture the mood you want to convey.

> **TIP**
>
> You have a lot of control over the mood. If you are upbeat and playful, your clients will likely feed off this vibe. If you are disgruntled or just in a bad mood, it will affect the entire mood of the shoot. Be aware of this and be sure to keep a positive, upbeat momentum.

Make Them Comfortable

If subjects are uncomfortable, it will show in their face. If he is too hot or too cold or the music is too loud, they won't be at their best. I have open communication with my subjects and let them know that their happiness is of the utmost concern to me.

If I need them to do a pose or something that is less than comfortable (perhaps pose in a cold waterfall), I encourage open communication so I know where their limits arc.

Try to get your subjects as excited about the location or pose as you are. Let them know how great they look, and they'll likely be up for just about anything!

> **TIP**
>
> Consider having cold water and little snacks like crackers around to help your clients if they get hungry or thirsty.

Model Releases

I collect a model release with all my client shoots. If a shot from my fashion flair shoot comes out especially well, I want to be able to use it to promote myself and my work. I typically include a copy of the model release with the basic client information form. That way, all clients who fill out a form with their name, phone number, and email address also provide me with a release to use their images. I use a slightly modified version of the model release available on ASMP's site. (Search "ASMP model release" in Google.)

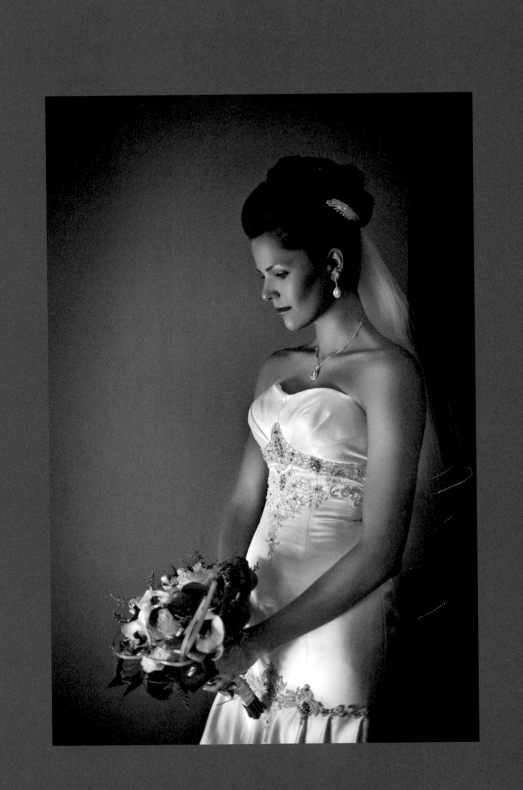

Part II

Techniques for Flair

5

Tools of the Trade: Basic Equipment

I consider myself a creativity-driven photographer. I'm not much of a tech geek. Don't get me wrong; I know plenty about photography equipment, but I'd rather talk about creativity and inspiration than f-stops and camera accessories.

Stunning images can be made no matter what equipment you use. In fact, I recently came across a pretty nice fashion shoot that was done 100 percent on an iPhone. Granted, you can't enlarge these images because of the low megapixels, but they were beautiful because the photographer recognized the rules of lighting, composition, and posing.

That being said, photography equipment provides specialized tools to achieve the creative effects you want. If you know how to correctly use your photographic equipment and are aware of the equipment available to you, new venues of creativity may open themselves to you.

I'll say this repeatedly throughout this chapter, but there is no "right answer" for equipment. There is no right lens or right camera. For example, some fashion photographers shoot with state-of-the-art cameras with weather-proof casing and extremely high megapixels and aim for sharp images. Other fashion photographers shoot with a Holga, which is known for its distortions, vignetting, light leaks, blurry images, and low quality to aim for creative effects. Figure 5.1 is an image of a Twin Lens Reflex Holga. The body is extremely light, made of plastic, and has minimal controls. In fact, you can't even really set the

shutter speed; you control it with your finger. The shutter speed is determined by how long you depress the shutter. The accidents or "mistakes" that occur when using a Holga can be quite interesting with artistic blurs and colors.

Figure 5.1

A Holga camera is an inexpensive, plastic camera known for its distortions and light leaks that often result in a creative, edgy look.

Following are my recommendations for equipment, not my formula for success.

Cameras

Many fashion photographers utilize a medium-format camera with a digital back. This provides them the same high-end quality they are used to with traditional medium-format cameras and extremely large digital files to provide to their clients. You may have heard of Leaf backs for digital cameras. Some digital backs currently offer 60 megapixels per frame. Although this option is arguably the best quality, it is extremely expensive and somewhat more bulky.

Because 35mm digital cameras regularly have megapixels in the high teens and twenties (some even up to 40!), many fashion photographers opt for this lighter and more versatile format. The file sizes are sufficiently large for most projects, and the optical quality is beautiful.

When shooting your fashion-influenced portraits, any 35mm DSLR camera will work. In general, your camera should have no fewer than 10 megapixels, because your high-end clients may want to purchase large prints or canvases. My clients often purchase 2ft×3ft prints to display fashion images in their living space. DSLR cameras are versatile, have a variety of interchangeable lenses, are relatively lightweight, and give you full control. DSLR stands for Digital Single Lens Reflex. It's a type of camera that uses a mirror to reflect light back to the viewer, giving an accurate preview of the image, unlike a Twin Lens Reflex camera (the Holga shown in Figure 5.1).

Figure 5.2

The Canon 5D Mark 2, shown here, is an example of a HDSLR camera. While you have high quality still images, you can also use this camera to capture high-end video.

Any camera brand will work, although you should consider purchasing a major brand such as Canon or Nikon because they have the greatest choice of lenses, and they are always improving their products. The battle of Canon versus Nikon cameras will likely be endless; really, either camera brand will do an excellent job.

Lenses

There is no "right" lens for fashion photography. Photographers use different lenses to achieve various visual effects. In fact, certain photographers develop their creative style by using the "wrong lighting," "wrong lenses," or other "wrong" creative techniques just to stand out.

If you are purchasing lenses, buy the fastest you can afford. If you hear the term *fast glass*, it means you can achieve wide apertures and therefore fast shutter speeds. For example, a lens that shoots at f/2.8 (can achieve an aperture of 2.8) or wider is considered a fast lens.

Fixed Lenses

I primarily shoot fixed lenses. They do not zoom, but they often have extremely wide apertures and are generally less expensive than zoom lenses. With fixed lenses, you can achieve wider apertures for more reasonable prices. Because fashion photography is a controlled event, you do not usually need a zoom lens. You can typically move your body forward or backward to adjust the zoom of the lens while maintaining the visual qualities of that lens.

Many beginning and even established photographers confuse the term zoom lens with telephoto lens. A zoom lens can change the focal length of the lens. For example, the 24mm–70mm zoom lens can be shot at any focal length between 24mm and 70mm. A telephoto lens, however, usually refers to a lens with a longer focal length. On a 35mm full frame camera, a 50mm lens is typically considered normal or "average." On these cameras, it is neither wide nor telephoto (although this will change if using a medium format or DSLR with abnormal sensor size).

> **TIP**
>
> I suggest that beginning fashion photographers buy 85mm 1.8 and 50mm 1.4 (or 1.8) lenses. These lenses are relatively inexpensive and provide great image quality. They're a great place to start!

85mm (1.8, 1.4, or 1.2 Lens)

I use the 85mm for beauty shots (close-ups) and mid-length shots. It is a fantastic lens because it has nice compression due to its slightly telephoto quality. The bokeh of these lenses is beautiful. The 85mm 1.8 is a great portrait lens that is extremely affordable. The lens is fast, and the depth of field is shallow. You can create a natural light portrait with a simplified background (due to narrow depth of field) in almost any environment. Figure 5.3 illustrates the effect of an 85mm 1.8 lens, with an out-of-focus background and beautiful bokeh.

> **NOTE**
>
> *Bokeh* describes the pattern or appearance of the blur created by a wide aperture. If you are taking a portrait at 1.8 and the background is blurred behind the subject, the blur caused by the depth of field is the bokeh. Each lens has a different optical quality; therefore, each bokeh looks different. A pleasing bokeh is best achieved at maximum (or nearly maximum) aperture for a lens.

Figure 5.3

In this example, the 85mm 1.8 lens gives an extreme narrow depth of field with a beautiful background bokeh. The slight compression of the lens is flattering for close-up shots.

The 85mm 1.2 is much more expensive but is pretty incredible. The depth of field is incredibly small. If a subject is leaning toward you, her eyes can be in focus at the same time her lips are completely out of focus. Most of the time a 1.2 aperture is unnecessary, but for creative effects it can be quite stunning. Such a narrow aperture creates a dreamlike image and simplifies any background.

Experimenting with an 85mm 1.2 can be frustrating at first. The lens has an incredibly narrow depth of field, and an image can fall completely out of focus just from breathing. Millimeters of movement can make a difference. The 85mm 1.2 requires a lot of practice, but it also yields numerous rewards.

50mm (1.4 or 1.2 Lens)

I use the 50mm lens for full-length shots of a subject. It allows me to get a wider angle without the distortion of a wide-angle lens. A 50mm lens is *not* wide angle, but it gives me a slightly wider field of view. The 50mm 1.4 is a reasonably priced, great lens. You might consider testing the 50mm 1.2 (if you have the budget) to try a narrow depth of field and sharper image. I have happily shot the 50mm 1.4 for several years whenever I had a full-length or 3/4 length shot. I shot the image in Figure 5.4 with the 50mm 1.4. Although there is more in the field of view, I still am able to maintain a narrow depth of field.

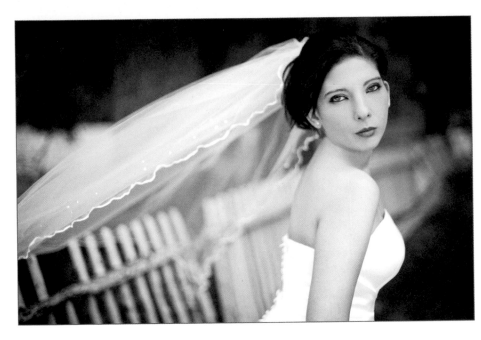

Figure 5.4

This image was photographed using a 50mm 1.4, lit from behind with natural light and using a silver reflector to help illuminate the face.

Lens Compression (for Portraiture)

As you probably know, a wide angle lens distorts an image. In photography, whatever is closest to the lens appears largest, and wider angles amplify this effect. With telephoto lenses, the image is not stretched or distorted; it is compressed. You have probably seen images taken in Africa of a gigantic sun in the background and an elephant in the foreground. The photographer achieves this effect using a telephoto lens. When taking portraits, however, you want to achieve a balance. If you shoot with a wide angle lens, you distort the face or body in an unflattering manner, often making the nose or chin appear larger. On the other hand, if you shoot with a telephoto lens (such as 300mm), the face appears flat because you have compressed all the features. Photographers have different preferences, but most use a slightly telephoto lens for portrait, often from about 70mm to 105mm.

I usually select an 85mm lens for close-up portraits because of the slight compression. Here are two shots with the same head size maintained, one photographed with a 50mm (Figure 5.5) and the other with an 85mm (Figure 5.6). The lens compression and difference in bokeh are clearly visible. In the 50mm lens, the features are slightly exaggerated. If you look closely at Figure 5.5, you see that the subject's forehead appears larger, and her features look slightly more pronounced compared to Figure 5.6, which was shot with an 85mm lens.

Figure 5.5

With the 50mm 1.4 lens, the features are slightly exaggerated.

Figure 5.6

The 85mm 1.8 helps to compress the features slightly; in this case the forehead and facial features have been diminished.

Zoom Lenses

Zoom lenses allow you to vary the focal length that you are shooting while using a single lens. Zoom lenses can be wide angle (zooming within wide focal lengths), telephoto (varying between longer focal lengths), or a combination of both. Zoom lenses often give you versatility when shooting and can help you reduce the number of lenses you need to bring on a shoot.

70–200mm 2.8 Lens

Many photographers choose the 70–200mm as their favorite portrait lens. I typically utilize this lens when I want to compress the subject and the background. For example, if a bride and groom are in front of an interesting scene, by using

a telephoto lens (this lens at 200mm), I am able to compress the scene and better combine the foreground of the couple and the scenic background. The lens is fast, has a pleasing bokeh, and offers the flexibility of being able to zoom to different focal lengths. When shooting weddings, this lens is simply indispensable.

The image in Figure 5.7 illustrates how to successfully utilize the compression of the 70–200 lens. Compressing a portrait (by shooting at 200mm) might leave a close-up shot looking flat and unflattering. In this example, however, by using a longer focal length, I was able to compress the background and the bridge to make a cohesive image of the bride and groom in a beautiful scene. By shooting at 2.8, I simplified the background while maintaining a sense of place. This image was shot around 105mm; the compression at 200mm would be much more pronounced.

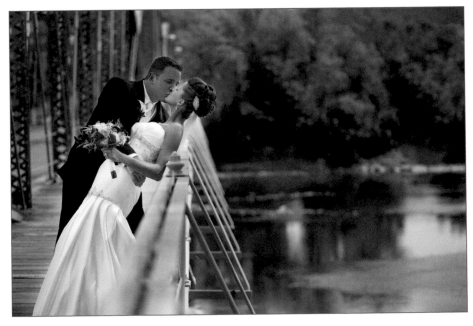

Figure 5.7

The 70–200mm lens is utilized here to unify the bride and the groom in the foreground with the rest of the scenic environment.

24–70mm 2.8 Lens

This is a nice "average" lens that provides convenient versatility with excellent optical quality. Many portrait and fashion photographers use this lens because they can achieve both wide angle and slightly telephoto in one fast lens. This helps cut down on changing lenses frequently or carrying multiple lenses.

16–35mm 2.8 Lens

I use this lens primarily when shooting a subject in a grand scene or landscape. In fact, I shot one of my favorite fashion flair images with this lens. Utilize this lens if you want the subject to appear as a small element within a larger scene

or to pose the model as the dominant subject matter. I never utilize this lens for a close-up portrait image; the results would be extremely unattractive, with distortion of the facial features.

The image in Figure 5.8 was photographed with the 16–35mm 2.8 lens. When using a wide angle lens, you often set the subject as an element within a larger scene.

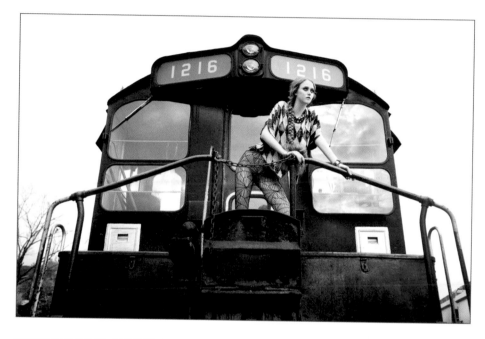

Figure 5.8

Wide angle lenses are used in fashion photography when the model is an element within a larger scene.

> **NOTE**
>
> People often ask me which lens brand is the best and if it is necessary to buy the more expensive name brand. Typically, Canon, Nikon, Sigma, and Tamron are sufficient if you buy a top-quality, fast glass. In other words, any brand is fine as long as you are purchasing good quality lenses. For example, you don't want to buy a wide angle to telephoto lens (like 28–300) because you will not get the same optical quality, and chances are you will not have fast apertures. Instead, opt for wide aperture fixed lenses. Work within your budget, but remember that if you try to buy an all-purpose lens now, you may end up having to buy more lenses later. Do your research, and try to test each lens before you purchase it.

Lensbaby

Lensbaby manufactures lenses and attachments that allow your camera to create a similar effect to view camera, bellows camera, or tilt shift lenses. You can adjust the plane of focus so it is no longer parallel to the film plane (or digital censor) of your camera. In other words, you can vary your plane of focus so

that the depth of field is not just foreground to background, but side to side, or on a specific area of the image. Using the Lensbaby tools, you can choose a narrow plane of focus that perhaps runs mostly vertically in the left side of the frame, or you can choose a small circle of focus in one area of the image. In Figure 5.9, the plane of focus is primarily on the bride's face and on her dress bodice, which creates a dreamlike image.

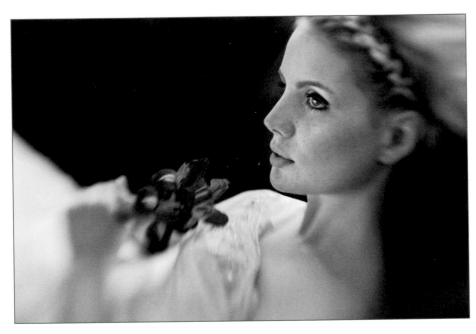

Figure 5.9

Lensbaby products allow you to select a narrow plane of focus to create a dreamlike image similar to that created by a bellows camera.

Lensbaby uses small bellows or ball-and-socket mechanisms to achieve this effect, but it does so in an extremely affordable way. Typical tilt shift lenses cost thousands of dollars, whereas Lensbaby products are a couple hundred dollars and offer many more creative effects.

CAUTION

Architectural photographers often use tilt shift lenses as perspective correcting lenses to account for keystone effects. Although you can use tilt shift lenses creatively for portrait and fashion photography, Lensbaby lenses are not appropriate for achieving the goals of an architectural photographer.

I utilize Lensbaby products when I want to achieve a specific creative, visual effect. The imagery from a Lensbaby is often ethereal and surreal. In Figure 5.10, the sweet spot of the lens and area of focus are only around the bride. The entire environment seems to wrap around her in a surreal way.

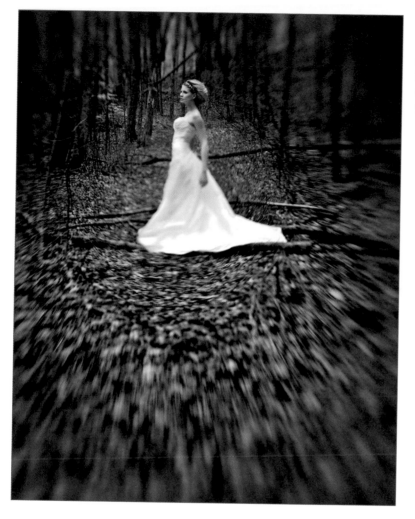

Figure 5.10

Lensbaby is fantastic for creating surreal imagery. In this example, the environment appears to wrap around the bride.

Lensbaby offers a variety of products, but the Composer is most practical for fashion images. The Composer is a ball-and-socket mount for your camera with interchangeable lens attachments. The easiest and most practical setup for a fashion photographer is the Composer with Double Optic. (If you go to buy or test Lensbaby, this is what you would ask for.) In Figure 5.11, you can see the current edition of Composer attached to a Canon 5D camera.

The Lensbaby Composer allows you to achieve those narrow planes of focus more easily than previous versions of the lens and other products. At approximately 50mm focal length for the Double Optic, it is great for portraits and is easy to focus and control.

Lensbaby recently released a product for Nikon and other cameras to allow you to take "normal" lenses and attach them to the Tilt Transformer to turn any lens into a tilt lens effect. You may consider trying this Lensbaby tool as well.

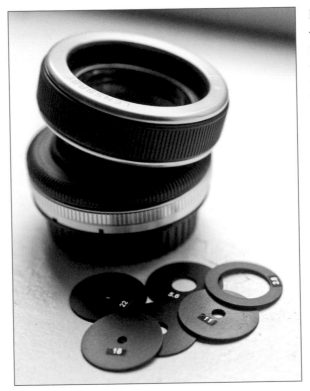

Figure 5.11

The Lensbaby Composer is a ball-and-socket mechanism with two rings for control: one for lens tension, one for focus. You can tilt and rotate the lens to move the lens sweet spot.

If you ever feel like you've hit a dry spell for in-camera creativity, try throwing on a Lensbaby. It forces you to see the world in a different light, and it gives you a unique visual effect that your competition is not likely utilizing.

If you become comfortable with the Composer and want to do something even more daring, Lensbaby has dozens of tools to spark your creativity. Whether it's using an odd-shaped aperture (stars, hearts), a soft focus lens, or a fish eye lens, you can keep experimenting and pushing your comfort zone for creative portrait and fashion work.

Using the Lensbaby Composer

If you've never used Lensbaby before, you can always visit the company's Web site for instructions on how to use the different lenses. Here are a few things you should know when using the Composer the first time. It's a great tool, but it's not 100 percent intuitive.

The Composer lens has physically interchangeable apertures. You change your aperture by replacing little magnetic rings to achieve f/2.8, f/4.0, f/5.6, and f/8.0. As a fashion photographer, you'll likely be using a wider aperture (often 4.0) so that you can achieve even more of a dreamlike, soft-focus image. You can see these apertures in Figure 5.11.

Many cameras cannot meter through Lensbaby lenses, and you must use manual exposure or exposure compensation (in AV mode) to achieve the correct or desired exposure. You can set your aperture (because you know that value) and then adjust the shutter speed until the exposure reaches your desired aesthetic look.

The Composer has two rings built into the lens for lens control. The inner ring adjusts the tension of the movement of the lens. With increased tension, you do not have to worry about the lens moving out of place once you've found your focus point. The outer ring is your focusing point. You achieve all focus manually.

To select your point or plane of focus, you move the lens in one direction or another. The lens has a sweet spot of focus that you can move around your composition. The farther you push the lens to the left, right, top, or bottom, the narrower your plane of focus will be. Because of this, when you push the lens to an extreme, it is much harder to actually focus, but the beautiful narrow depth of field is more pronounced. Once you have decided where you want your subject in the composition, move the lens in the direction of the subject to achieve narrow depth of field around that point. For example, if the subject is in the top-right third of the image, move the lens slightly upward and toward the right to achieve focus. This moves the lens sweet spot onto your subject matter. In Figure 5.12, the lens was tilted to the extreme left; the focus point is on only the left eye, while everything else falls out of focus. In Figure 5.13, the lens was located halfway between center and right, so the focus is purely on the subject's face.

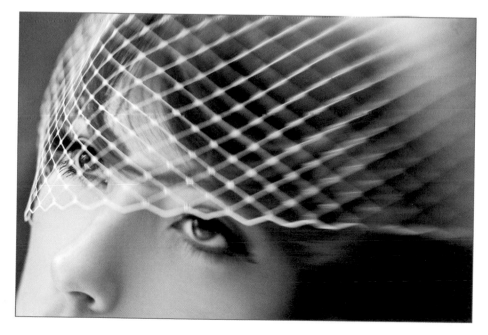

Figure 5.12

In this image, the sweet spot is on the left eye. The rest of the image falls to soft focus.

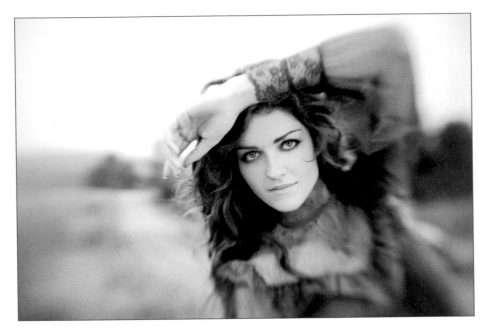

Figure 5.13

In this image, the sweet spot is located directly on the model's face; the rest of the environment is blurred because it is out of the plane of focus.

Other Equipment and Accessories

I need few camera accessories in most of my fashion photography. There are so many other elements to worry about that I try to keep things simple behind the camera. I will talk about lighting in future chapters. (See Part III, "See the Light.") Some photographers develop techniques that involve many other accessories, but in general, those accessories are unnecessary to produce high-fashion imagery. This section discusses a few accessories that I do utilize periodically.

Battery Grip, Vertical Grip

I use a battery grip on my camera for several reasons. First, the battery grip allows me to have two batteries connected to the camera at all times. This saves me from having to change batteries in the middle of a shoot. If I am in the groove in the middle of the shoot, I don't want to have to keep interrupting the flow to stop and change camera batteries. Also, the battery grip has a vertical shutter release. In other words, when I am shooting an image in vertical format, I do not have to contort my body to reach the normal trigger. Instead, there is a trigger on the grip so that my arm, hand, and body position remains identical no matter what orientation I am shooting in. This saves me time, and more importantly, it saves my back a lot of discomfort and helps me stay active longer. Different camera manufacturers have their own grips, and they vary among camera models.

Off-Camera Flash

An off-camera flash can serve a variety of purposes. I will talk a bit more about off-camera flash in Chapter 10, "Flash on Location: Taking Control." Using off-camera flash allows you to shoot in low-light situations, create interesting lighting effects, and fill in undesired shadows. Although it's best to try to use natural light when you're not working in a studio environment, there are times when an off-camera flash is essential to achieve certain creative effects.

Tripod

Some fashion photographers regularly shoot on a tripod. They leave the camera on the tripod and interact with the subjects without looking through the lens. The camera becomes stable, and the subject interacts with the photographer for dynamic movement and expressions. For photographers using larger format cameras, tripods are necessary for weight and technical reasons. I almost never use a tripod, though, because it restricts my movement and creativity, and I am always varying my angle. One minute I am shooting on the ground, and the next I am standing on a chair shooting downward. Even a few degrees of movement to the left or right, up or down, can completely change an image. I don't want a tripod to restrict me from making these minute changes that are so important.

When I am shooting a night scene, however, I often use a tripod if I want the environment to be in focus. If I'm shooting a city scene as a background, for one image I will use a tripod and keep the subject and background in focus. Then I'll take another shot off the tripod and get that "city excitement" blur created from long exposures and camera movement.

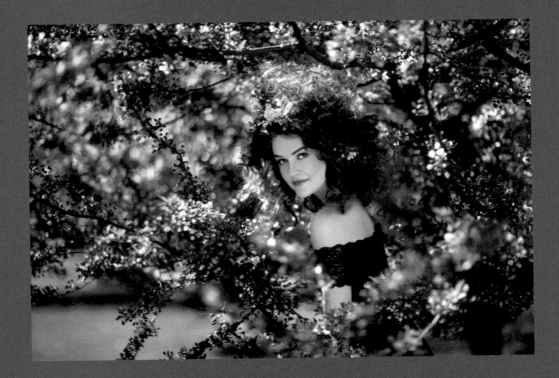

6

In-Camera Flair

*F*ashion photography often breaks the usual rules of photography. Frequently you will see extremely overexposed highlights, centered composition, lens flare, and a lot of other elements that you are initially taught are "wrong." Fashion photography is bold, and breaking these rules portrays this edginess.

This chapter gives you a few in-camera and shooting techniques to think about when shooting your fashion flair imagery. Figure 6.1 breaks a traditional rule of composition. In general, we are taught not to center our subjects within the frame, but in this case it creates impact and symmetry.

Camera Angles

A typical portrait is a vertical photograph (hence "portrait" orientation) of a subject at about eye level. The subject mostly fills the frame, with a safe amount of negative space on all sides of the head. This is the most typical—and boring—view of a portrait. However, you can still create beautiful portraits with this basic, static orientation using flattering light or poses. You can see a sample of a successful traditional portrait in Figure 6.2.

Figure 6.1

This image breaks the traditional rule of centering the subject in the middle of the frame, but it works because it creates tension and symmetry and is bolder than a "correctly" composed image.

Figure 6.2

This image is elegant but demonstrates that even a static, "unexciting" portrait can be beautiful and high fashion.

One way to get more creative is to vary your camera angle. Shoot from a side angle, shoot from slightly above, shoot from below, or shoot from an angle high above the subject.

Photographers are usually taught not to shoot at a low angle to the subject because of getting an "up the nose" view. Fashion photographers, however, often shoot from their knees or even on their stomachs. By shooting full-length images from a low angle, you emphasize the height and slenderness of the subject. Shooting from below makes the model appear taller and to have longer legs, both of which are desirable attributes. When you are on the ground shooting from slightly further back (with a 50mm or longer lens), the effect is flattering. Generally, you won't get at a low angle right beneath the model, but from more of a distance.

Also, in most situations, you do not want to shoot slightly down on the subject if it is a full-length shot. This makes the subject look short and squatty. Many photographers make this mistake. They shoot from their standing position, and if the subject is shorter than they are, the effect is foreshortening. When you are photographing your portrait and wedding clients, many won't be tall and

slender like models are. For this reason, you need to be even more aware of the height you are shooting at. Even if shooting on your knees is unnecessary for full-length shots, you should at least consider having the camera angle at about waist or hip height. Give it a try on your next shoot; you'll be sure to see a difference.

Figure 6.3 was taken at ground level. The low angle slenderizes the subject and gives her longer legs. Figure 6.4, however, was taken from my normal standing position. If I had shot the same composition from the standing position, it would have been much less flattering; she would have looked shorter and appeared wider. To remedy this, I adjusted my composition and instead moved in for a close-up shot at eye level.

Figure 6.3

This image was taken from ground level. (I was actually on the floor.) This low angle slenderizes the subject and makes her appear taller.

Figure 6.4

This image was taken from a standing position at nearly eye level. If I had shot full length, she would have appeared shorter at this less flattering angle, so I opted for a close-up.

If you take shooting from above to an extreme, you can create interesting imagery. You can have the subject lie on the floor or recline in a chair or on the couch while you shoot while standing or perched on a ladder. Shooting from high angles allows you to craft more interesting images and more dynamic compositions. I took Figure 6.5 standing above the subject and tilted my camera to create dramatic compositional angles. In Figure 6.6, I took the same position but laid down on the ground for a different feel.

Vary your angles, and you will get images that are far from typical.

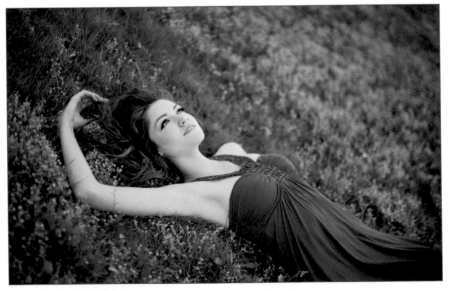

Figure 6.5

Shooting from a high angle can create dynamic compositions and visual interest. Here, I stood above the subject and photographed her with a 50mm 1.2 lens.

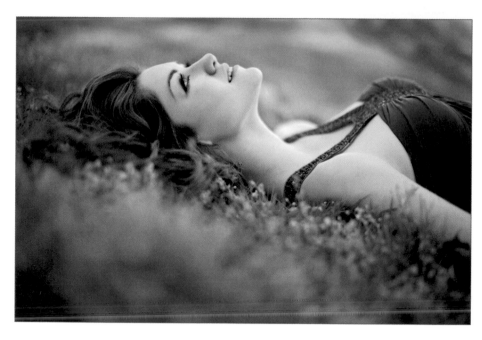

Vertical Versus Horizontal

When I was just getting started in photography, one of my mentors taught me this amusing saying: "When's the best time to take a horizontal image? After a vertical. When's the best time to take a vertical image? After a horizontal."

In other words, try both vertical and horizontal images. With digital photography, you should feel even more willing to experiment and capture multiple shots because there are no extra costs except your time. We are used to shooting landscapes horizontally, but there may be a dynamic composition vertically. And we are accustomed to taking vertical portrait images, but horizontal portraits can take on a "fine art" feel. Be sure to shoot plenty of images in both orientations. Some locations lend themselves more naturally to a vertical or horizontal composition, but consider both orientations. Figures 6.7 and 6.8 show the same image in both vertical and horizontal composition. Each has a different feel and emphasis.

> **TIP**
>
> Fashion photographers often shoot horizontal images for magazine fashion editorials because it helps to guarantee double-page spreads. The images run larger and more prominently.

Figure 6.7

When the image is shot in vertical format, the focus is the entire face and hair.

Figure 6.8

When the image is shot in horizontal format, the focus in more on the subject's eyes.

Eye Contact

Typical portraits have the subject looking directly into the camera. Direct eye contact can help the viewer connect with the subject. A piercing direct gaze or big, soft eyes looking into the lens can make for a great shot.

You should, however, have your subjects vary their eye contact. Have them look at the camera, off into the distance, over their shoulder, and so on. Varying eye contact creates a more voyeuristic view, as if the viewer is looking in on a scene. Also, it creates more of a moment for storytelling if the viewer is looking into the scene, imagining what the subject is looking at.

I frequently have subjects look slightly up and into the distance to create a more pensive feeling or show a different, perhaps more flattering angle of their face. Figures 6.9 and 6.10 show the difference between a subject looking at the camera and away from the camera during a fashion shoot. Typically, if the shot is aggressive and bold, the subject makes eye contact, whereas if the image is soft, the subject looks away.

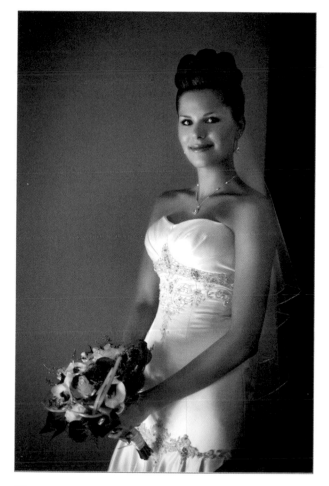

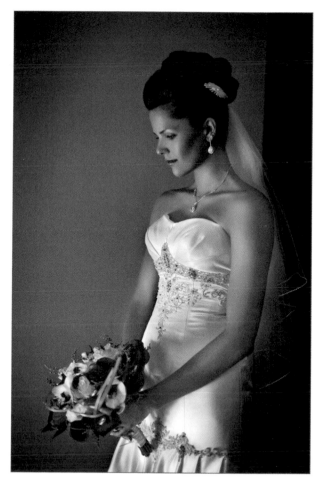

Figure 6.9

In this fashion image, the model is making direct eye contact with the camera. The result is bold, with the focus on her eyes.

Figure 6.10

In this shot, the model is looking away, which creates a soft, pensive mood.

When having subjects look away from the camera, be aware of the white of their eyes. If you are having them look off into another part of the frame, be sure their eyes are not looking too far to one side or the other, or too much of the whites of their eyes will show and create a creepy and unflattering effect (see Figure 6.11). I usually tell the subject exactly what to look at to help prevent this mistake that I see often in portraiture.

Figure 6.11

Viewing too much of the whites of a subject's eyes becomes creepy and unappealing.

Hidden Identity

In fashion and conceptual portraiture, sometimes the subject's face is not even visible. The portrait is revealing something about the subject that doesn't necessarily require seeing the face. Perhaps the subject is turned away from the camera or is in silhouette. For example, one of the most famous portraits of Mike Tyson showed just the back of his head, yet his thick neck and shaved head clearly identified him to the public. In Figure 6.12, my client's hairstyle was distinct and easily identifiable to her friends and family. Because her hairstyle

was her trademark, I wanted to create an image that emphasized her silhouette. The resulting image does not show her face, but it does show her style, personality, and fashion flair. I shot this image in the studio with two strobes pointed at a white background at full power.

Figure 6.12

With this client's profile and hair as easily distinguishable features, this image embraces fashion flair to the fullest.

An image with a somewhat hidden identity is very fashionesque. The name and identity of the subject become secondary to the quality and concept of the image. This technique of hidden identity is even more successful when the subject has other features that are easily identifiable in silhouette. Many clients who are seeking a creative image don't mind if their faces aren't obvious; they know that they are the models in the image. When shooting in silhouette, aim to create a dramatic image or one with extremely powerful graphic quality.

The image may tell a piece of the story that, when put together with other images in a series, helps make for a fascinating image.

In Figure 6.13, the identities of the husband and wife are hidden, but this makes the image more mysterious, as if you are peaking in on a private, romantic scene. The image becomes a piece of a greater story about their relationship.

Figure 6.13

Having the husband's and wife's identities hidden doesn't detract from this image; rather, it makes for a more mysterious and romantic image, as if the viewer is peering in on a private moment.

Attitude

When shooting a fashion portrait session, I have my clients express a variety of emotions and vary their attitude during the shoot.

When most people think of fashion photography, they think of serious models looking stoic or pensive. But this isn't necessarily true. Fashion photography encompasses the entire range of emotions. For example, photographer Bruce Weber is famous for the imagery he shot for the Abercrombie catalogs. These catalogs were full of young men and women laughing, fooling around, and having fun.

The concept of the shoot influences your subject's attitude. For example, if your shoot is themed "punk rocker," you probably wouldn't want the subject demonstrating a bright-eyed, smiling attitude. You might have her show a serious expression or look as if she is shouting or being aggressive.

Encourage a range of emotions. Clients who say they want to smile might end up liking the serious pensive shots because they have never been photographed that way before. I usually have the client progress from being serious to showing a soft/pleasant face, then a small smile, then a full smile, and finally a laugh.

TIP

Some clients struggle to make serious faces. They are used to smiling during portraits and feel uncomfortable not doing so. When they get serious, their face becomes almost angry looking. For these clients, I don't tell them to be serious. I tell them to relax their face, not smile, and to think of something pleasant. I take time before the shoot to get to know my clients, so perhaps I can mention a particular person or pet in their life that will result in a pleasant but nonsmiling emotion on their face. You can develop your own tricks for getting people to look comfortable while serious or to have genuine smiles during the shoot.

NOTE

In most classical portraiture, subjects are not smiling. For some people it is more comfortable to have just a relaxed expression instead of forcing a smile. Furthermore, the nonsmiling look is timeless.

Lens Flare

When you start in photography, you learn that lens flare is bad. In truth, it often is. *Lens flare* occurs when unwanted light scatters within the lens, usually creating unwanted highlights or artifacts. This often washes out or desaturates the image, or it creates undesired rays of light within the final frame. That's why we often use a lens hood to protect the front element of the lens, or we have someone hold shade over the camera to block unwanted light. There are even camera accessories made specifically to help photographers block out the light.

Lens flare, however, can be used as an artistic tool. Commonly, fashion photographers utilize lens flare to make an image feel dreamlike or to emphasize the warmth of an environment. You can use this technique to make an image soft or dreamy, particularly when shooting near sunset. When you're in the studio, you can purposefully create lens flare to build a surreal, glowing effect. In Figure 6.14, I achieved the lens flare by placing three strobes at full power on the background. The light bounces back, wraps around the subject, and refracts within the lens, creating this softening effect.

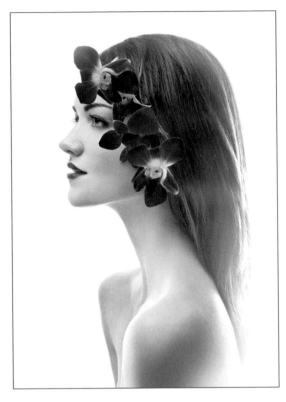

Framing

Framing is a technique commonly used in travel and landscape photography. You might frame a waterfall with the branches of a nearby tree or frame a macro of a flower with the petals from other flowers. Framing is a common practice that is often forgotten in portraiture.

In fashion imagery, you can often utilize framing to improve the composition of an image. You can frame the model using elements within the scene, or frame her with accessories. Frames don't need to wrap an entire image; they can simply frame a key element of an image, such as a model's face being reflected in a mirror within a scene. That mirror acts as a frame to focus the viewer's eye. The arches within a building can also act as a frame from the entire image, with the model as an element within that image, as seen in Figure 6.15.

Some photographers use framing to give a voyeuristic visual effect. For example, you could shoot an image through an open door with the subject sitting on the bed within the room. The cracked door acts as a frame and makes viewers feel as though they are peering into a forbidden world. You can even use something as simple as blurred foliage, which makes viewers feel as if they are peaking in on a moment or scene, as seen in Figure 6.16.

Figure 6.15

Framing is a compositional tool to bring interest and impact to an image. In this instance, the architecture of the building frames the subject to focus the viewer's eye.

Figure 6.16

When a subject is framed by a blurred foreground, a voyeuristic effect results, as if the viewer is peaking in on a scene.

Keep an eye out for how you can use framing to build more interesting compositions.

Cropping

The way you crop an image can largely affect its composition and impact. Be sure to crop out any distracting elements within the frame. With fashion and portrait photography, you are in charge of every element within the frame. Because you are *making* the picture, not just taking it, you are responsible for every pixel. If something isn't working toward achieving your final goals, you can change it in Photoshop, although it is always better to achieve your desired effect in camera.

> **NOTE**
>
> With Photoshop CS5, Adobe introduced a tool called Content Aware Fill. This tool can help you remove distracting elements. Loosely select the object you want removed from the image. You do not need to trace it, but just generally circle the unwanted item. From there, right-click and select Fill, Content Aware. That's it! In most cases, the computer correctly calculates the pixels that should replace the unwanted object!

Also, feel free to crop into the image, even if that involves cropping part of the subject's head or face. I always approach this as artistic cropping that helps bring the viewer's eyes to the essential elements of the picture. You don't need to see the top of a person's head. You know what the top of his head looks like, and it's not important to the image. Cropping an image brings you close to the eyes and makes the portrait even more intimate. By cropping in so close, the viewer feels physically and emotionally close to the subject, as demonstrated in Figure 6.17.

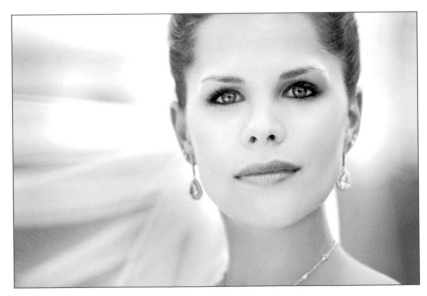

Figure 6.17

By cropping tight into the image, the viewer feels more connected with and emotionally engaged with this bride on her wedding day.

Depth of Field

There is no "right" answer for your depth of field in an image. You can shoot a successful fashion image at f/22 or f/1.2. That being said, a lot of successful fashion images shot on location are shot at wide apertures. The aperture you shoot at depends completely on the scene and the artistic effect you are trying to achieve. Many location fashion images are shot at f/2.8 aperture and wider. I love shooting at f/1.4 or f/1.8. It gives me just enough focus for the face/body, while providing a nice blurry background. It seems to be a sweet spot for me and my portraits.

If you have the opportunity, consider trying a camera with f/1.2 capabilities. When photographing your subject at such a narrow depth of field, the eyes may be in focus while the lips will be out of focus. It is an incredibly narrow sliver of focus, but it can be useful when you're photographing in a distracting environment or you're trying to achieve a dreamy effect, as seen in Figure 6.18. The complete out-of-focus branches in front of and behind the subject are only a few feet from the subject, but because of the 1.2 lens, they become soft and create a dreamlike atmosphere. If I had been shooting with greater depth of field, the branches would have become distracting elements in the frame.

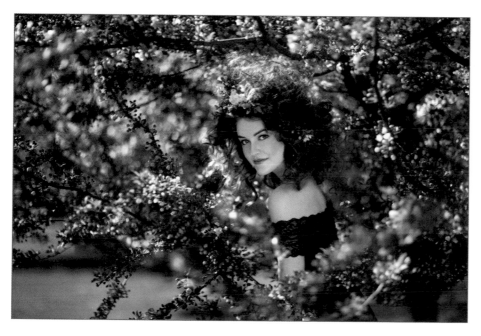

Figure 6.18

Having an extremely narrow depth of field can create a quiet and dreamlike scene. This image was shot with a 1.2 lens, blurring out detail in the foreground and background.

Composition

The composition of an image affects how the viewer interacts with your portrait and its subject. All the typical rules of photography can apply. Keeping the subject in the rule of thirds helps give strong composition, yet breaking this rule and centering the subject can result in a successful composition. There are no special rules of composition with fashion or portrait photography. You should just remember that traditional tools of composition, such as leading lines and framing, are still important methods of improving your imagery. To learn more about some useful compositional tools, see Chapter 2, "Shoot on Location."

Experimental Flair

Fashion flair is essentially more creative than typical portraiture and pushes the boundaries of traditional portrait imagery. It is your opportunity to try out unusual techniques to create extraordinary photographs.

You can experiment with unusual locations, unusual clothing, or unusual shooting techniques. Try for something eye catching that your clients know they could not find elsewhere.

One such unusual photographic technique is painting with light. That's a technique in which you create an exposure in complete or near darkness, and you "paint" the illumination on your subject using a variety of light sources. You control the direction of light, intensity of light, and color of light on the subject and the scene.

Figure 6.19 is an example of a painting with light to create striking results. Painting with light requires a great deal of trial and error. You must experiment with different light sources, gels, and lengths of exposures. This figure was shot at 16mm, ISO 400 at f/2.8 using a 15-second exposure. During this exposure, the subject was illuminated for approximately 5 seconds with a warm tungsten balanced-flash light. My camera white balance was set to tungsten so that the tungsten light appeared almost neutral in tone. I flashed the background and the tree several times with a daylight balanced off-camera flash/strobe. Because I set the white balance to tungsten, the daylight strobes created a blue illumination on the scene.

Obviously, painting with light is just one of many unusual techniques you may consider experimenting with.

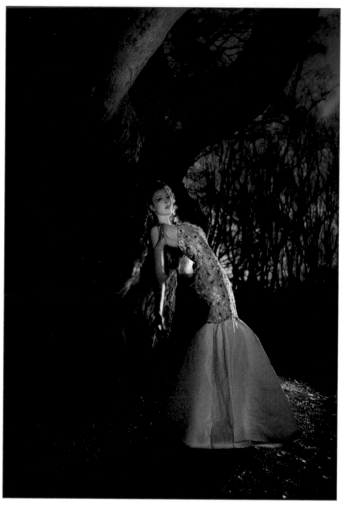

Figure 6.19
One experimental technique for your portrait work is painting with light to create bold colors and unusual portrait results.

If You Choose to Accept This Mission

Fashion photography and fashion flair are about thinking outside the ordinary and creating something extraordinary. When you market your fashion flair imagery to clientele, you will be expected to create something beautiful, eye catching, and unusual. You always need to be experimenting with new styles, new lighting, and new shooting techniques.

When you are first getting into fashion flair, I suggest that you experiment and try to build a relatively diverse portfolio. This portfolio can act as inspiration for your clients. They can give you ideas of shoots they like and concepts they'd like to build upon. More importantly, building a fashion flair portfolio is a chance to push your creativity and to enrich your artistic self.

If you want to build up a fashion flair reputation and portfolio, self-assign a variety of these concepts so that every week or two weeks you can add a new piece to your repertoire. Give yourself missions that you must complete. I still continue to do this in my fashion photography career. I am always trying something new and adding new images to my portfolio.

You can also present this list to potential clients and see if they'd like to help you create any of your "goal" images. The list can be a combination of locations you want to shoot, techniques you want to implement, or styles you'd like to emulate.

Your list may look something like this:

- Flapper era fashion shot (finger curls, long cigarette holder)
- Farm girl (cowgirl standing on top of tractor)
- Night on the town (lights blur, motion, party feel, party dress)
- Strong studio silhouette (cool dress/hair)
- 1950's pinup (with vintage car?)
- Punk couple downtown at Mikey's Bar
- Rebel (dramatic lighting, cool demeanor)
- Paint with light
- Rooftop sunset couple's image
- Underwater (long dresses)
- Warrior theme (lots of metal, war paint?)
- Hippie or tree hugger theme (on location, flowing dresses)
- Bright red theme (red clothing, red makeup, red background)
- Punk beauty shot (metal spikes, close-up studio)
- Girl on a horse at sunset
- Shot at Town Hall (long gown, dramatic lighting)
- Trash-the-dress session in an ocean
- High-fashion studio bridal portrait (concentrate on poses)
- *Pride and Prejudice* inspired (manor location, Victorian styling)
- Beauty shot with intricate jeweled makeup

Your list could include hundreds of ideas and be accompanied by dozens of tear sheets and pieces of inspiration. Mark the shots on your calendar for goals of completion, or just have the list ready to share with clients when they come in for a consultation.

For example, I looked at my portfolio for clients and realized I was short on images that would appeal to men. I had many portraits of women, couples, and even children but few individual flair sessions for men. Seeing this, I added this goal to my list and set up a shoot with an attractive male client to do a rebel-inspired shot. To achieve the rebel image seen in Figure 6.20, I needed dramatic lighting (beauty dish and barn doors), a cool unaffected pose, and styling that conveyed this message.

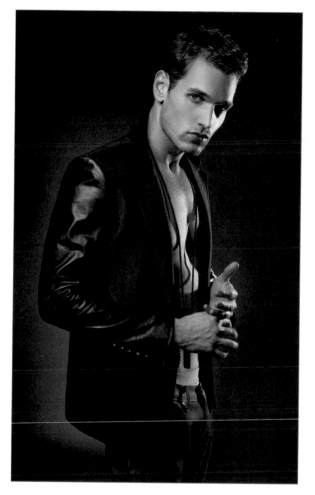

Figure 6.20

This image of a male rebel portrait help me fill the gap of fashion flair men's shoots in my portfolio.

Write down the techniques you need to master or the gaps in your portfolio, and shoot to fill these gaps.

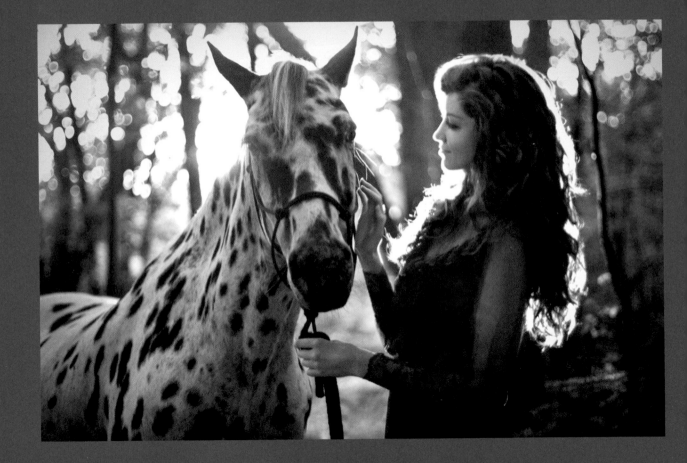

Part III

See the Light

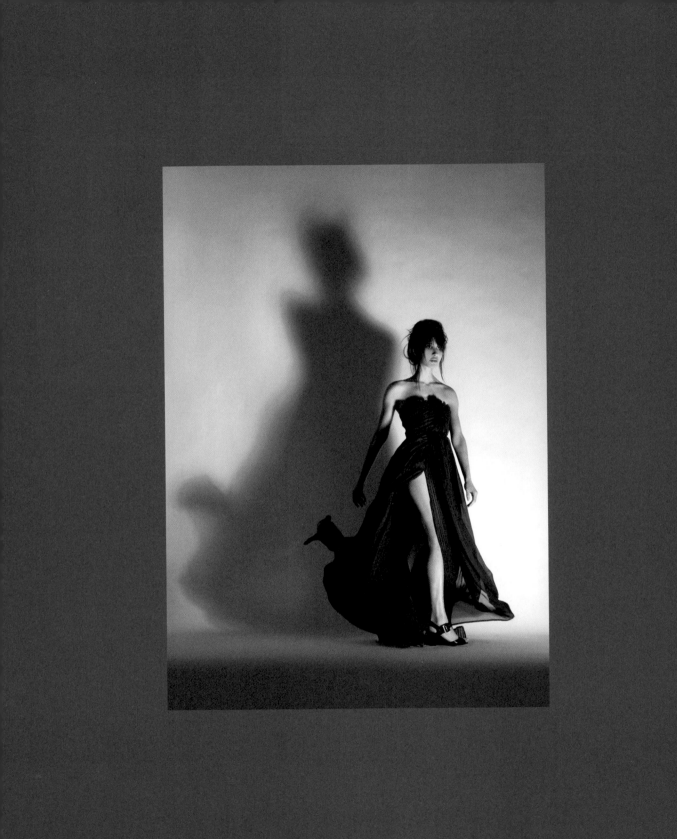

7

Analyze the Light

One of the greatest tools available to a photographer is light and the knowledge of how to manipulate it.

The most successful fashion photographers of all time were known for their stunning mastery of light. Photographers from Richard Avedon to Albert Watson to Irving Penn had exquisite light to help them express their visions.

This section of the book presents the essential techniques that fashion photographers utilize regularly to light their fashion and beauty images. It covers natural lighting, studio lighting, ETTL Flash (speedlights), and studio lighting on location.

Determining How an Image Is Lit

You should know a few tricks about analyzing light. When you look at a fashion image or any portrait, take a minute to analyze the light. You don't need to see a lighting diagram or ask the photographer. If you study an image, the way it was lit usually reveals itself. This is particularly useful if you are interested in duplicating a lighting setup from a magazine and have only a single image to figure out how it was created.

When determining how an image was lit, analyze the following aspects of lighting:

- Quality of light
- Catchlights in subject's eyes
- Direction and quality of highlights
- Direction and quality of shadows

Let's look at each of these elements.

Common Studio Lighting Terms

In this chapter, I will use various terms to describe the types of light used to illuminate an image. Here are some terms you should be aware of. Not all these lights are used on every image, but they are terms you want to be familiar with when talking about studio photography.

- **Key light or main light.** This is the primary source of illumination for your subject. It's the main light on your subject, but it does not necessarily need to be in front of your subject. It's the light that defines the main highlights/shadows and general quality of light for your image.

- **Fill light.** This is a secondary light in an image that is often used to further define the quality of light by affecting shadowed areas of an image. For example, a strong fill light eliminates shadows, making the image brighter and possibly softer. Many images do not use a strobe/flash for fill light and instead use reflectors and fill cards to adjust shadow quality.

- **Background light.** A light whose main purpose is illuminating or defining the background. In traditional portraiture, photographers used a background light to define the subject and the background. By separating the subject from the background, the image appears more three dimensional.

- **Kicker light.** This light is also known as *rim light* or *backlight*. A kicker light usually illuminates part of the subject to separate the subject from the background. A kicker light often adds a bright highlight on the shoulder, hair, or side of a subject. Kicker lights can be soft and subtle or harsh and bright.

- **Hair light.** In portraiture, a light is sometimes used specifically to illuminate the hair to give it shine and to create additional definition from the background.

Quality of Light

You need to distinguish the properties of light that illuminate the subject. Is the lighting soft and diffused? Or is the lighting harsh and direct? Is this light coming from a dramatic angle or from straight on? You can analyze the catch-lights, shadows, and highlights to determine how these effects were achieved, but first you must distinguish the overall quality of light.

What is the overall mood and feeling of the image? Is it soft and airy, dark and dramatic, or something in between?

In Figure 7.1, the light is soft and diffused. The lighting is pretty even with minimal shadows and overall a light feeling. I created this effect with a beauty dish and fill cards to minimize shadows, which I'll talk about later (see Figure 7.10 and Figure 7.12). If you look carefully, you also see subtle highlights on her neck and hair, indicating other light sources to add highlights from behind and to the side.

Figure 7.1

This portrait is an example of soft, diffused lighting.

In Figure 7.2, the light is even more dramatic. There is a highlighted (right) and shadowed (left) side of the face as well as defined highlights. The light is neither soft nor overly harsh. I created this lighting effect with a beauty dish placed to the right of the frame as well as hair lights to define the subject from the background.

Figure 7.2

In this image, the light is dramatic but not too harsh.

In Figure 7.3, the light is harsher and more dramatic. This is atypical lighting in portraiture.

Here a large silver dish (a light modifier you can attach to a strobe) was placed on the floor to the front of the model and to the right of the frame. The light was angled upward at a sharp angle to create these dramatic shadows. You almost never want to light a subject below, but sometimes breaking the rules can create dramatic effects.

Figure 7.3

This image has more harsh, dramatic lighting. In this instance, a silver dish was placed on the strobe and the strobe placed on the floor (to the right on the frame). This created large and harsh shadows on the backdrops.

Knowing the quality of light in an image gives you a start place to figure out the type of modifier or type of natural light used.

Catchlights in a Subject's Eyes

A great way to determine the main source of lighting in an image is to study the catchlights. *Catchlights* are the highlights created in a subject's eyes, usually by the key light of the image. They give life and vibrancy to an image. Without catchlights, a subject often looks dull, creepy, or lifeless.

> **TIP**
>
> In high-fashion images, the angle of light is dramatic, and the catchlight is absent. In general, you want to avoid this for portraiture, but using it selectively can create a dramatic and unique image.

First determine how many catchlights exist. If there is just a single catchlight, you know that one main light illuminates the front angles of the subject.

> **NOTE**
>
> Some famous photographers, such as Jill Greenberg (Manipulator.com), use many lights to illuminate their portrait subjects. Greenberg, for example, often has three or more catchlights in the subject's eyes and another four or five sources of light within the image. This is an extremely unusual approach, but it defined her style and made her images instantly recognizable.

After finding the number of highlights, determine their shape so that you can distinguish the light source. If you look closely, you can tell whether an image is lit by a softbox by the rectangular shape of the highlight. If the image is lit by a beauty dish, you will see a round highlight with another round shape in the center of the circle. If the catchlights are irregular instead of crisp, the light source might be natural, such as a window or open shade.

Take a look at the images that follow to get a feel for the different shapes of catchlights created by different modifiers. Figures 7.4 through 7.9 provide a reference for the different catchlights.

Figure 7.4

Catchlights for an umbrella.

Figure 7.5

Catchlights for a beauty dish.

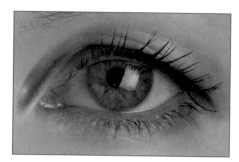

Figure 7.6

Catchlights for a softbox.

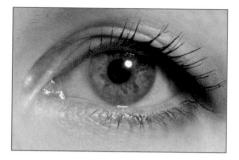

Figure 7.7

Catchlights for an octobox.

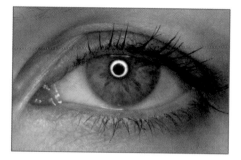

Figure 7.8

Catchlights for window light.

Figure 7.9

Catchlights for shade and reflector.

Now that you have determined the number of catchlights and their shapes, you must discover the location of the catchlights. Analyzing the location of the catchlight tells you the location of the main light in relation to the subject.

For example, if the light is a rectangle located in the top left of the model's eyes, you can deduce that this light is a softbox that is raised somewhat above eye level to the model and is placed to the left of the frame. You can further confirm your theory by analyzing the direction and quality of the shadows (discussed next).

CAUTION

Natural light is somewhat harder to determine because the catchlights are not as defined. If you study the catchlights carefully enough, you can still determine a lot. You can pinpoint how large the light source was (based on the size of the catchlight) and what direction it is illuminating from (perhaps a large light source on the right, versus a small and narrow one from above). You can also see any light modifiers used in natural light, including fill cards and reflectors. They create distinct patterns of their own.

If the catchlight is a circle within a circle, located in the center of the iris, you can deduce that the light was a beauty dish located directly in front of the model at eye level.

In many images, the eyes reveal nearly the entire formula for reproducing the same light.

NOTE

This technique doesn't work as well if the subject is completely backlit. Determining catchlights will still help you see if there is illumination in front of the subject, but it won't reveal the main source of illumination for the image.

Other Highlights in the Eyes

The main catchlights aid in establishing the key light of the image, including the light modifier used, the direction of light, and more. Sometimes, however, you will see subtle highlights in the eyes. These highlights indicate the presence of reflectors or fill cards. Figure 7.10 is one such example. A fill card was placed beneath the model's chest to bounce light back into the image and even out the shadows. You can see the soft, lighter rectangle in the bottom part of the eye, which indicates that a reflector or fill card was utilized. Notice the reflectors in the bottom of her eyes.

Figure 7.10

Here you can see the faded outline of a foam core fill card
in the bottom of the subject's eyes.

TIP

You can learn a lot about the lighting of an image by examining the size of the
catchlights. A big catchlight indicates that the light source either was very close
to the subject or was a very large light source. Similarly, a very small catchlight
indicates a light source farther from the subject or a relatively small source
of light. Typically, a large catchlight (close light source) creates soft light that
illuminates a large amount of the subject. On the other hand, a small catchlight
usually results from a more point-source of light, thus creating more contrast
and harsher light.

Direction and Quality of Highlights

You need to analyze the number of highlight in an image, the direction they're coming from, and their quality.

Besides the main illumination, are there highlights on the shoulders or the hair? A highlight on the background? Other highlights on the face or body?

When you find all the highlights, take a moment to determine which direction the light source must be coming from by the way the light forms to the subject.

Finally, what are the qualities of this highlight? Is it soft and subtle, or is it bright and crisp? For example, if there is a highlight on the subject's left shoulder and side of face, determine how bright and crisp this highlight is and what direction the light must be coming from. In a studio environment, a crisp backlight high-light can indicate the use of barn doors, whereas a softer highlight might be a strip light. Both of these are common modifiers utilized for kicker light or back-light highlights. We'll discuss these modifiers more in Chapter 9, "Studio Light: Complete Control."

Direction and Quality of Shadows

After you've examined the catchlights, take a look at the shadows to determine the source and direction of light. Which way are the shadows falling? Are they diffused or crisp? Are there shadows at all?

I often try to analyze the shadow created by the nose. If the shadow falls down and to the right, it means that the key light was up and to the left. If the shadow is long, it means that the light was high and close to the subject (casting a strong downward shadow). If the light is completely from the front, shadows may be nearly eliminated. Look at the shadow cast in Figure 7.11. You can tell by the direction of the shadow that the light was shot at a downward angle from the top left of the frame, thus creating a shadow toward the bottom right.

Figure 7.11
Because the shadow on the nose falls down and to the right, you know that the main light was above the subject to the left.

Putting the Puzzle Together

All the elements we've been discussing will help you analyze the lighting of an image so that you can re-create the effect yourself. In many cases professional lighting is quite simple, with only one or two lights. It's the styling, makeup, model, and angle of light that make the image unique.

Check out Figures 7.12 through 7.15 and try to piece together the elements that make up the image. Can you determine the main lighting? You might want to read Chapter 9 first to become a bit more confident with the attributes of different light modifiers before continuing.

Figure 7.12

This image was illuminated by a beauty dish (centered and straight on) and fill card (placed beneath the torso).

- **Quality of light.** The light is even and relatively soft. It has a glowing quality to it.

- **Catchlights in subject's eyes.** There are two main catchlights (defined highlights) in the eyes. First, there is a main circular highlight (with a small circle within) located just above the subject's pupil and slightly to its left. It is more or less center. Second, there is a faded highlight in the bottom of the eye. It is rectangular (edges visible) but faded.

- **Highlights.** There are no distinct highlights—just the main light on the face.

■ **Shadows.** There are no distinct shadows—just a bit of a soft shadow beneath the nose and chin. The shadows are relatively even with a direction. (They don't fall hard right or left.)

■ **Summary of likely lighting setup.** This image was illuminated with only one light. This light, a beauty dish, was placed above the camera almost directly in front of the subject. It was raised slightly above the subject's head, as you can tell by the location of the catchlights. The light was made glowing and even by putting a large white foam core board just out of the bottom of the frame. This type of board ($5 or less at arts and craft stores) acted as a bounce card to almost eliminate shadows. The light and its glowing quality resulted from the combination of beauty dish and foam core reflector. The rectangular faded highlight in the bottom of the eye is evidence of this reflector.

Figure 7.12 was an artist's portrait for her promotional materials and an article to appear in a local magazine. This light is flattering for women who have nice facial structure. This lighting setup does not work well for men.

Figure 7.13

This image was illuminated by a softbox (left side of frame) and kicker strip light (back 45-degree angle).

- **Quality of light.** The light is directional with clear highlight and shadow areas, but it also has a softer quality and wraps around the face and body.

- **Catchlights in subject's eyes.** The catchlight is in the shape of a rectangle in the left side of her eye.

- **Highlights.** There are two highlights. The first is the light on the subject's face, which is softer and more broad. The second is a relatively crisp highlight on the right side of the image on the subject's arm and chest.

- **Shadows.** The shadows are soft and not very dark but also not very filled in. Here they give definition to the face and body and add a bit of drama to the image. The shadows from the nose on the face fall almost level to the right (perhaps even slightly upward).

- **Summary of likely lighting setup.** There are two lights in this image. The main light is a large softbox to the left of the frame. The softbox is about level with the torso of the subject, which is why the shadows fall almost level from left to right and even slightly upward. The light is soft and broad, which characterizes a softbox. The softbox is positioned farther to the left of the frame, creating the shadow on the right side of the face. You can tell the location of the light based on the catchlights and the direction and location of the facial shadows. The second light is a kicker light to the back 45-degree angle (on the right) of the subject. This light could either be barn doors (open slightly broader) or a strip light (long narrow softbox for highlights). In this case, it actually is a strip light, and it is not as sharp of a highlight as would be created by barn doors.

Figure 7.13 was a portrait taken as part of a model portfolio while building up my fashion flair portfolio a few years ago. This lighting setup (softbox and kicker) is the most common portrait lighting setup. Although this setup is somewhat traditional, the poses and direction of light make it an engaging fashion flair image.

- **Quality of light.** The light is harsh and dramatic.

- **Catchlights in subject's eyes.** There are no catchlights because there's no front light. The eyes are cast in shadow.

- **Highlights.** Note the two sharp and narrow highlights on the left and right side of the subject's body. Light is restricted to the sides and back of her head and face indicating light coming from an appropriate back 45-degree angle.

- **Shadows.** The large shadow in the middle of the subject's face is dominant, sharp, and very dark.

Figure 7.14

This image was illuminated with two silver dishes (two strobes) from back 45-degree angles, creating two harsh highlights on either side of the face. This image was part of a model portfolio.

■ **Summary of likely lighting setup.** This image was lit with two strobes and silver dishes. You can create a similar effect with two lights with barn doors, although the beams of light would be narrower (and likely not spread onto the face as much). These two lights were at a back 45-degree angle on either side of the subject. The light was at an even distance and angle on either side to create this symmetrical image.

The setup for Figure 7.14 was for a local model portfolio, but you could easily use this light for any subject with a strong profile. I've used this setup often for images of musicians playing their instruments, because the light is dramatic and feels very much like stage/performance lighting. For musicians, I often use one light as a silver dish to be a bit broader, and a more focused barn doors highlight for the back side.

Figure 7.15

This image, part of a high
school senior portrait, was
backlit by the sun and a silver
reflector to illuminate the
subject's face.

- **Quality of light.** The light is bright and glowing. The light on the background is harsh and bright, whereas the light on the subject is crisp and even (much softer than background light).

- **Catchlights in subject's eyes.** The main catchlight is an oval/round one on the left side of the her eye, centered. There is also another very broad and soft catchlight covering the rest of the eye.

- **Highlights.** The main highlight is behind the subject on the background and on her shoulders and hips. The highlight is strong and crisp.

- **Shadows.** There are minimal shadows in this image. The light on the subject is even overall, with no distinct or defining shadow areas.

- **Summary of likely lighting setup.** This image was taken about an hour before sunset with the sun to the subject's back and a silver reflector illuminating her face. The sunlight was bright and crisp, so it created the distinct highlights on her body. The silver reflector was to the front and slightly to the left of the frame, which is why the distinct catchlight is to the left of her eye. The other more broad highlight in the image is actually created by the light in the open sky behind the camera. In other words, for this image the main light is illumination on the face from the silver reflector bouncing light back onto the subject. The fill light for this image is the open sky, and the rim light (backlight) is from direct sunlight.

Figure 7.15 was taken as part of a high school senior portrait and dance portfolio shoot. In a typical photography class or professional club competition, this image might get lower marks because of the blown-out highlights and lens flare. In fashion photography, however, this lighting is common and highly praised because it is flattering and creates a dreamlike, fantasy feeling. This was one of the client's favorite images from the shoot.

> **NOTE**
>
> There were no background lights used in these images. I often use kicker lights instead of background lights to define the subject from the background. This is purely personal taste.

8

Ambient Light: All Natural

*A*lthough shooting in the studio requires a certain type of knowledge, shooting with purely natural light is a skill set of its own. You must learn to approach an environment and really *see* the light. Once you identify the light, you must learn how to position your subject so that the light is flattering, or you must utilize natural light modifiers to shape the light. Figure 8.1 is an image taken completely with natural light, but it looks like a scene from a movie. The subject was standing in a narrow alleyway, so the light in the foreground gave frontal illumination to her face, whereas the light at the end of the alley gave her a stunning hair light. You, too, can find striking light like this. But first you must take the time to see natural light, and then you can decide how to modify it.

There are dozens of books and instructional DVDs based solely on the topic of natural light and natural light techniques. For the purposes of fashion flair, I will cover some basic natural lighting techniques that I regularly utilize to achieve a pleasing effect.

Although I love shooting in the studio because of the control I have, I love the feel of natural light and shooting on location. When I was starting out in my photography business, I mostly shot in the studio because I believed that what made a professional photographer stand out was her expensive studio equipment and her ability to make studio light images. This was far from the truth, however. I've found over the years that my clients generally prefer shooting on location with natural light. They love the richness of the light and interacting with interesting environments. A professional photographer stands out when she is able to really bring out the energy and beauty in a location.

Following are a few tried and true natural light techniques I utilize regularly.

Direct Sunlight

Shooting in direct sunlight can be perilous. In fact, most photographers are taught to avoid shooting in direct sunlight because the light is harsh, the shadows are deep, and it is hard for the subject not to squint. Typically, the light is not flattering, and it's just a pain to shoot in.

But if you look at the pages of high-fashion magazines, photographers regularly shoot in direct sunlight. It has taken on an edgy feel because it breaks traditional photographic rules. Photographers use the harshness of the light to really shape the face and body and to create a certain mood.

For example, Figure 8.2 was achieved using direct sunlight filtering through the trees. Although I usually avoid direct sunlight because of its harshness, here the light illuminating the subject's face made the scene more dramatic and mimicked the light illuminating the background roots. The direct sunlight gives shape and dimension to this particular image.

Figure 8.2

Direct sunlight can be a tool to create dramatic lighting. Although you should use it carefully, it can add dimension and shape to a scene and subject.

If you shoot in direct sunlight, I have two general recommendations. First, watch the light. Really see how it shapes the subject's face or interacts with the environment. Make it look like you chose to shoot in direct sunlight, not like you had no other choice. Second, try to shoot earlier or later in the day. If you shoot more toward sunrise or sunset, the sun will be at a lower angle in the sky.

These angles of light are more flattering and give definition to your subject. Figure 8.3 was taken near sunset, so the light was rich and golden while shaping the face.

It's easier to shoot in direct sunlight with men because their faces typically can handle the harsh light, although you can use this lighting for both genders.

Figure 8.3

When shooting in direct sunlight, consider shooting earlier in the day or later in the day when the sun is at a lower angle. This low angle creates an interesting mood and a more flattering effect on the face.

Backlight (Sunlight) with Reflector

This lighting technique is surreal and cinematic. In the next dramatic or romantic movie you watch, see how many times you come across this lighting scenario. The light is flattering and creates a feeling of perfection and fantasy. That's why it's popular with my clients. Figure 8.4 was shot using this technique. Notice the mood of fantasy and nostalgia it creates.

Simply put the sun to the subject's back, and use a reflector to bounce light back into her face. This creates almost a glowing halo around the head and nice crisp light on the face. I typically use a 30-inch 3-in-1 or 5-in-1 reflector. The 5-in-1 reflector I'm using has a silver side, a gold side, a silver-gold mix, and a white diffuser in the center. I almost always use the silver or silver-gold mix; however, I wanted a warm and golden look in Figure 8.5, so a gold reflector was appropriate to capture this image.

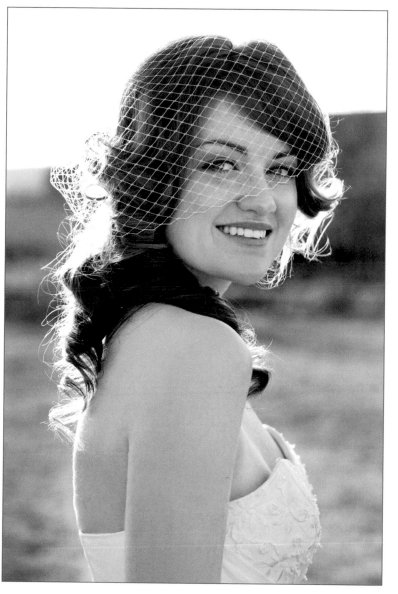

Figure 8.4
Here, the backlight on the bride's hair makes the scene more romantic and fairytale-like.

NOTE

A 3-in-1 reflector has a silver side, a gold side, and typically a white diffuser in the center. A 5-in-1 reflector allows you to slip the reflection material inside out and provides additional combinations of reflecting surfaces, including a silver and gold mixed reflecting surface.

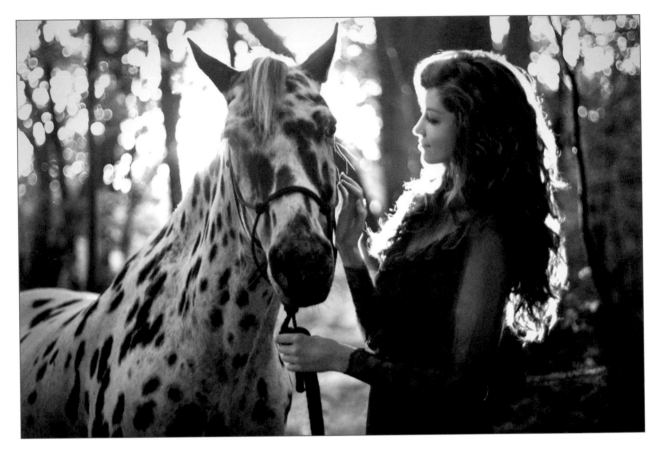

Figure 8.5

This image was meant to be warm and feel like a dream, so a gold reflector lends an appropriate feel.

CAUTION

Avoid too harsh use of the reflector. On a bright day if you use the reflector at full power (catching all the sunlight), the result will be harsh and overpowering light. In nearly all cases this is undesirable. Instead, move the reflector so that the subject isn't receiving a full-power reflection. This is called *feathering the light*; it allows you to have more control over the strength and direction of your reflected natural light.

CAUTION

In this lighting situation, it is easy to get lens flare. Because the sun is behind the subject coming back at you, the light can easily bounce around the lens, resulting in flare or muddying of your image. Try using a lens hood, your hand, or a *gobo* (go between) to block out excess light. In the movie industry, gobos are also referred to as flags and are used to block light from hitting undesirable areas, including your lens. Sometimes you can use lens flare as a creative tool, but in most instances you want to avoid it.

I typically use this technique on women because it gives a somewhat angelic look, although I have seen it used successfully on men. As with most natural light, utilizing light earlier or later in the day gives more pleasing effects. The light will be more directional and rich.

TIP

When using a reflector to catch and bounce light, watch the angle you are reflecting from. If you are catching light beneath the subject's face or body, the result might be a bottom-lit image. This is generally unflattering (which is why bottom light is often used in horror movies). You may need to have an assistant hold the reflector at a higher height to bounce light straight into the subject or just to avoid a low angle.

Diffused Sunlight

As mentioned before, we are often told to avoid direct sunlight or midday light in portraiture. Yet if you know how to modify the light correctly, this may be some of the most flattering light available.

On a bright day you can use a diffuser (included in most reflector kits) or a larger scrim to turn the sun into a giant, glowing softbox. Figure 8.6, for example, was taken near midday in extremely harsh sunlight, yet the light is still soft and glowing because of the large scrim that diffuses the light.

Figure 8.6
I captured this image around noon on a bright and sunny day, but I used a diffuser to soften the light.

A *scrim* is a large metal frame that can hold different materials, including reflector material or diffusion material. On a sunny day you can place the diffuser between the subject and the sun to create bright, glowing light. Figure 8.7 shows a Scrim Jim (particular brand of scrim) with this diffusion material attached. Scrim Jims come in various sizes, including my favorite, the 6-foot by 6-foot scrim.

Figure 8.7

Here you see a 6-foot by 6-foot Scrim Jim with 1 stop diffusion material taken during one of my workshops in San Francisco.

Scrims, which many companies manufacture, are worth the investment. They're commonly used in swimsuit photography on the beach to diffuse the bright sunlight. Popular brands include California Sunbounce and Scrim Jim. You can buy diffusion material in different stops (strengths), but 1 stop diffusion is typically sufficient.

Window Light

Since the beginning of portrait photography, photographers have utilized the beautiful qualities of window light to illuminate their images. Window light can be soft and directional. By moving your subject in relation to the window, you can literally watch as the window light helps shape and carve the face while maintaining its soft qualities. Figure 8.8 show a traditional use of window light for portraiture. Light is soft and flattering, with the window to the left of the frame. The light sculpts the subject out of the darkness and gives a deepness and sadness to his eyes.

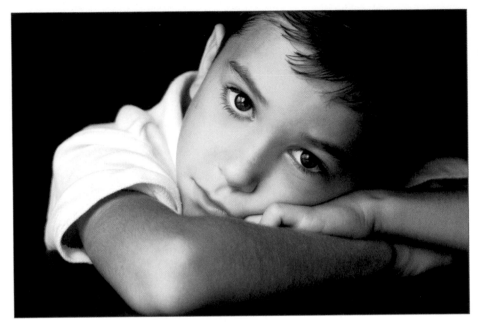

Figure 8.8

In this example of traditional window light, the subject is sculpted out of the background. The light wraps around him in a quiet and flattering way.

For window light, you are not looking for direct sunlight. Avoid situations in which the sunlight is streaming through a window. Instead, you are looking for indirect light in which the brightness of the outdoors glows through the window.

> **TIP**
>
> Pay attention to the light on the subject's face. The window light is constant, and you can pose your subject to make use of the best angles of the light.

> **TIP**
>
> Don't put the subject too close to the window. If the window is large and you put the subject close to the window, the light begins to come from overhead and creates shadows in the eye sockets. If you back the subject away from the window, the light becomes more frontal and more flattering.

In some instance, you want to put the window to your back and the subject directly in front of you. This creates frontal light. Although it is somewhat flat lighting, it is often very flattering for women. The light is soft and glowing, eliminates shadows, and reduces the appearance of wrinkles.

Window Light Backlight With or Without Reflector

If you have a large, bright window at your studio or the location you are shooting, it can be a great lighting source for high-fashion imagery. If you place the window behind the subject and overexpose your image (to correctly expose for the face and skin tones), the light begins to wrap around the subject for a high-fashion feel.

In some cases you don't even need a reflector; you can simply let the light wrap around the subject for illumination. In other situations, you might use a silver reflector to help even out the exposure and make the light more crisp. In Figure 8.9, the sole source of light is the sunlight streaming through the window. The resulting image is crisp and striking.

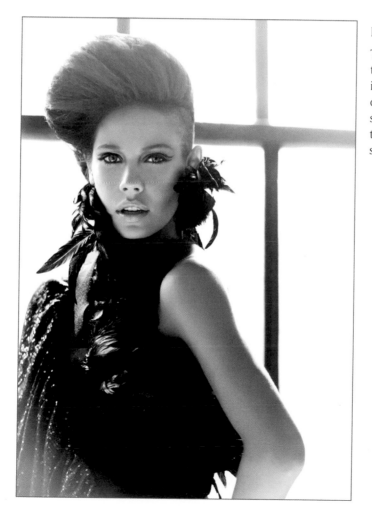

Figure 8.9

This fashion image was taken in the window of my studio. There is nothing lighting the front of this image, only the light streaming through the window that then bounced around the studio's white walls.

Window Light Plus Curtain

If you want a dramatic lighting effect achieved with purely natural light, this is your lighting solution.

Find a relatively bright window that has thick curtains. Close the curtains so that only a thin beam of light is showing through. Position your subject so that he is standing in the narrow sliver of light. Figure 8.10 is an example of the dramatic split light that window and curtain light can create.

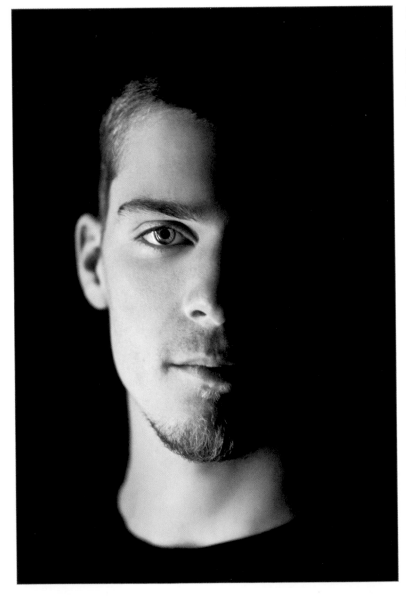

Figure 8.10

Using curtains on a window, you can narrow the window light to a narrow beam. You can then position your subject to create dramatic lighting.

This creates focused and narrow light that is great for dramatic effect. It is most useful when photographing men, but you can use it for women as well.

> **CAUTION**
>
> Be sure that you have thick curtains. If they are somewhat transparent, the light shines through, and the effect is not as drastic. If the curtains are transparent, ideally they are a neutral color. For example, if the curtains are green and light passes through them, they create a green cast on your subject.

Open Shade

If it is an overcast day, it is possible to use no light modifiers. Using open shade comes down to "seeing the light." *Open shade* just means shooting out in the open on a nonsunny day or shooting in an area shielded from direct sunlight.

Be sure to turn subjects' faces so that they capture the brightest part of the sky and do not have unsightly shadows in their eyes. This is similar to shooting in direct sunlight because you must carefully watch shadows and highlights, but the light is much more diffused and soft.

There is a trend in recent fashion photography to shoot open shade only for edgy fashion editorials. Because the light is not modified, it feels natural and therefore much more real. Photographers in many fashion magazines utilize this verisimilitude in their imagery.

I took Figure 8.11 in open shade, using no reflectors, diffusers, or light modifiers. An overcast day creates a relatively soft look. To learn how to add textures to your images (as seen in this example), see Chapter 12, "Stylized and Creative Effects."

When shooting in open shade, just watch how the light affects the face, and throw in a silver reflector if needed.

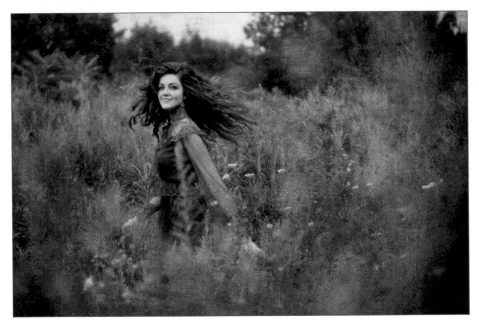

Figure 8.11

On an overcast day, you can use the natural available light of open shade to illuminate your subject without modifiers.

Shade: Overhang or Doorway

This is probably one of my favorite lighting solutions when shooting a subject on location. It's great for cloudy days and sunny days alike, and it's a way to create extremely flattering light.

You simply put your subject in the shade of a doorway, porch overhang, or covering. This situation would not work in the shade of a tree or building, because you need a definite opening or distinctive covering for shade. Figure 8.12 shows two brothers in a cave opening on the beach. This opening acts the same as a doorway. The opening of the cave allows light to reach the subjects, and the overhang on the cave blocks out overhead light. This technique is sometimes called *subtractive lighting*. In other words, you start with full light (overhead open sky) and slowly subtract unwanted highlights and lighting. Subtractive lighting is often used in the studio using black reflectors to absorb unwanted light.

When subjects are in the shade, put them 3 to 4 feet from the opening of the door or overhang. When you are doing this, watch the light on their face. Make sure the shadows in their eyes are eliminated. The farther back in the space you put the subjects, the more frontal and more flattering the light is. Also, the light will be more focused coming from a seemingly smaller area/entrance. Figure 8.13 was taken shortly after Figure 8.12. To make the light more chiseled and dramatic, I moved the subject farther back into the cave (which acted like a doorway).

Figure 8.12

The overhang on a cave near San Diego blocks out overhead light and illuminates the subjects with frontal natural light.

Figure 8.13

The farther back into the cave I put the subject, the more focused the light becomes and the more dramatically it carves out the features of the face.

This doorway lighting is extremely flattering for both genders. It's easy to find in most locations.

Shade with Reflector

This is probably the most common lighting solution for location or natural portraits. Put your subjects in the shade. This way there is no direct sunlight on their face, and you can eliminate undesired shadows. You more or less start with a blank slate of a face—no unusual highlights or shadows.

You then use a larger silver reflector to capture nearby light and reflect back into the face. You can reflect in sunlight, window light, or really any light source brighter than what is illuminating your subject. The reflector gives you control over how much light hits the face and what direction that light is coming from.

This light is flattering for both men and women, both models and everyday people. It is neither too soft nor too harsh. Figure 8.14 is a sample of a shade and reflector image. I placed the subject in the shade of a tree over the path, and sunlight was reflected back in for a crisp image.

Figure 8.14

By putting your subject in the shade and using a silver reflector, you can easily have quality light, particularly on a bright, sunny day.

Watch for Natural Reflectors

Sometimes nature gives you the gift of beautiful natural reflectors. A perfect example is a beach. Usually the sand is white and smooth and bounces back all the sun's rays. If you photograph a subject in the shade near the beach, the sand acts as a giant reflector, evenly filling in all the shadows.

Also, if you are in the shade and there is a sunlit concrete sidewalk, it is a likely a great reflector. Watch to see what the sun is illuminating. This illumination might create a great natural reflector or natural softbox. Floors, cars, and sides of buildings are potentially great sources of light.

Figure 8.15 is a behind-the-scenes image of me creating the portrait in Figure 8.16. I did not use light modifiers to create this beautiful, glowing light. Instead, I watched the natural reflectors already present in the environment. The sun was bright and was reflecting off a large, white concrete sidewalk. I noticed this bright reflector and put the subject in the shade, using the sidewalk to fill in the shadow.

Figure 8.15

I placed the subject in the shade to avoid the harsh sunlight, and the well-lit concrete sidewalk acted as a giant reflector to fill in the shadows and create the beautiful result shown in Figure 8.16.

Figure 8.16
When shooting portraits, look for natural light reflectors. I achieved this glowing portrait without light modifiers, using only available light.

When shooting on location with natural light, you can't just be aware of your main light. Can other sources of light benefit your image? Perhaps there is an open doorway casting a highlight into the room that could be used as a nice rim light on your subject. If you watch the light carefully, chances are you'll discover these other sources that can add dimension to your images by acting as a hair light, rim light, or even interesting background illumination.

Experiment with Light

Don't be afraid to use light in an unusual way. Perhaps you can blow out your highlights or strongly backlight an image. Use a light source that isn't typically a source of illumination. Often, the more creative you are with light, the more rewarding the resulting image. Figure 8.17 is an example of using light in an atypical way. When I was shooting in this alleyway, the end was bright and glowing. Instead of using this light as a background element or just for highlights, I used it as the focus of the image. The subject appears to disappear into the glowing light, and symbolically to the "light at the end of the tunnel."

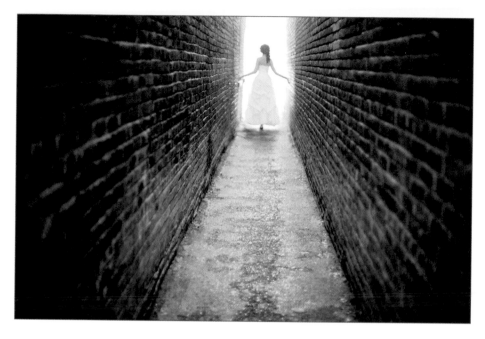

Figure 8.17

You don't need to stick with traditional lighting solutions. Here the model nearly disappears into the glowing "light at the end of the tunnel."

9

Studio Light: Complete Control

When I use studio lighting, I use it with purpose. I am either trying to create a particular creative effect or achieve a more polished or refined look. I often prefer to shoot on location because I enjoy using beautiful natural light and utilizing interesting environments. That being said, I also truly enjoy the control that the studio offers me. There, I can manage every highlight and every shadow. The studio is a blank slate, and I can build the mood and feel of the shoot from scratch.

In Figure 9.1, I was able to turn a client into a pinned butterfly. She appears delicate, fragile, and beautiful. I achieved this effect by shooting two separate frames (one close-up of real butterfly wings and one full-length shot of the subject) and merging them in Photoshop. By using similar qualities of light in each photo (softbox, direction of shadows), I was able to create a realistic-looking fantasy in the studio.

This chapter is an overview of how I utilize studio tools to create unique fashion imagery. Often I avoid the typical formulas for portrait lighting, including "main light, fill light, kicker light," because they are overused. They fail to capture the viewer's attention and do not help you stand out from the crowd. My lighting techniques break the rules, so they stand out and feel high fashion.

Figure 9.1

Shooting in the studio provides control over light and a lot of creative freedom.

TIP

There are reasons to learn the "rules" of lighting. These rules help you achieve solid visual effects and learn to "feel" the light and how it behaves. As with many artistic practices, learning the rules is a great asset in learning to break them effectively.

If you have never shot in the studio before, this chapter will *not* teach you the basics. I will not teach you how to set exposures or give you general info on light modifiers. You can read hundreds of books on that. Instead, I cover the tools and setups I utilize most frequently for fashion flair results. I've provided a variety of diagrams and tips to take your studio lighting to the next level and give your images a high-fashion feel.

Practice Makes Perfect

If practice doesn't make perfect, it at least makes you a lot better. If you are new to the studio or haven't tried more complicated lighting setups, I recommend that you practice. Find a model, and try the different setups I share in this chapter.

In college, I studied photography, but I didn't learn about how to use light modifiers and different setups in class. Instead, I developed my comfort and familiarity with the studio from spending hours every day experimenting. The more you play around with light modifiers and setups, the more you'll come to understand how light works and even develop your own lighting style.

There's No Right Answer

First and foremost, there are no right answers for lighting in fashion photography. Whatever looks right and feels right is right! In fashion photography, creating striking imagery sometimes involves breaking traditional rules.

Although I'll be providing you with formulas, no formula is the "right" formula. Every shoot depends on the mood and creative results you are trying to achieve. Don't feel that you must stick to my suggestions. Just make your shoot work and make your images look great!

> **CAUTION**
>
> For most of this chapter, I am referring to studio strobes, not to constant light setups. Later on in the chapter, I briefly describe constant lights and their benefits.

How Should I Light?

When shooting in the studio, I use a different number of lights, depending on the effect I'm trying to achieve. When I approach the studio, I break the lighting process into steps.

1. I ask myself, what is the aesthetic and general feel I'd like to achieve with my image? Do I want the image to be dark and moody? Or do I want the image to by light and airy? By examining my subject matter and intended creative goals, I can figure out the general mood I want to achieve.

2. I figure out how to achieve this lighting effect. What light modifiers do I need? If the image should have soft and airy light, perhaps I want to use a softbox and reflector boards. If it is dark and dramatic, perhaps a silver dish or beauty dish would be most appropriate. Dark and dramatic means more angular lighting and harsher shadows. Light and airy, on the other hand, means reduced shadows and more even or glowing lighting. How can I achieve the effect I want?

3. I determine how many lights I need to achieve this look. Do I need just one light on the subject, or do I want a hair light and background light, too?

Upon answering these questions, I know how to approach the studio and begin building my lighting setup. If you look back to Chapter 7, "Analyze the Light," you can see how to analyze the lighting of other photos to determine how to mimic these lighting conditions. These analysis skills often come in handy when you're trying to figure out how to achieve a certain aesthetic in a studio environment.

Some people go overboard and think that the more studio lights that are used, the more interesting the lighting will be. This is *not* true, however. Many of the most beautiful fashion images were lit with a single well-placed light. I seldom, if ever, use more than three studio lights at a time. In fact, usually I use just two lights. The following sections go into detail about my use of one, two, or three lights.

Position Your Lights

Look at Figure 9.2 to become familiar with a couple different terms that describe lighting positions. You don't need to memorize these terms, but you may find them useful in the future when you're reading descriptions of lighting setups. For example, when the light is directly in front of the subject (with the subject facing forward), the light is often called *paramount lighting*, or *butterfly lighting*. When you pull the light to a front 45-degree angle, this creates a triangle of light on the shadow side of the face and is called *Rembrandt lighting*.

> **NOTE**
>
> The effect of these lights (where the shadows fall) changes based on which direction you face the model.

If you change the orientation of the subject to the camera, you modify the way the light plays on the face. Front 45 light is not Rembrandt if the subject is turned 90 degrees to the left or right. (The light hits the face in a different way.) Think of these angles as the number of degrees off the center of the nose. In other words, 45 degrees to the right of the center of the nose is always Rembrandt in effect, no matter which way the subject is facing.

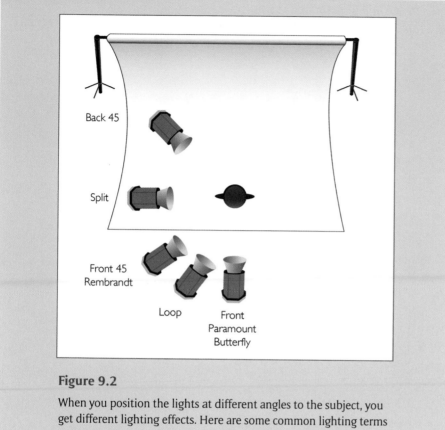

Figure 9.2

When you position the lights at different angles to the subject, you get different lighting effects. Here are some common lighting terms you may want to be familiar with.

Popular Light Modifiers

In this chapter I use a few key light modifiers repeatedly. In case you are unfamiliar with these modifiers, I have included images and a brief description in this section. Again, since this is not a beginning lighting book, I'll only briefly provide overview on these tools.

- **Softbox.** Typically shaped like a rectangle or octagon (octobox), a softbox provides soft light that wraps around the subject. You can see a softbox in Figure 9.3.

- **Beauty dish.** A softbox is a large dish-shaped modifier. Typically, the strobe points into a small reflector that bounces light back into the dish. The dishes are white or silver; I recommend white. The light resulting from this modifier is soft but crisp. It's between a softbox and a silver dish in quality of light. A typical 22-inch beauty dish can be seen in Figure 9.4.

Figure 9.3

A softbox light modifier.

Figure 9.4

A beauty dish light modifier.

- **Silver dish (parabolic dish).** A silver dish is the most basic light modifier. It looks like a wide inverted silver cone placed on the end of a strobe. The light is focused and crisp with this effect and can be used to create harsh light. Light modifiers such as barn doors and snoots are often added to the silver dish to modify its effect. A typical 8-inch silver dish can be seen in Figure 9.5. Dishes come in a variety of sizes, though 8-inch is standard.

- **Barn doors.** Barn doors are light modifiers that help you control the spill of your silver dish/strobe. They are added to your strobe or dish to modify the quality and shape of the light. Four pieces of metal allow you to control the beam of light (making it side, narrow, and so on). Barn doors are frequently used for rim light/hair light. A barn doors light modifier can be seen in Figure 9.6.

- **Strip.** A strip light is a narrow softbox that creates a soft but defined highlight. It is often used as a subtle rim light on the form. A strip light modifier is shown in Figure 9.7.

- **Snoot.** A snoot, usually attached at the end of a silver dish, helps to concentrate your light. A snoot restricts the spill of light to a narrow point and can even be used like a spot light in a scene. The light is extremely concentrated and harsh. A snoot light modifier is shown in Figure 9.8.

Figure 9.5

A silver dish light modifier.

Figure 9.6

Barn doors light modifier (attached to a silver dish).

Figure 9.7

A strip light modifier.

Figure 9.8

A snoot light modifier (attached to a silver dish).

One Light

Your main light is the light you use to shape the face and determine the general mood of the image. If this is the only light in the image, you must be aware of the resulting highlights and shadows.

For a brighter, less dramatic image, you can place your main light in front of the subject. This front-light illumination reduces shadows and gives a cleaner, more "cosmetic" look to the lighting. The more you reduce the shadows, the more clean and refined the image looks.

Figure 9.9 is an example of some cosmetic beauty lighting. I utilized just one light, a beauty dish, almost directly in front of the subject. Beauty dish light is great for subjects who have more angular or defined features. The light is crisp but not harsh. I also used three foam core fill cards: one to the left of the subject, one to her right, and one directly beneath her neck. By using fill cards, I was able to fill in and reduce all the shadows, which created a glowing and cosmetic photography feel.

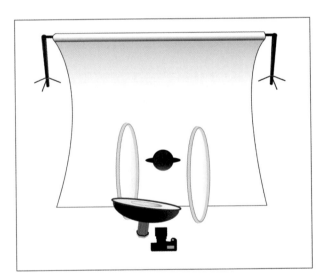

Figure 9.9

You can achieve beautiful cosmetic lighting with just a single light. Here I utilized a beauty dish with fill cards to reduce shadows and give a glowing appearance.

To create a much more dramatic approach to a single light, pull the light more toward the model's side. By placing the light at a front 45-degree angle, you can create Rembrandt lighting, as demonstrated in Figure 9.10. Carefully watch the shadows on the face until a distinct triangle of light appears. To actually see the distinct triangle, you need to use a harsher light such as a beauty dish, a silver dish, or a snoot. I used a small silver dish to create the lighting effect shown in Figure 9.10. The entire image was made with just one light placed strategically to create this beautiful triangle shape. I most often utilize this technique on men, but here you can see it creates an elegant drama for women as well.

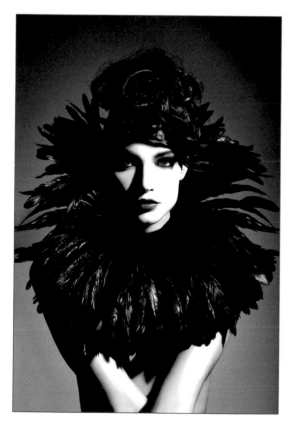

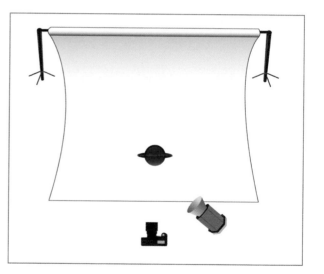

Figure 9.10

You can use a single light to create dramatic effects. Here, use of a silver dish light resulted in classical Rembrandt lighting, creating a sharp triangle of light under one eye.

> **TIP**
>
> To make the highlights and shadows even more defined in this image, I increased the contrast in Photoshop. By making the shadows darker (dragging the black point) and the highlights lighter (increasing the exposure), I ramped up the dramatic effect.

With just a single light, you can achieve vastly different and equally beautiful effects.

Two Lights

I add a second light when I need to define the subject from the background. The second light is used as either a hair light (light hitting the subject's hair or shoulders) or a background light.

I typically do not use a second light to fill in shadows. I control shadows with fill cards and the location of the main light. Instead, I use the second light to give definition to the subject.

In Figure 9.11, I added a rim light to the subject's hair and forearm to separate him from the background. Without the second light, the subject's light-colored hair would have simply blended in with the neutral gray background. The additional light gives a more polished look. The main light in this image is a single beauty dish to the front and right of the frame. The second light, a rim light on the hair, was a silver dish with barn doors to the back-right 45-degree angle to the subject.

In Figure 9.12, the second light in the image served as a background light. By illuminating the background, I created a highlight that separated the side of the face on the right from the background. Because of this highlight created by a snoot light modifier, you can see the contours of the subject's jaw, her ear, and the outlines of the Mickey hat in the photo. Without the highlight, the entire right side of the photo would have been a solid, dark mass. The main light in this image was a beauty dish to the front left of the frame. The light was at a high angle to the left, creating this dramatic Rembrandt lighting.

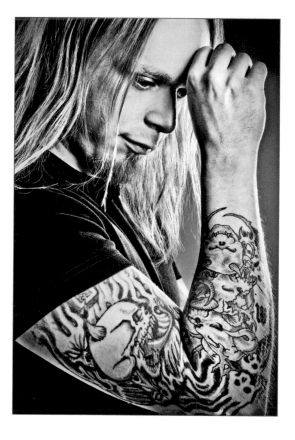

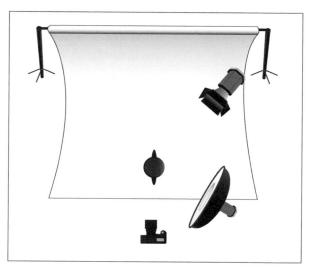

Figure 9.11

The first light used for this portrait was a beauty dish placed at a side angle to carve out the facial features. The second light was a silver dish with barn doors from a rear angle to define the hair and to create a highlight on the arm.

Three Lights

When I use three lights in an image, I am typically either trying to create a polished look or aiming for a particularly creative effect.

Adding Polish

By adding extra highlights or additional lights, you create a clean and polished look. The downside is that it can feel commercial and refined. It can also begin to feel surreal, with the more highlights you add. This is particularly true when you go beyond three lights. As you add additional lights and highlights, the image can become more of a surreal fantasy. When I want something to look polished, however, I do use three lights.

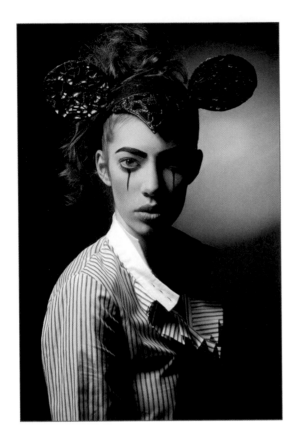

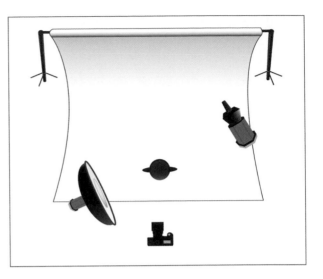

Figure 9.12

The main light of this image is a sharply angled beauty dish, creating Rembrandt lighting. The second light is a snoot (like a spotlight) pointed at a dark gray background, which gave definition to the subject's ear, her jaw, and the side of her face.

In Figure 9.13, for example, there is the main light and then a highlight on the subject's hair and on her profile. Notice how these highlights make for a clean and refined feel. One highlight gives a nice sheen and definition to the hair. The other highlight emphasizes the subject's beautiful feminine features, including her long neck, full lips, and attractive profile. You do not often see these two highlights in everyday portraiture, so here it adds a high-fashion, elegant feel.

Using Creative Effects

By using three or more lights, you can carefully place highlights and create a dramatic, creative effect. Most commonly, I utilize three lights for creating "faux high-dynamic range" (HDR). If you are a fan of travel or landscape photography, you may have attempted HDR photography, whereby you create detail in the highlights and detail in the shadows by combining multiple frames of an image at multiple exposures. In short, you extend the exposure range contained within a single image.

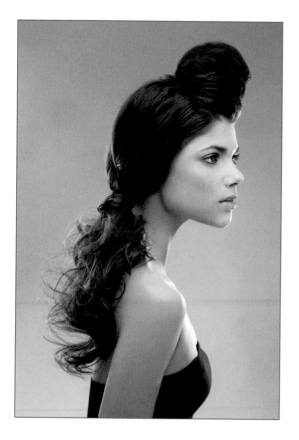

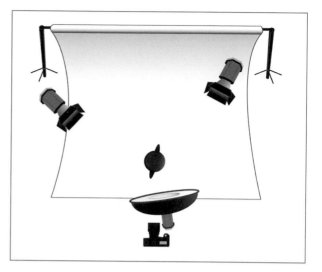

Figure 9.13

Using multiple highlights and sources of light can make an image look more polished and refined. Here, the main light is a beauty dish, with a rim light on the subject's hair and profile created by barn doors.

This technique, however, is not practical with moving subjects. All three or more exposures need to be of the same frame; if someone moves, ghosting results.

I have developed a technique for shooting in the studio and developing a similar feel to HDR photography by using multiple highlights and Photoshop effects.

Figure 9.14 is an example of this faux HDR effect. It is gritty and is a great technique for accomplishing fashion flair with men.

TIP

To make this HDR effect more apparent in Photoshop, I usually decrease the vibrance of the image (mute tones) and increase the contrast (establishing a strong black point). Utilizing tools in Photoshop can make the faux HDR even more pronounced. When necessary, I play with the Shadows and Highlights tool in Photoshop to bring out even more details in the shadows and compress the tonal range.

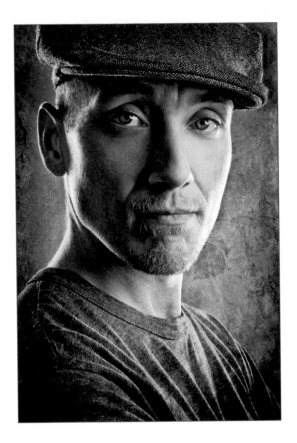

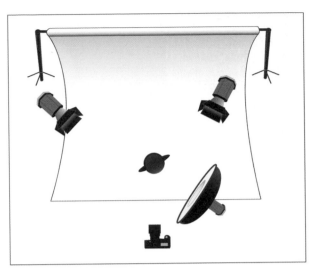

Figure 9.14

To achieve a "faux HDR" effect in the studio, I use multiple highlights as well as some post-processing techniques in Photoshop.

Broad Lighting Versus Short Lighting

Broad lighting is the most common form of lighting. It occurs when the main light is to the front of the subject and the shadows fall beside or behind the subject. Figure 9.15 is one of the purest examples of broad lighting. I placed the beauty dish to illuminate this image in the front, so shadows are minimal.

To make the lighting more dramatic, you can put the lighting to the sides of the subject and begin to see distinct shadows on the face. Pulling the light behind the subject so that the shadow side of the face is toward the camera is a technique called *short lighting*. Short lighting can help you achieve drama. It works well for men and women alike. Notice in Figure 9.16 how the shadow side of the face is toward the camera. By putting the darker side toward the camera, the image takes on a much more cinematic and dramatic feel. The shadow on the left side of the frame is softer than would be created by barn doors. It is accomplished by using a 4-foot strip light.

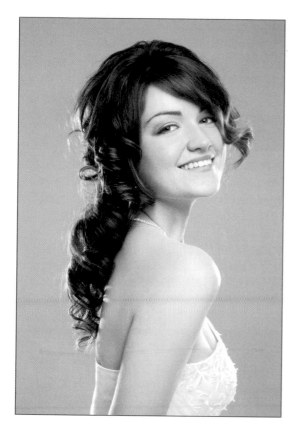

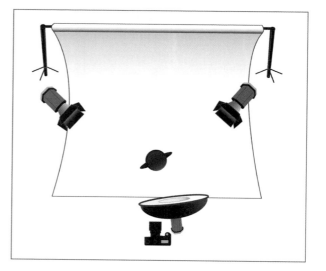

Figure 9.15

This is an example of broad lighting, with the main light source to the front of the subject and the shadow side of the subject away from the camera.

NOTE

A *strip light* is a longer, narrower softbox usually used to make softer highlights on a subject. Sometimes it serves as rim light, and other times as hair light.

TIP

People have often used short lighting as a way to slenderize heavy-set women. By utilizing shadows, you can downplay the width of the face and other features.

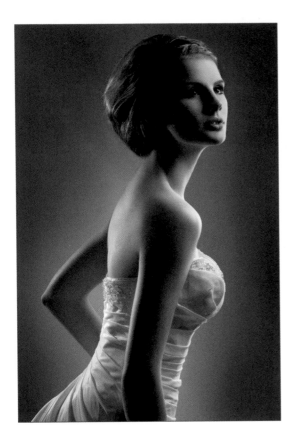

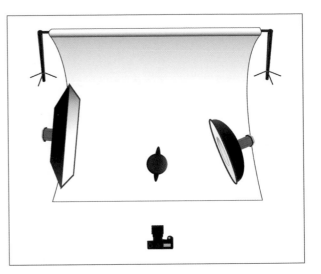

Figure 9.16

This image is an example of short lighting. By moving the main light, a beauty dish, to the back right of the frame, the shadows become more pronounced and visible to the camera.

Buying a Studio Setup

Studio lighting can be a major investment that you'll want to research. It's a balance between power output (watt seconds), price (brand), and portability (power packs, size, and so on). When you are looking for studio lighting, you need the following as a *minimum* setup if you want to achieve fashion flair lighting:

- Two strobes (two lights)
- One main light modifier: beauty dish or softbox
- One kicker light modifier: barn doors or strip light modifiers
- Fill cards (white foam core reflector boards)

Constant Light

When I am shooting in the studio, I almost always shoot with studio strobes. Another option is working with constant lights, which do not flash. As their name suggests, they are a constant source of illumination. Many companies and brands make constant lighting, although most people are unfamiliar with the options available.

> **NOTE**
>
> Constant lights are also referred to as *continuous lights*. Photographers also commonly use the term *hot lights* because in the past the most common constant lights were actually hot due to their brightness. Today, many constant light sources are cool and emit little or no heat.

Constant lights have three main benefits. First, what you see is what you get. For a beginning photographer learning to work in the studio, it is easier to visualize the effects of constant lighting because what you see through your lens is what appears in the digital file. You don't need to worry about adjusting apertures and miscellaneous power outputs. You can see exactly the lighting effects you are achieving.

Second, it is easier to achieve a narrow depth of field with constant lighting. With strobes, most packs and heads cannot dial down to a weak power unless they are top of the line. With constant light, however, you can move the lights and control them to get a narrow depth of field. This is great for creative effects because you can photograph a subject indoors whose eyes/face are in focus but whose background is distinctly out of focus. This is usually difficult to achieve with strobes.

Finally, constant lights are useful if you are interested in shooting video. If you choose to market your video capabilities (doing video profiles, interviews, and fashion videos), constant lights are a great tool to utilize.

> **NOTE**
>
> Different constant lights have different white balance. Many inexpensive constant light setups are tungsten balanced, whereas others are daylight balanced. It's one thing to consider when selecting your setup.

If you are interested in creating a unique visual aesthetic to make your images stand out from your competition, look at trying constant fluorescent tube lighting. The main company that creates these movie lights, Kino Flo, has lit just about every major movie since the early 1990s. Broncolor Kobold also makes these tube lighting solutions. Although these are fluorescent tubes, they are actually daylight or tungsten balanced and are frequently employed for unique lighting in music videos and fashion shoots.

As a fashion flair photographer, your goal is to construct images that stand out from the competition. A Kino Flo (or another fluorescent tube) might be the perfect solution for creating one-of-a-kind lighting. You can arrange these tubes in various configurations that create light unlike anything you've ever seen.

In Figure 9.17, for example, I took four tubes, tied them together into a tic-tac-toe pattern, and then shot through the center of the lens. The catchlights in the subject's eyes are fascinating, and the even lighting looks high fashion. Furthermore, because the light is weaker constant light, I could shoot at wide apertures and create a beautiful and narrow depth of field.

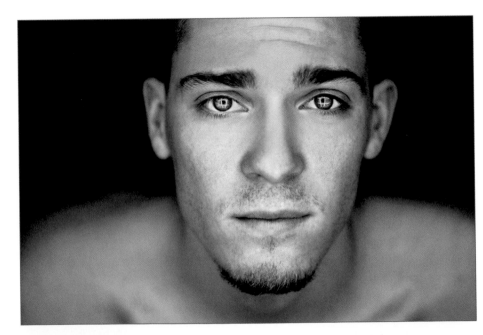

Figure 9.17

I achieved this image by arranging four Kino Flo tubes in a tic-tac-toe pattern. These constant-light fluorescent tubes allow for truly unique lighting setups that create distinct fashion flair in your imagery.

Fashion Flair Studio Diagrams

Here are a few more lighting diagrams to get your creative juices flowing for fashion photography. I don't have my lights anchored to a specific place on the floor of my studio; I move them around frequently. I often change the power of the lights, their location, and the modifiers. I don't restrict myself to formulas. The "formulas" that follow are just guidelines to inspire and guide you. Don't get caught up in power ratios and number of feet from the subject. You need to do what makes the image look "right" to you. Check out the diagrams for general configurations of lights and techniques I have employed. Whether you want something soft and polished or something dark and dramatic, you'll find some helpful guidelines by reading on.

Clean and Dramatic: Silver Dish

Using a single silver dish gives you a focused and harsh light source. In Figure 9.18, I have the subject right near the background so that the single light hits the background and casts a shadow from her body. Although the image is clean, it is also edgy with its dramatic light. To achieve this effect, I placed the silver dish

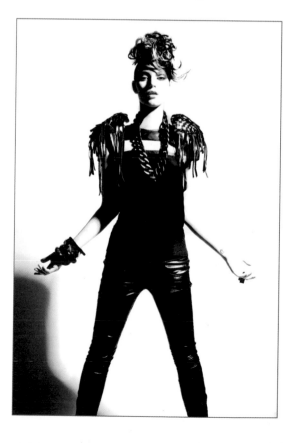

Figure 9.18

I placed the subject near the background to cast a shadow and used the high angle of the silver dish to create even more dramatic light.

(the small one that comes with most heads) a couple of feet about the subject's head. Then I watched the placement of the light carefully to ensure that I had a crisp Rembrandt lighting effect.

> **NOTE**
>
> As mentioned in Chapter 7, "Analyze the Light," soft or harsh light may be affected by the size of the light source relative to the subject. For example, if a light is closer to a subject, it appears softer and broader. The farther the source is from a subject, the harsher the light appears.

Soft and Polished: Softbox Plus Barn Doors

Figures 9.19 and 9.20 were lit by a softbox and barn doors. The biggest variable here was the position of the subject.

In Figure 9.19, I used the large softbox (3 feet by 4 feet) as the main illumination, with barn doors to create the soft highlight on the subject's arm. In this image, I turned the rim light down so it was more subtle and expanded the barn doors so that the light source was broader.

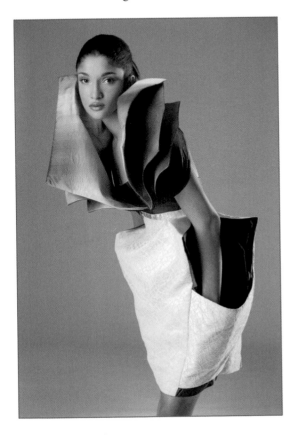

Figure 9.19

A large softbox and barn doors illuminate this image. I opened the barn doors wider so the highlight would be broader and less harsh.

> **TIP**
>
> To make a rim light crisper, narrow the opening on the barn doors and turn up the power to two f-stops above the main light. This makes the highlight more defined. To soften the highlight, open the barn doors and reduce the power.

In Figure 9.20, I turned the subject away from the main light and closed the barn doors to create a more focused highlight. I was careful about how the highlight illuminated the face. This image becomes more dramatic because the rim light plays a prominent role in defining the face.

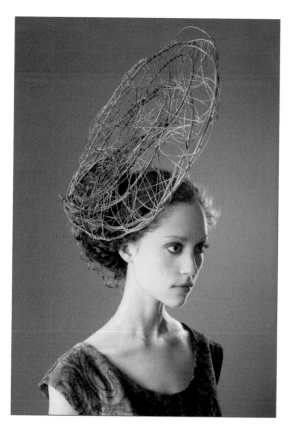

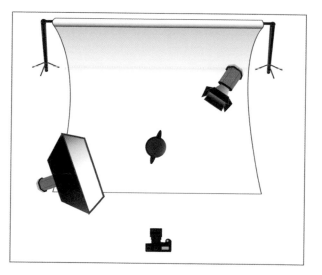

Figure 9.20

By moving the subject away from the main light, the rim light becomes more important in the lighting. I narrowed the barn doors (for rim light) to focus the beam of light.

Crisp and Commercial: Beauty Dish (Plus Illuminated Background)

A beauty dish is my favorite lighting tool. I use it for a majority of the studio work I do. It is also frequently employed in catalogue photography. The setup utilized in Figure 9.21 is typical of a clean, commercial image. I have used a

single beauty dish (about head height with the model) and two strobes to illuminate the background and make it white. The light is simple and crisp and works for both men and women.

> **TIP**
>
> In this image, I added the motion blur in Photoshop. I used Filter, Blur, Motion Blur and then erased the blur from the face and the body, while keeping the feeling of motion to the left of the subject.

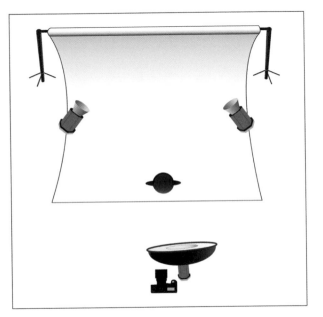

Figure 9.21

A single beauty dish can be a great source of illumination. Here the beauty dish is the main light (at paramount position), with two strobes illuminating the white background.

Elegant and Surreal: Beauty Dish and Flare

As I mentioned before, sometimes breaking the rules is the best way to create striking imagery. In Figure 9.22, I have broken several "rules" by blowing out the highlights and creating lens flare. Although these are usually things to avoid, in this instance it has given the image a beautiful and surreal appearance. To achieve this effect, place your subject 2 to 4 feet away from a white background. Then illuminate the background with a strobe at full power. This blows out the background and bounces back on the subject and into the camera, creating flare.

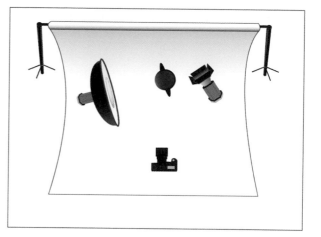

Figure 9.22

If you place the subject close to a white background and then illuminate that background, you can create glowing reflections and lens flare. Here a beauty dish was the key light for the face, and barn doors at full power lit the white background.

The main light is a beauty dish above the subject's head and to the left of the frame (helps define the face). I also utilized a fill card under the chest to eliminate even more shadows. This lighting feels airy and surreal.

> **TIP**
>
> You need to increase the contrast and adjust the saturation of the image in Photoshop when you are finished. By creating lens flare, you reduce the contrast and make the image muddier, which you can fix in Camera Raw or Photoshop.

Dramatic Short Light: Barn Doors Plus Strip Light

Shadows help make an image dramatic. In this case, the shadows and highlights seem theatrical. In Figure 9.23, both lights that illuminate the subject are in back-45 positions, leaving the face mostly in shadow. The light that illuminates the subject's face on the left was barn doors (hence the more crisp, focused light) placed at a back-side angle. The light illuminating her neck (softer highlight) was a narrow strip light placed to the back right of the frame.

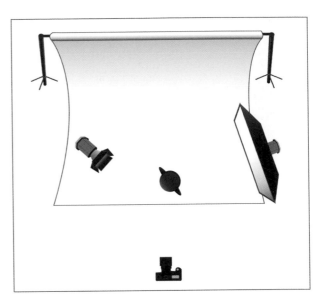

Figure 9.23

This image was illuminated by lights that cast a shadow on the majority of the face: barn doors (left) and a strip light softbox (right).

Polished but Dramatic: Barn Doors and Beauty Dish

When I want an image to look more polished and clean, I carefully place highlights on it. In Figure 9.24, I utilized three lights. The main light was a beauty dish to shape the face. By placing it at a far left angle, I was able to carve out the features of the face by utilizing a shadow to show the jaw line and cheek bones. I then used two barn doors to create highlights on the face. The highlight on the left is subtle (because it is on the highlight side of the face); it simply adds polish to the image. The highlight on the right is more pronounced and gives definition between the subject (her hair in particular) and the background.

> **TIP**
>
> Figures 9.23 and 9.24 are similar. They have a similar pose and utilize two rim lights. Because I wanted to more clearly show the face in Figure 9.24, I added a beauty dish as a main light. When you find a pose or lighting setup that works well for you, don't be afraid to utilize it time and again. This can become a foolproof tool and even help you develop your visual style.

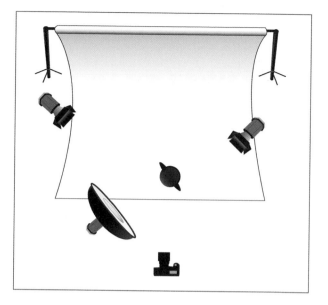

Figure 9.24

I used the beauty dish at a more dramatic angle to carve out the features of the subject's face. I then utilized barn doors to add two extra highlights to define and refine the image.

Studio Backgrounds

In the world of fashion photography, most studio backgrounds are neutral. Typically, a white, gray, or black seamless (paper) background is utilized. This is not a rule by any means, but it's usually the approach I take as well. All but one of the images in this chapter have a neutral background. A neutral background keeps the focus on the subject and the composition, lighting, or styling of the image. If I do use a brightly colored studio background or scene, it is to enhance the goals of my image. Feel free to use any background that suits your style, but remember that less is often more. For portraits, people often utilize brown tone or neutral muslins. You can add texture and depth to a background without detracting from the subject.

10

Flash on Location: Taking Control

I'll start this chapter by saying that I usually shoot either completely with studio light (in the studio) or completely with ambient light (on location). For fashion flair, I shoot flash or studio on location in limited situations and for specific reasons. At the same time, however, I know that some fashion flair photographers shoot most of their work studio/flash on location because they have developed it as part of their creative style.

I could write an entire book just about shooting flash and studio on location. In fact, I teach an entire two-day workshop just on this topic. If you have never shot with studio or flash on location, you'll want to read up or watch videos on how to accomplish these techniques. This chapter is simply an overview of how to achieve fashion aesthetic using these tools. It's not a basic how-to.

Using studio on location helps you gain more control over a scene and shape the scene to fit your creative goals.

NOTE

Many words are used interchangeably when discussing off-camera flash and studio lighting. Flash, strobes, speedlites, and speedlights are different terms used for flash, often interchangeably. Speedlights or speedlites typically refer to off-camera portable flashes. This is what you think of for hand-held flash. Strobes (usually) refer to studio heads and can be self-contained units (monolights) or head and power pack combinations.

Why (and How) to Shoot Flash or Studio on Location

My decision to rarely shoot flash or studio on location has nothing to do with its difficulty or the inconvenience of lugging extra equipment. Instead, I use flash on location selectively so I can achieve certain creative looks or practical purposes.

Some of the reasons that you would shoot flash or studio on location are spelled out in the next sections.

Supplement Ambient Light

Sometimes in a specific location there is simply not enough light to shoot, or the ambient light is of poor quality. In this situation, I use artificial light to reshape the scene and capture the moment. A scene might have beautiful light, but it just wouldn't be flattering to the subjects or correctly illuminate them (especially with larger groups). This is another instance where artificial light on location would be appropriate.

For the engagement portrait in Figure 10.1, we wanted to shoot on location at night to create a more romantic ambiance. This location, however, was poorly lit. We liked the statue in the background (shot in midtown Manhattan) and the starburst element (the center of the statue) that we could work into our composition. Although the statue was dimly lit, there was little or no illumination on the subjects. In this instance, flash becomes essential to make the image.

Figure 10.1

This engagement scene was lit with two off-camera flashes without light modifiers. With my camera on aperture priority, I used a wireless transmitter to trigger the two Canon 580EX flashes.

For this image I utilized two Canon 580EX flashes, both off-camera. I used a wireless transmitter to make the flashes fire. I placed the first flash (my main light) on the ground at a front 45-degree angle to my subjects. This allowed me to illuminate the scene but also create shaping light (by having a more dramatic angle). I placed my second flash at a back angle to the left of the frame. This is the light creating the highlight on the woman's legs.

I did not utilize any particular lighting formulas. I set my camera on aperture priority and used exposure compensation to capture the correct ambient exposure. From there, I used my main flash on full power (ETTL) to illuminate the subjects and adjust the power of the secondary flash up and down (eventually to +1/3) until I got the correct highlight strength.

This is nearly what the image looked right after I took it. In Photoshop, I did add a slight vignette and removed some distracting background elements. I also decreased the vibrance on the subject's skin to give a muted tone.

By shooting flash on location, we give the scene a cinematic feel. Fashion is about fantasy, and this image has an air of perfection and fantasy to it because of the lighting and composition. Women want their proposal to feel like it was taken from a movie, and this image achieves that.

> **NOTE**
>
> I shot this image with a Canon 5D and a 50mm 1.4 lens. The exposure was 1/20 sec, f/1.4 at ISO 100. These settings gave me the narrow depth of field and the motion blur in the water behind the couple (created by a longer exposure). The flash was the only illumination on the subjects, so the longer exposure was not a problem and didn't create motion blur on them.

Figure 10.2 is another example where I supplement ambient light with studio strobes. Looking at this image, you cannot tell if it was shot using 100 percent natural light or by using artificial light. In this instance, the highlight on the subject's face was indeed studio lighting. I liked the dramatic light and composition of the scene, but if I stood the subject in the sunlight I didn't like its harsh qualities, and I couldn't pose her in the correct composition. To remedy this I used a beauty dish just out of frame (left-hand side of the image) to illuminate the far side of her face. I have more control over the scene when I am selecting all the highlights and the direction of the light.

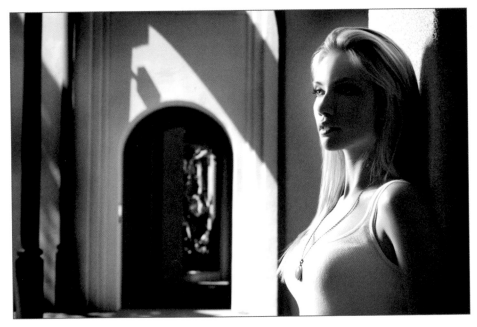

Figure 10.2

This image was lit with a studio strobe with beauty dish light modifier. I balanced the exposure of the natural light and used the strobe to shape the highlights on the woman's face.

Create Drama

Because you are able to control the angles and output of light, you are able to create dramatic and almost cinematic-looking scenes using artificial light on location. Like lighting on a stage, you can create an intense mood. This is the most common reason I shoot studio or flash on location.

In Figure 10.3, I have created drama by using dramatic angles of light and by underexposing the ambient light. This image was from a high school senior portrait session. The student, who was planning to be a music major in college, wanted theatrical images that showed his passion for music and made him look like a professional.

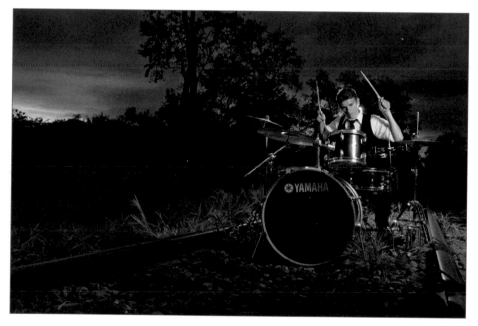

Figure 10.3

In this image, I underexposed the ambient light by nearly three stops and used two off-camera flashes (one with a softbox attachment) to illuminate the subject and create drama.

To achieve the element of theatre and professionalism for this picture, we went on location and utilized dramatic light. The subject selected some old train tracks where he wanted to set up and shoot the scene. If I had shot this image with ambient light, the effect would have been nowhere near as dramatic. The colors of the background would not have been as vibrant, and his actions wouldn't have stood out in freeze motion. Figure 10.4 gives you a behind-the-scenes view of this shoot. When doing a "normal" exposure, the scene completely loses its mystery and drama. This behind-the-scenes shots was taken at the same time as the more dramatic final image.

Figure 10.4

To get the effect I wanted in Figure 10.3, I utilized one flash (with softbox) as the main light and another flash as the rim light (from behind). By underexposing the general scene, I was able to create a much moodier image.

I utilized two off-camera Canon 580EX flashes for this image. I placed the first light (main light) at a front 45-degree angle to the subject, creating almost Rembrandt lighting on his face. This strobe was on a stand with a softbox light modifier attached, as seen in Figure 10.4. I used this light modifier because I wanted the light to be a bit more broad (illuminate more of the scene) but not be as harsh as the backlight. I placed the second flash just a few feet behind the subject so that it would create a beautiful rim light and dramatic highlight behind him. Because the light was barely visible over his shoulder, it created a starburst effect that added to the drama. When I was shooting, the subject's sister would duck out of the way while holding the flash in place.

When setting my exposure, I put my camera to manual and set my exposure based on the ambient light to start with. I wanted the ambient light to be darker and more dramatic, so I underexposed almost three stops of light. I left the flashes, however, at full power so that they correctly exposed the image. I used ETTL flash and a wireless transmitter to fire the two flashes.

This is a bit of the magic of photography. The beautiful sunset skin was not visible to the naked eye. Only after underexposing the image did the textures and colors of the sky begin to reveal themselves.

Again, the shot shown in Figure 10.3 was nearly the in-camera version. In Photoshop, I did darken the sky a bit more and increase the saturation in the color of the sunset.

> **NOTE**
>
> I captured this image with a Canon 7D and a 16–35mm lens (at 16mm). The exposure was 1/125 second, f/5.6 at ISO 100.

Stop Action

In some situations the light is nice and flattering but simply insufficient to capture action or movement. Here you can use artificial light to capture the movement and perhaps still balance with ambient light. Furthermore, if you want motion blur in the background, you can use a slow shutter speed to blur the background. While blurring the background, you use a flash to stop the motion of your subjects. This is another creative effect I utilize often to convey energy and movement in a still frame.

Figure 10.5 conveys the feeling of movement and excitement in the big city. By using a slow shutter speed (approx 1/8 sec in this image) and moving the camera during the exposure, I was able to create the blurred lights of the background. I was able to stop action on the subjects by utilizing an off-camera flash to illuminate the couple.

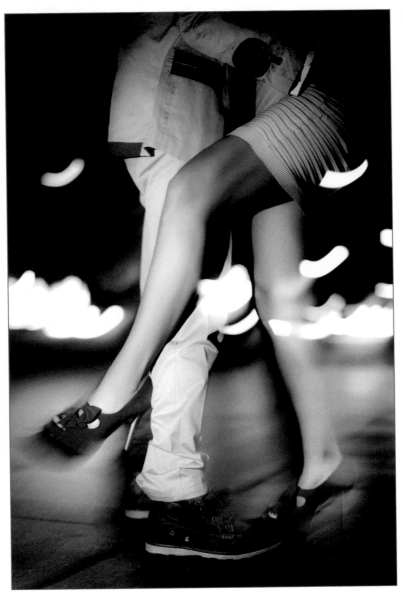

Figure 10.5

Here I used a long exposure to blur the lights in the background, but I utilized the flash to stop the motion of the subjects. This technique creates a lot of energy and feeling of movement in a still frame.

Create a Polished, Commercial Look

Bringing artificial light into a scene sometimes gives a professional feeling to an image by default. Because you do not typically see well-lit studio-on-location images, it already feels more polished and professional.

For the scene in Figure 10.6, I liked the light as it filtered through the beautiful trees, but it simply wasn't directional enough. The main light on the scene was bland and had no distinct direction or mood, just some pretty highlights.

To remedy this, I utilized studio on location. I strategically placed the client so that her hair was catching some of the sunlight. These filtered highlights would act as a natural "kicker light" to distinguish the client from the background and add a glowing quality. From there I utilized a single beauty dish on a studio strobe to act as the main light of the scene.

> **NOTE**
>
> To achieve the appropriate exposure for this frame, I set my camera on manual and achieved an exposure of f/8 and 1/40 second. For a balanced exposure, I would have set my flash to f/8. Instead, I adjusted my studio strobe to read f/8 but decreased the shutter speed to 1/80 so that the background would be one stop darker than the subject.

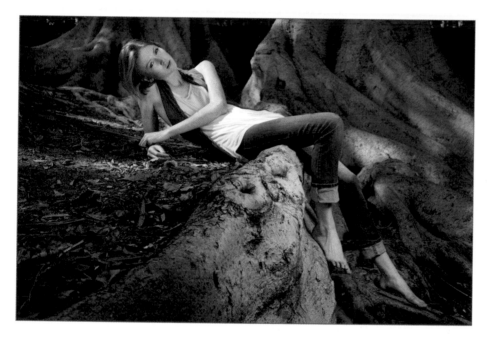

Figure 10.6

Here I illuminated the scene by a single beauty dish, which gave the image a more concrete, commercial feel.

> **NOTE**
>
> I took this image with a Canon 5D and a 50mm 1.4 lens. The exposure was 1/80 second, f/8 at ISO 100. By shooting at 1/80 second, I darkened the ambient light so that only the bright highlights of the sun would show through in the final exposure (seen on the subject's hair and in patches on the leaves).

Achieve Creative or Stylistic Effect

There is a certain visual aesthetic created by using flash and strobes on location that you simply cannot achieve with natural light. Some people use flash on location to create a certain stylistic look that sets them apart from others.

Figure 10.7 is one example of this stylistic look. I really enjoy using this "studio light on location" technique because it feels polished and high end. I've seen this technique utilized in several top fashion magazines because of the drama and surrealism it creates.

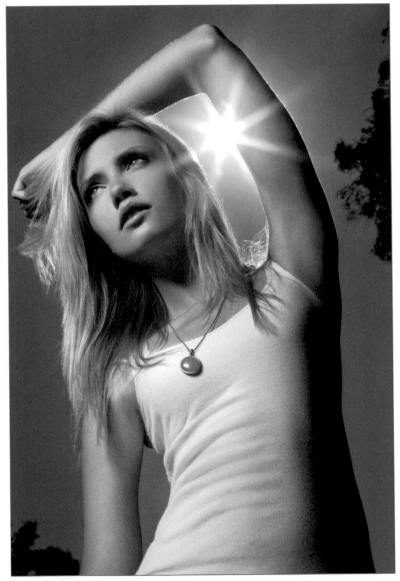

Figure 10.7

By turning the studio strobe to f/22 (full power for this strobe), I was able to completely over-power the ambient light of the scene, making the sky darker and a rich blue.

You can achieve this look using studio lights (in this case a beauty dish) on location, typically turned to full power—in this case f/22. You must use higher-powered studio lights (not just a flash) on location because you need to have enough power output to completely overpower the ambient light and base your exposure completely on the strobe.

By overpowering ambient light, you can close down your aperture, in this photo to f/22. This accomplishes two things. First, by shooting at f/22, you are able to create the starburst in the sun, as seen in Figure 10.7. If I had shot at an f/8 or f/11, you would not have this same creative effect. The starburst shape is created from small apertures. Second, by shooting at f/22, you can have a darker ambient exposure (underexpose the natural light) to give you this rich blue in the sky and darkness in the trees. I made my ambient exposure as dark as possible by shooting at my max sync speed (1/250 sec) and smallest achievable aperture (f/22).

> **NOTE**
>
> Sync speed refers to the fastest shutter speed your camera can shoot flash with. At a faster shutter speed, you see black shutter bars in your image because the camera and flash did not synchronize correctly. This value varies, and for many digital cameras the sync speed is 1/250 second when working with studio strobes (and higher when working with flashes/speedlights).

As a creative photographer, you can use flash on location to develop a unique style if it fulfills your creative needs.

Flash Versus Studio Strobes

Sometimes you need to bring your studio strobes on location, and other times your off-camera flash will suffice. But how do you decide? First let's briefly discuss some basic differences between flash and studio strobes.

Off-Camera Flash

Remember that a flash is a portable lighting unit that can be attached to the camera or used off-camera for illumination. A flash is typically powered by AA batteries, or you can use a portable power pack as a source of more continuous power.

ETTL Flash (pretty much any new flash) can communicate directly from camera to flash to determine exposure and flash output. This makes calculating exposures quick and easy.

Pros. These are portable, less expensive than studio strobes, and have a renewable power source (AA batteries, portable power packs).

Cons. These have a weaker power output, a slower recycle time, and less control overall than you can achieve with studio strobes (strobes with power packs in particular).

NOTE

Canon uses the spelling *speedlite*, whereas Nikon spells it *speedlight*.

Studio Strobes

These are the lights you typically envision in a studio, and they come in two varieties, including monolights and the power pack head systems. Monolights require no external power pack and can simply plug into the wall. All the controls are on the head. Power pack head systems require a power pack to control the output and exposure of the light. These studio strobes do not, however, need to stay in the studio. You can take them on location for a striking professional look.

Pros. These have a higher power output, a much faster recycle time, and more light modifiers than ETTL flashes.

Cons. They are much more expensive and difficult to transport than ETTL flashes.

NOTE

Strobe can also refer to off-camera flash, though this is not typical.

When to Use Studio Strobe Versus Off-Camera Flash

There are two main factors to consider when deciding between a flash and on-location studio light.

First, how much power output do you need? If you are trying to overpower sunlight or must completely illuminate a large room, you must use studio strobes. They have much stronger power outputs and can achieve more illumination.

Second, how portable or compact must your lighting be? If you must fit your lights into a small space like an office or must travel a greater distance, flashes are much more practical. Studio strobe are generally heavy and bulky—an extremely important consideration for the practical or traveling photographer.

> **NOTE**
>
> Another important thing to consider is your power source. Flashes require only AA batteries or a portable battery pack. On the other hand, you must plug studio strobes into the wall or purchase specialized portable battery packs. Every lighting company has some form of portable battery pack, but many are quite pricey. A reasonably priced pack (for monolights only) is the Vagabond pack by Paul C. Buff.

Light Modifiers for Off-Camera Flash

Nowadays you can buy a variety of light modifiers to adjust the quality of light coming out of your flash head. You can buy a dome to bounce and reflect light to create a softer effect. You can use a speedlight and umbrella setup for studio-like qualities. You can even buy an attachment that simulates beauty dish lighting.

My favorite technique is a combination of softbox attachment and bare speed-light. Many softbox setups allow your flash to shoot through an opening into a softbox, giving softer light and more wrapping qualities. I use this as my main light and use a regular (unmodified) flash as a kicker light to define the subject from the background. This is the setup I utilized in the drummer shoot from this chapter.

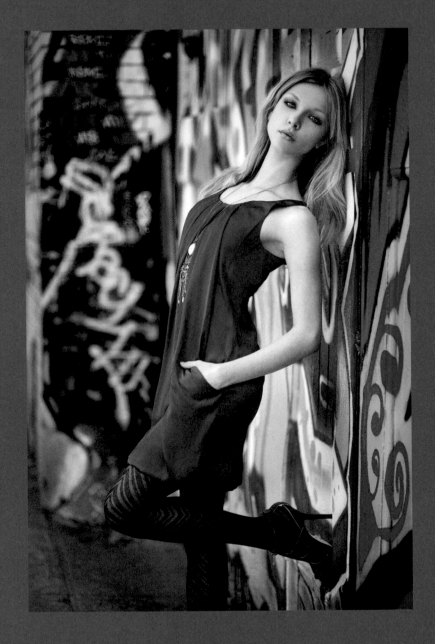

Part IV

The Power of Post: Photoshop and Other Tools

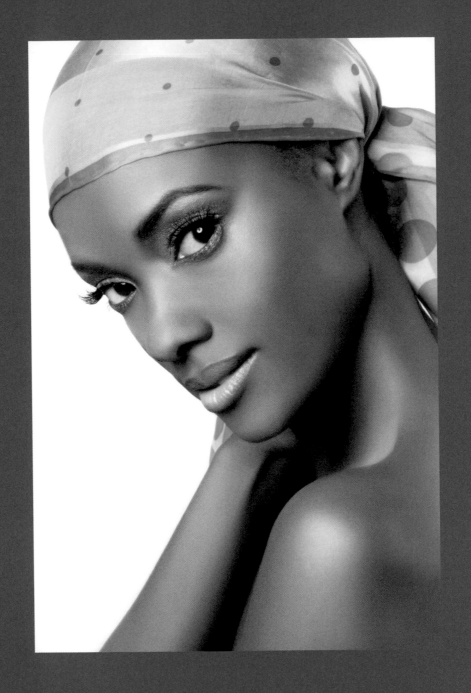

11

Retouching for Perfection

\mathcal{R}etouching and creative effects are the final steps in the creative process. With typical portraiture, it may be acceptable to give clients a final file that has been corrected for exposure, white balance, and nothing else. For fashion flair, however, retouching and creative effects are essential ingredients to the final product.

Every final image that goes out of my hands to a client has been retouched to suit the client's needs and to express my creative vision. Your prints and files represent your business. They are your promo cards and portfolio when they are shown to other potential clients. They need to be the best work you can produce; retouching often helps you achieve this.

For this reason, I do not offer unretouched files or prints for purchase. Retouching is built into my price and is an essential part of my fashion flair style. You may take a different approach to the way you build retouching into your business, but either way it is essential that work be thoroughly retouched.

CAUTION

Having an image "thoroughly retouched" does not mean that the retouch is obvious. On the contrary, the retouch should be subtle and in most cases unnoticeable. Ideally, the retouch should make the person look more vibrant and her best (not 15 years younger or 20 pounds lighter unless that was requested).

In Figure 11.1, you see a before and after series of a retouched portrait. The original image is okay, but the polish of the retouch makes a substantial difference. The retouch really allows the subject's beauty to shine through. I don't typically need to do such an intense retouch, but because this was a beauty image, I wanted the skin to be smooth and flawless. In this image I have adjusted levels, used the Patch tool, Clone Stamp tool, Spot Healing Brush tool, and Skin Softener tool—all discussed in the pages to follow. I have also utilized the Liquify tool for the subject's neck and shoulder.

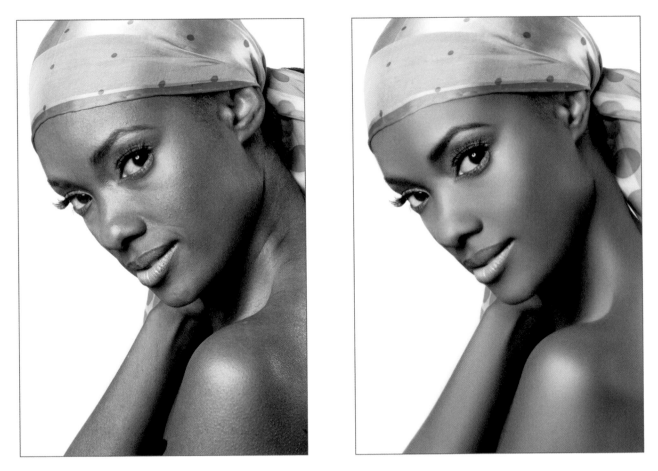

Figure 11.1

Skin retouching can make a substantial difference in the final result of the image. The retouch allows the beauty to shine through so that the viewer doesn't concentrate on the textures of the subject's skin, but on her beautiful features and expression.

> **NOTE**
>
> *Post-processing* is whatever you do to a file in the computer to modify or improve it. Adjusting exposure, removing blemishes, and adding a special effect are forms of post-processing.

> **CAUTION**
>
> If you are extremely new to Photoshop, this chapter may be a bit too advanced. Many of these techniques are based on a basic knowledge of the functions of Photoshop, such as making selections, feathering selections, and using layers. If are not comfortable with the basics of Photoshop, try to improve your comfort level by watching online tutorials, attending workshops, or reading up on the topic in books or online.

Check out my blog at http://blog.lindsayadlerphotography.com for some basic retouching tips and videos. Click the Blog tab at the top, and then on the right side, under Categories, click Tutorials and Video.

My Workflow

You need to have a method of handling and organizing your images the same way each time you bring them onto your computer or hard drive. This is your image workflow. This workflow should ensure that files are correctly named, organized, and easy to find in the future. Furthermore, your workflow should ensure that your files are backed up to multiple locations to prevent losing your images due to hard drive failure, image corruption, or other types of unexpected events.

I have often taught 2- and even 4-hour courses on the concepts of organization in the digital age and options available for managing your image workflow. If you go to my blog (http://blog.lindsayadlerphotography.com), you can find the PDF of my PowerPoint slides for these classes. Go to the Workshops tab and then select Class Notes to find a wide range of presentations. If you have a question about my recommended workflow, this presentation will likely answer it!

Speaking purely of managing the organization of digital files, I prefer Lightroom to other studio management and image management programs. Lightroom is the tool I use to import my files, add key metadata, catalog them, and give a live image review session to clients. Figure 11.2 is a screen shot of my Lightroom gallery view during an editing session. Here I have edited my selections from the shoot to the top images rated three stars. From there I will continue to narrow my favorites to be edited in Photoshop.

Figure 11.2

Lightroom is the workflow management software I use to make overall changes to the images and handle image selection.

What follows is an extremely brief overview of my workflow. To learn more about the process, visit my Web site.

1. Import the images into Lightroom. Rename and add metadata and keywords upon import.

2. Make the necessary batch adjustments to overall exposure and images' white balance.

3. Edit to select my favorite images using Survey mode, Compare mode, and star ratings.

4. Make additional selective adjustments to the top images in Lightroom. I tweak the exposure, reduce the noise, add vignettes, and correct the white balance.

5. Optionally, test the developed presets to preview the creative effects.

6. Open the images in Photoshop.

7. Remove large blemishes.

8. Add Skin Softening plug-in for portraiture.

9. Whiten eyes and teeth.

10. Use the Liquify tool to reshape the body.

11. Add creative effects using a plug-in or by hand.

12. Save and reimport the images into Lightroom.

13. Use ChronoSync to back up files to another drive.

Every photographer I talk to has a different system for organizing and managing files. The important thing is that all the successful photographers have a consistent system of organizing and archiving.

TIP

ChronoSync is a program that allows you to automatically back up your files to another hard drive or server with the click of a button. You can schedule backups, mirror drives, and much more.

A Touch of Perfection

Here is an overview of my retouching and basic editing process. I could write an entire book just on the process of editing your images and adding creative adjustments. For now, though, here are some essentials you must be aware of when doing basic retouching and image correction.

Optimization of Your Images

When you open your image to begin editing, start by making overall adjustments to the entire image. Your first concerns are correcting exposure and white balance. You need to correct these aspects of your image before moving on to retouching skin or making any creative adjustments.

First, adjust your general exposure, ideally in Adobe Camera RAW, Lightroom, or Aperture. In this base exposure, attempt to maintain detail in the important highlights of the image, such as skin tone highlights. If your computer monitor is correctly calibrated, you can judge the exposure from the histogram in camera RAW accompanied with the appearance of the image onscreen.

In Figure 11.3, I used the Develop module in Lightroom 3 to adjust the image's exposure, recovery (to return detail to the highlights), and saturation. Without adjusting the recovery, I would lose all detail in the white of the dress, which is typically undesirable when working on wedding photography. I'll complete any of my more advanced adjustments (such as skin softening) in Photoshop and discuss them later. It is essential to get these basic adjustments taken care of up front because they affect the retouching and adjusting of the rest of the image.

TIP

In Lightroom and Adobe Camera RAW, hold the Alt key (or Option key on a Mac) while making adjustments to recovery. This creates a mask on your image that allows you to see when detail returns to bright areas of the image. (The mask will remain on blown-out, overexposed areas.) This helps you not just judge detail and exposure "by eye" but by the numbers.

Figure 11.3

Your first step in editing is handling basic image optimization, such as correcting exposure, recovery, and white balance, as done in this image in Lightroom's Develop module.

Adobe Camera RAW (ACR) is conversion software built into Photoshop that allows you to make a variety of adjustments to an original RAW file. Because you are working with RAW data (like an undeveloped negative), you can make more drastic adjustments to exposure and white balance without damaging the pixels.

> **NOTE**
>
> Calibrating your monitor is an important part of your post-processing. If your screen isn't accurately representing your images, you'll make adjustments incorrectly. Numerous calibration tools, including ColorMunki, X-Rite, and Colorvision Spyder, can do the job. It is common for professional photography organizations or photo clubs to purchase a calibration tool for their group and share it between members to save on cost.

In fashion photography, an image's exposure, white balance, and effects are not a science. Post-processing is an art. If you are new to photography, stick to the science so that you can learn how to create a correctly exposed, correctly colored image. But if you have mastered these basic techniques, it may be time to embrace the mood of fashion photography and try a different exposure or effect.

Generally, I get the image looking "correct" and then experiment with a variety of adjustments after the fact, including blowing out the highlights or adding purposeful color casts.

Typically when setting the exposure, you try not to lose detail in the highlights (sometimes called *blowing out the highlights*). This happens when pixels exceed 255 on the 0 to 255 scale of pixel values. Going "by the numbers" allows you to retain highlight detail, but this may not have been the creative effect you wanted to achieve. Sometimes rules can be broken.

> **NOTE**
>
> Don't be afraid to blow out highlights when it's to achieve a specific creative goal. Post-processing is the first place where fashion photography (and fashion flair) differs from traditional portraits. When adjusting your exposure, it might be correct to completely overexpose the highlights for creative effect. If you look through the pages of the biggest fashion magazines, you will see blown-out highlights everywhere, but always on purpose. Figure 11.4, for example, has lost most of the detail in the highlights and shadows. The skin looks smooth and overexposed, whereas the shadows are solid black. By traditional photography standards this is "incorrect"; however, this is exactly the effect I wanted on this image, so it's completely acceptable.

Figure 11.4

In this image I have purposefully overexposed the skin and darkened the shadows for a dramatic glowing effect in this fashion portrait.

> **NOTE**
>
> Nowadays there is absolutely no reason *not* to be shooting RAW. I've been shooting RAW for every shoot for the past six or seven years. Although you may be saving some disk space shooting in the smaller jpg format, you are certainly losing a great deal of quality. RAW allows you more flexibility to correct exposure, white balance, and reduce noise. It's simply the best option. If you aren't shooting RAW, start now.

Once you've adjusted the basics, you are ready to open images in Photoshop for retouching and creative effects.

> **NOTE**
>
> Various plug-ins for Lightroom and Aperture allow you to do retouching (skin softening) as well as creative effects. Some people try to get as much done as possible in Lightroom. I apply special effects and retouching within Photoshop, though. I have a lot more control and flexibility there because I can utilize layer masks, opacity, and additional selective controls.

Perfect Skin

The next step in my process is to remove major problem areas on the skin and face. I remove major blemishes, scars, and other undesired discolorations on the skin. The main tools I use to achieve this are the Patch tool and Spot Healing Brush. Let's first discuss a couple of basic retouching tools and their differences. I'll use the image referenced before to show how and where to use these tools.

> **NOTE**
>
> If you visit my Web site, YouTube, or Vimeo pages, you can find some how-to retouching videos that might be of use. Retouching is easier to watch and learn than read and learn.

Spot Healing Brush

This tool (see Figure 11.5) is best for removing single spot problem areas such as pimples or large pores. The Spot Healing Brush tool is extremely easy to use. Resize your brush so it covers the entire blemish. Then simply click, and the blemish is removed. The Spot Healing Brush works by sampling the pixels directly around the selected area. It takes an average of these pixels and replaces the blemish based on the estimation of what should replace it. When you use the Spot Healing Brush, the edges are automatically blended for a smooth retouch transition.

> **CAUTION**
>
> This tool does not work well near sharp edges because it samples the pixels near this edge and incorrectly replaces and blends them.

> **TIP**
>
> In Photoshop CS5 and newer, you may want to adjust your Spot Healing Brush so that it uses new content-aware technology available in this version. After you have selected the Spot Healing Brush, a variety of options appear in the toolbar under the menus of Photoshop. You can set the type of the brush to Content-Aware to get the best results for this tool.

Patch Tool

The Patch tool (see Figure 11.6) is my favorite retouching tool. It's great for larger blemishes or problem areas on the skin. This tool retains the lighting and texture to the skin while seamlessly blending in with surrounding skin areas.

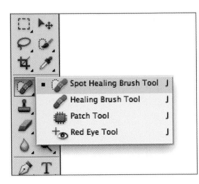

Figure 11.5

Spot Healing Brush tool.

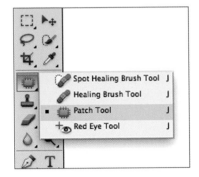

Figure 11.6

Patch tool.

Using the Patch tool, select the blemish area on the skin. From there, drag the selection to an area of skin you want to replace the original blemish with. Photoshop actually previews the skin you are selecting so you can be sure it will look right. When you let go of the selection, Photoshop replaces the original pixels with the new pixels you have selected and blends the edges so that the transition is seamless.

This tool works great for stray hairs, large scars, rough patches of skin, and any major blemish on someone's face or body. If a blemish is any more complex than just a small spot, this is my tool of choice.

> **TIP**
>
> The Spot Healing Brush set on Content-Aware is also a great tool for removing stray hairs without the retouch being too obvious.

> **TIP**
>
> The Patch tool is great if you want to eliminate a large, defined wrinkle such as a smile line or forehead wrinkle. If you want a little of the wrinkle to show through, you can always reduce the opacity on your layer to let some of the original texture/wrinkle show.

Clone Stamp

I think of the Clone Stamp tool (see Figure 11.7) as the "copy and paste" of pixels in Photoshop. With this retouching tool, you set a sample point of where to copy pixels from by holding the Alt or Option key and clicking. This sets the source of the pixels. When you click again, you are basically pasting these pixels in a new area.

You have various tools to control the Clone Stamp. The size of the brush is obvious. Next, you have the edge hardness. Basically, this is the way you control the blend of the edge. The harder the edge, the crisper the lines on the outside of the clone appear. A hard edge is usually not desirable because you can see where you have cloned to. I often pick something around the 25 percent hardness range.

Next, you have the opacity adjustment to control the Clone Stamp. The lower the opacity, the more transparent your brush will be. This allows the original layer to show through.

I use the Clone Stamp in Photoshop to reduce bags under the eyes or smooth out large, rough patches of skin. When I work, I have a stamp opacity between 20 and 30 percent so that the bottom layers still show through, as seen in the settings of Figure 11.8.

Figure 11.7

Clone Stamp.

Figure 11.8

The Clone Stamp tool has a variety of controls, including opacity and edge hardness.

CAUTION

With retouching, I avoid using the Clone Stamp tool too much because it often removes skin texture. When you layer skin textures upon skin textures using the Clone Stamp tool, the skin becomes smooth and surreal. Sometimes this is exactly what I am trying to achieve in a fashion image, but other times it just gives that lifeless and plastic retouch that you want to avoid.

> **TIP**
>
> When using the Clone Stamp tool, move your sample point around a lot. If you keep selecting pixels from the same area of the image or skin, you will begin to see repeated patterns and textures.

The Spot Healing Brush, Patch, and Clone Stamp are the main tools I utilize for basic skin retouching.

Utilizing Your Retouching Toolkit

In Figure 11.9, you see the unretouched version of this photo. Each number on the photo refers to a step in the process of retouching corresponding to the area of the photo that requires that retouching. The numbers that follow indicate which tools I utilized to fix the imperfections.

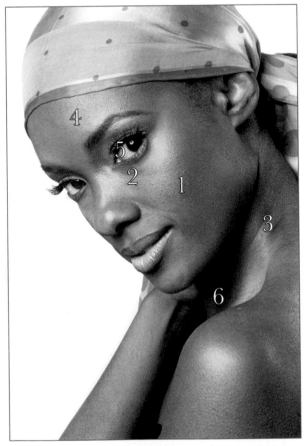

Figure 11.9

Here you can see the unretouched version of the photo. Each number corresponds to a retouch adjustment I made (discussed in detail next).

1. Remove larger blemishes and spots using the Spot Healing Brush. Adjust the size of the brush to completely cover the blemish, and then click to remove.

2. Reduce the darkness and texture of the bags under the eyes. Use Clone Stamp at approximately 25 percent opacity. Sample from the skin just below the bag. Apply repeatedly if necessary to reduce bag appearance. Each time you clone, select a slightly different sample point so you are not reusing the same skin textures.

3. Utilize the Patch tool to remove any large blemishes and unwanted skin. In this image, I used the Patch tool to remove the wrinkles in the subject's neck and smile lines beside her mouth. Select the unwanted wrinkle or skin, and then drag this selection to the area of skin you want to replace the wrinkle or blemish.

4. Use selective skin softening to smooth out skin using Portraiture (see "Imagenomic's Portraiture," later in this chapter). Using this plug-in, select the skin tones to be smoothed, and then apply the amount of smoothness you require.

TIP

If, after skin softening, there are still areas of the skin that are rough or imperfect, I may run a separate pass at skin softening specifically for that skin tone. If a photo has areas of bright highlights and deep shadows, multiple applications of skin softening may be necessary to cover all the tonal area.

5. Fix other issues such as redness in eyes and stray hairs using the Patch and Clone Stamp tools. These other blemishes vary greatly from image to image. In this image in particular, I spent time eliminating red eyes.

6. Liquify. Use the Forward Warp tool (discussed in the "Nip Tuck" section) to elongate and narrow the neck. Also, adjust the shape of the subject's ear and forehead for a more pleasing aesthetic.

NOTE

Typically with a retouch, I do not need to go this extensive. This image was a beauty shot for a model, so I wanted to show a more extreme close-up. This lighting revealed all the model's bumps and imperfections and required a more advanced retouch.

Figure 11.10 is the fully retouched version. At first it will likely take at least an hour to get these results. With practice, however, retouching becomes a series of steps and utilizing a few powerful tools.

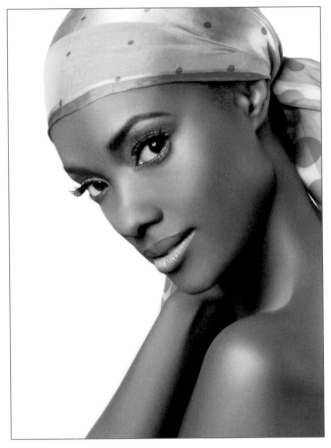

Figure 11.10

The fully retouched portrait has smooth and glowing skin.

More Retouching Tricks

There are a variety of tips and tricks that you might find useful when attempting to help your clients look their best.

Teeth Whitening

For nearly every smiling portrait, I whiten the subject's teeth even if they are only slightly yellow. This helps emphasize the smile and make it glow. This is actually quite easy to do. Figure 11.11 is a sample of a smile that needs some quick and easy whitening.

Figure 11.11

Here are the teeth before they have been whitened. Although they are not overly yellow, they still would benefit from some retouching.

1. Make a selection of the teeth with the Lasso tool. This doesn't need to be exact. This is just a general selection of the teeth area.

2. Feather the selection. I typically feather between 15 and 40 pixels (depending on the size of the mouth in the image).

NOTE

Feathering (choose Select, Modify, Feather) is a way to soften the edges of a selection or change. The number of pixels you select is the number of pixels over which the effect you apply goes from full effect to no effect. The higher the number of pixels, the softer the edge of the adjustment and the more gradual the change.

3. Create an adjustment layer by clicking on the "half moon cookie" (also known as the adjustment layer) on the bottom of the Layers palette and select Hue Saturation.

4. Go to the master channel and select the Yellows channel, as seen in Figure 11.12. You are going to desaturate this channel. In other words, you are removing the yellow tones from this portion of the image. Drag the saturation slider to the left until the yellows look reduced enough for your image.

The final result is noticeably whiter teeth without lines or evidence of the whitening, as seen in Figure 11.13.

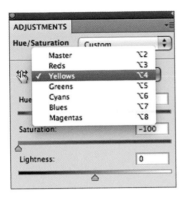

Figure 11.12

After selecting the Yellows channel, desaturate it. As a result, you will remove yellows in this selection (and whiten teeth).

Figure 11.13

The teeth are noticeably whiter than Figure 11.11 with just a few simple steps.

> **CAUTION**
>
> If you make your selection too wide, you will pull yellows out of the skin tones, and it will be noticeable. Also, for some people, removing the yellows will leave their teeth looking a bit dull and gray. You may consider leaving in a bit of yellow or brightening their teeth using levels.

Brightening Eyes

There are a few tricks out there for helping to make the eyes really "pop" from the photo. One technique is to make a selection around the eyes and simply increase the contrast of this selection using levels. This is a basic and effective technique for adding life to the eyes.

In Figure 11.14, the eyes are a bit lifeless and dull. After adding a levels adjustment (moving the black and white points as seen in Figure 11.15), I am able to add contrast to the eyes. Figure 11.16 is much brighter and has more energy in it. You can also achieve this effect using curves.

Figure 11.14

These eyes are a bit dull and lifeless and could use a bit of pop.

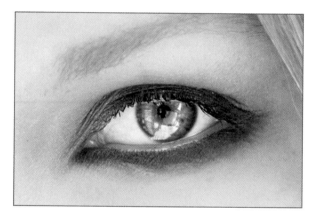

Figure 11.16

After adding contrast to the eyes, they stand out and have more life.

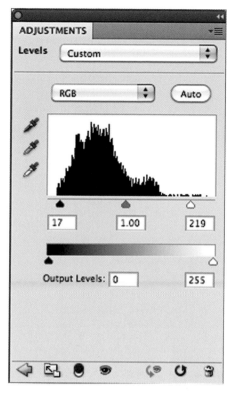

Figure 11.15

By moving the white point and black point in Levels, I increase the contrast in the eyes and give them more energy.

CAUTION

Do not overwhiten eyes. Doing so makes them look surreal and makes the client look possessed. People often overdo this effect. Furthermore, the eye isn't always completely white because the upper part of the eye often falls in the shadow of the eyelid. If you do whiten, be subtle.

Another more advanced technique helps to enhance the detail in the iris of the eye while increasing contrast.

1. Select the eyes and feather (15 to 40 pixels).

2. Copy and paste the eyes into a new layer (press Option/Alt+J).

3. Go to Image, Adjustments, Shadows/Highlights.

4. Adjust the Shadows slider, pulling it toward the right to bring out detail in the shadows, as seen in Figure 11.17. The results can be more vibrant eyes with more detailed irises.

After applying this technique, you see more color, detail, and contrast in the iris. The eye grabs much more visual attention, as seen in Figure 11.18.

Figure 11.17

To bring vibrance and detail to the iris, utilize the Shadows/Highlights adjustment.

Figure 11.18

Using Shadows/Highlights reveals more vibrance and depth in the subject's iris.

CAUTION

This technique works best on lighter colored eyes (blues, greens), where there is more detail to extract in the iris to begin with.

Skin Softening and Blemish Removal

Removing blemishes and smoothing out skin is an important and somewhat challenging part of retouching.

Skin smoothing and softening can really improve an image. In fashion flair, the skin needs to be impeccable. The tones across the skin should be even and any roughness eliminated. You can smooth out skin with Photoshop, but more advanced skin softening requires a plug-in.

I hate telling people that the solution to retouching (or other creative problems) is to buy a program. Photoshop is so expensive as it is, and insisting that a plug-in is required seems wrong. But in this instance of advanced skin retouching, a plug-in really is essential. Using a retouching and skin softening program will save you time and, as a professional, time is money.

CAUTION

If you do choose to soften skin manually, do *not* simply use the Blur tool or basic Gaussian blur to soften skin. These give unpleasant and obvious results.

Furthermore, sometimes you need more sophisticated tools for retouching, such as maintaining freckles while still smoothing skin. It's great to photograph beautiful redheads, but if they come to me with pimples and freckles, I know I have a challenge ahead of me. This is where plug-ins are essential. In this case, retouching is extremely difficult to do by hand, but specialized programs give you control. Here are three programs I have used to help with my skin softening and blemish removal process.

Nik Color Efex

Nik Color Efex Pro is a Photoshop or Lightroom plug-in that offers you a range of creative effects to apply to your images. Options include everything from Glamour Glow to Infrared Film to a Fog filter. This program can also act as a plug-in with Lightroom or Aperture. If you already own Nik Color Efex, you might want to try out its Dynamic Skin Softener option. This tool allows you to select skin tones and then blend these tones to smooth out the skin.

If you already own Nik, you should definitely test and see if you like its capabilities. Out of all the skin softening and blemish-removal programs discussed here, however, it is the least powerful.

Portrait Professional

Portrait Professional is stand-alone (not plug-in) retouching software that describes itself as "airbrushing and portrait enhancement" software. Unlike Portraiture (discussed next), this program isn't solely for smoothing skin. In fact, you can make much more advanced and extreme adjustments. This program allows you to smooth the skin, reshape the face and neck, lighten the eyes and teeth, adjust the exposure, and remove blemishes—all within one program. I could go on and on about the amazing adjustments that Portrait Professional allows.

As you can see by comparing the before and after previews in Figure 11.19, I've modified many of the subject's features. Her face is more slender, her neck is longer, her eyes are slightly larger, her lips are fuller, and her skin is extremely smooth in the picture on the right. For a model beauty image (and this type of light), this retouching creates a striking result. As you can see, the adjustment sliders are at 100 percent. Typically for portraits, you have the Face Sculpt controls at 25 percent or even completely turned off.

Figure 11.19

Portrait Professional not only smoothes and evens out the skin, it reshapes and adjusts facial features.

The capabilities of this program are fascinating if not always practical or desirable. Built into the software are formulas of what our society typically considers flattering, beautiful features. For women, this includes big eyes, a long neck, and a slender face. Using control sliders within the program, you can adjust the shape of a person's face and attributes of her features with almost no effort. The Portrait Professional Web site even admits that this feature is a bit "contentious"; in portraits you don't want to alter your subject's features, because they define the subject.

I have mixed feelings on the subject of modifications. In most cases, these adjustments are unnecessary and undesirable. Yet the way you light and pose people can make them more slender and create a more flattering image. Subtle use of this program is just an extension of creating flattering effects. For example, when I want subjects' eyes to look bigger, I have them lean forward and shoot from a slightly downward angle. Using Portrait Professional, however, I can easily make their eyes just a tiny bit bigger for a softer, more feminine look. I almost always slenderize and lengthen a female's neck using Liquify (talked about in "Nip Tuck," later in this chapter), but this program has that feature built in. If you don't want any of these body-modifying aspects of the program, it is easy to turn them off.

If you are shooting models for your portfolio, I say feel free to modify their faces as much as you want! Adjust their faces to perfection so you can have stunning images to represent your work. With your subjects and portrait clients, however, I'd generally recommend using these tools with extreme care. Lengthening the neck might be okay, but changing the face shape can be dangerous.

The skin softening on Portrait Professional is pretty good and makes it easy to remove pimples and smooth out skin tones.

Test the trial for yourself and see how you like its capabilities. The program works in an interesting way. It allows you to define the eyes, mouth, face outline, and nose so that the program actually knows what the face looks like. After you define the contours and features of the face, the program automatically applies basic adjustments that you can then modify.

NOTE

Compared to Imagenomic's Portraiture (see the next section) or the Nik Color Efex package, Portrait Professional is the least expensive skin softening and retouching option.

Imagenomic's Portraiture

Although this is the most expensive program discussed for skin softening, I also find it to be the best program. I don't have all the "extra" controls of Portrait Professional, but I prefer Imagenomic's Portraiture's fine adjustments for skin softening. When I find a setting I like, I can save it as a preset so I can go back and utilize it later.

I have created settings for high-fashion ultra-smooth skin, subtle skin softening for a male, and more.

When working within Portraiture, you select the skin tones or colors you'd like to affect and then adjust how much to blend and smooth these tones. Figure 11.20 is a preview of the sliders and control available within the Photoshop plug-in version of this software. The numbers correspond to the functions of the numbered area within the program.

Figure 11.20

Portraiture allows you to select skin tones within your image and to make small or large adjustments to the smoothing in these tones.

Select skin tones using the Eye Dropper tool. Pick the average skin tone in the image. Then hold down the Shift key and click on other skin tones to expand your selection of skin.

Next, adjust how the different tones are smoothed and blended in the Detail Smoothing dialog box. As you move the sliders, you see the previews to the right. Faces need different levels of smoothing. When I find settings I like, I save them as presets so I can come back and utilize them in the future.

For retouching, I find the following settings to be most effective as a starting point. (I might tweak a bit from picture to picture.)

Fine: Between 0 and 10

Medium: Between 10 and 20

Large: Between 10 and 20

Threshold: Between 30 and 35

Adjust Sharpness and Softness: If I need some extra smoothing, I sometimes adjust the Softness tool. In general, I do *not* adjust softness because it tends to give that blur look common in glamour images.

CAUTION

Portraiture is the most expensive of the retouching software, and it has no other function than retouching. Try the free trials for all these programs before making a purchasing decision, particularly if your budget is price sensitive.

Nip Tuck

You can find a lot of other tips online for improving the retouching on an image, including adding eyelashes, whitening teeth, and adjusting the hair line. For the purposes of this book, I will now address an essential fashion flair retouching tool: Liquify.

I regularly utilize the Liquify tool to help clients look their best by slenderizing them or emphasizing certain features of their body. In Photoshop under Filter, Liquify is a tool that allows you to push, pull, squeeze, or bloat your image to achieve a desired visual goal. Liquify has many modification tools, but I use the Forward Warp tool (finger on the top of the screen) most often for retouching. I don't use the tool to completely change the body, but to emphasize features considered beautiful.

Figure 11.21 shows before and after shots of the same image. On the second image I used Liquify to lengthen the subject's neck and give her shoulder a more slender and pleasing shape. Is this shape reality? No, not really, but it is the fantasy you are paid to create.

Be careful not to overdo a retouch, or others will consider it unbelievable. I recommend that you show the image to a photographer and a nonphotographer alike; note their reaction to the image. If they feel it is clearly a fake, you should probably back off the effect a bit.

Figure 11.21

In this before and after series, I have adjusted the shape of the subject's shoulders to be more slenderizing and pleasing.

I utilize Liquify to do the following:

- Give shape to hips, waist, and other sensual areas of the body
- Reduce double chins and undesired flab
- Lower shoulders and elongate neck
- Reshape asymmetrical features, such as uneven eyes
- Give more pleasing shape to body features

As with anything, practice makes perfect with the Liquify tool. I recommend testing the Forward Warp tool to get a feel for how it affects pixels and your image. With the Forward Warp tool, you are essentially clicking and dragging

to move pixels in an image. This may mean clicking and dragging to pull in the waist line. Or it may mean clicking and dragging upward to even out certain features. You can use the Liquify tool for fine adjustments (such as smoothing out bulges in the contours of clothing) or large adjustments (such as slenderizing a person's form).

I often try to use a larger brush (1000 pixels or more) when adjusting larger areas of the body. By moving large areas with a single brush, the adjustments tend to be less noticeable because many pixels are moved at once. In Figure 11.22, I am utilizing the largest brush available (1500 pixels) to reshape the shoulders using the Forward Warp tool.

Figure 11.22

When using the Forward Warp tool in the Liquify menu, consider a larger brush when you need to move a large section of a body/image.

CAUTION

If you use too small a brush or move pixels too far, a smearing of pixels will be visible, as appears in Figure 11.23.

Figure 11.23

A frequent problem of Liquify is the "smear" effect that can result when pushing or pulling pixels over too far a distance.

TIP

When you use Liquify, you must be extremely careful not to move certain elements in the photo. For example, accidentally liquifying a clearly vertical line (and making it wavy) can give away your secret! For this reason, the Freeze tool in Photoshop allows you to mask out areas of the photo you need to remain frozen (not liquified). For example, the masked area is visible in Figure 11.24. This allows me to liquify the subject's body without affecting graffiti on the walls in the background.

Figure 11.24

The red in this image is a mask preventing me from liquifying those areas of the image.

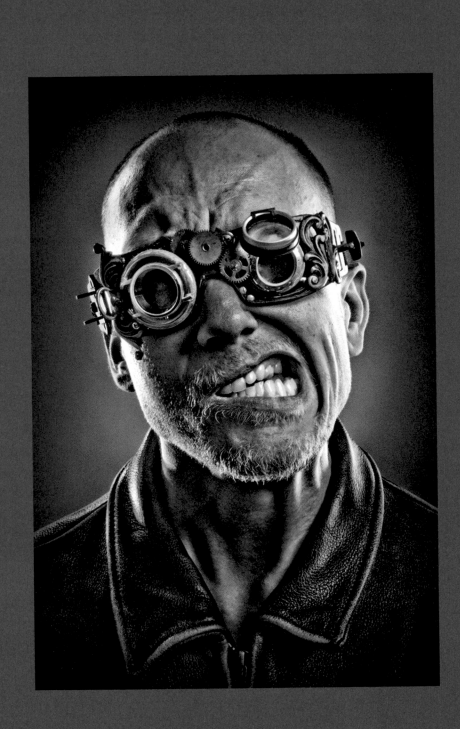

12

Stylized and Creative Effects

I really do agree with the saying, "Get it right in camera." In other words, don't be lazy when shooting just because you think you can fix it in Photoshop. If you get it right in the beginning, you will save yourself time and hassle later on. Sometimes, however, you can't achieve a desired effect in camera. In addition, Photoshop allows you to take creativity to a level not possible in camera.

In fact, a lot of my shoots look completely different in their final form compared to how they looked in "real life." I frequently apply unique effects to perfect my work and differentiate it from what other photographers are doing.

Take this example of a portrait I took in Queens, New York. Figure 12.1 is the original, completely unretouched image. Straight out of the camera, it is a decent image; the light is pretty, the colors are nice, and the subject's skin looks acceptable. However, I felt that this straight image was a bit typical, so I decided to add a bit of a vintage Hollywood feel. To do this, I utilized a Lightroom preset to warm up the tones, added a vignette, and pumped up the contrast. Figure 12.2 is more interesting and stylistic than the original. You can choose to add creative interpretations to your images, too.

> **NOTE**
>
> A Lightroom preset is a set of instructions of how to "develop" an image in Lightroom. Any changes you can make to the image, including white balance, black point, clarity, split toning and hundreds of other adjustments, can be combined to make a preset. Because of this, there are thousands of presets. Some automatically come with Lightroom, and you can create your own presets. Many sites online offer FREE presets for download, including http://www.presetsheaven.com, http://www.lightroomkillertips.com, http://www.ononesoftware.com, and dozens more.

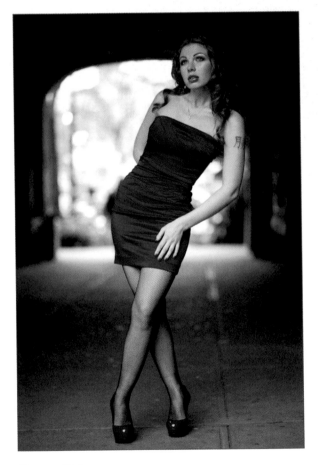

Figure 12.1

In this unretouched image, the portrait is beautiful but lacks unique stylistic effect.

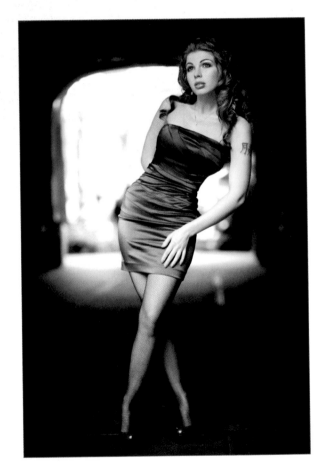

Figure 12.2

In this version of the portrait, I utilized a Lightroom preset to add a creative and stylistic effect to warm the tones, add a vignette, and pump up the contrast.

Plug-Ins and Creative Tools

If you are seeking inspiration for interesting creative effects for your image, consider using plug-in software or creative technique actions.

Although I still do a lot of effects by hand, these tools make creative effects easy and can provide instant previews of how different effects might look for a particular image. Again, these are great time-saving tools that help creativity flow.

This section discusses three of the most popular creative effects plug-ins and program options.

Nik Color Efex

Nik Software is a company with a range of products for photographers, but its most popular product is Nik Color Efex Pro. This plug-in software has 50+ separate filters with more than 250 different overall effects. From giving an image a 1950's glamour feel to a vintage film effect, there are dozens of effects you can instantly preview. This is a great tool for inspiration, because you see your image transform with different special effects applied. Nik's free trial allows you to test these tools firsthand.

onOne

As with Nik, onOne has a range of products addressing different practical and creativity needs. Many of the basic creative functionalities for Nik and onOne are similar. For creative purposes, you may want to try onOne's PhotoTools product for dozens of beautiful creative effects or its PhotoFrame product for edge and frame enhancements. A free trial lets you test these tools in Photoshop or even test as Lightroom/Aperture plug-ins.

Kubota Image Tools

Kubota Image Tools is a company that provides a variety of creative Photoshop actions and training materials. Photoshop actions are fundamentally instructions of repetitive changes to make to a file in Photoshop. For example, if you want a high-contrast image with desaturated colors and a vignette, you could create an action so that every time you want this effect, you apply this action to the file. This saves you time and creates consistent effects. Thousands of actions allow you to add creative effects to your images. Kubota sells themed action packs, so you can choose to purchase only effects that match your creative style. Kubota even has a pack specifically designed to complement the effects of Lensbaby. As a fashion flair photographer, you may be interested in Viva la Vintage, A3 High Fashion-Edgy, or the Texture Tools pack. Kubota's site,

http://www.Kubotaimagetools.com, gives you much more detail about the different effects available.

You can purchase dozens of action packs from other companies, but the three discussed in this section are the most popular among professional photographers.

Post-Production: Creative Effects

The possibilities for creative effects in Photoshop are endless. Everyone has a different style of retouching and post-processing. For some people, these techniques become a part of their style and branding. For others they are just tools to reach a final goal.

I use a variety of techniques to add interest to my fashion flair images. In this section, I discuss four techniques:

- Adjustment layers and layer masks
- Porcelain skin
- Rough, worn textures
- Faux HDR

> **NOTE**
>
> If you check my YouTube page or Web site, you can find guides to several retouching techniques, including selective black-and-white conversions and makeup applications in Photoshop.

What follows are my most commonly used techniques. Note, however, that each photographer has her own "bag of tricks."

Adjustment Layers and Layer Masks

An *adjustment layer* is a layer that affects the appearance of the layers below it without actually changing those layers. You can easily delete adjustment layers and add new adjustment layers at any point in the process without permanently changing your image.

To demonstrate the concepts of adjustment layers and layer masks, we will utilize Figure 12.3. This image was taken during a dancer's senior portrait session in late summer. It was about 1.5 hours before sunset, so the light was at a lower angle. In Figure 12.4, you can see the empty Layers palette, with nothing but the Background layer.

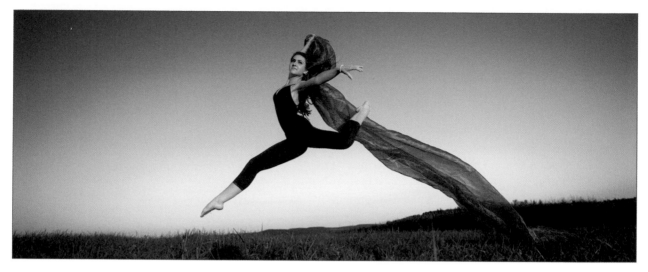

Figure 12.3

Here is the original image taken during a dancer's senior portrait session.

Figure 12.4

By default, your Layers palette is empty except for your Background layer.

Figure 12.5

The "half-moon cookie" button allows you to create an adjustment layer.

If you want to make an adjustment, click on the half-moon cookie shape in the Adjustment Layer palette, as seen in Figure 12.5. Clicking this button creates an adjustment layer and provides many adjustment options to choose from, as seen in Figure 12.6.

Figure 12.6

Clicking the Adjustment Layer button brings up a number of choices, including a black-and-white conversion adjustment layer used in this example.

For example, you can create a black-and-white adjustment layer, which will make the image look black and white. When you turn off the layer or delete it, all the layers beneath remain intact and in full color. Imagine all your image's layers as stacks of photographs and your adjustment layer as a transparent gel. It affects the appearance of the layers beneath without fundamentally changing the layers beneath. In other words, it's like adding a gel above a print; it looks like it affects the layers below, but it hasn't actually changed them. Figure 12.7 shows the image with the black-and-white adjustment layer, and Figure 12.8 shows what this adjustment layer looks like. It reads "Black & White conversion" and has a solid white box beside it.

So with this current adjustment layer, the entire image goes black and white. Now let's suppose that you want just the large ribbon the dancer is holding to remain in color. The layer mask allows you to achieve this effect.

A layer mask allows you to take complete control over a layer or effect's transparency. For example, if you create that black-and-white adjustment layer, you can use the layer mask to determine how much of this black-and-white layer is applied and to which parts of the image.

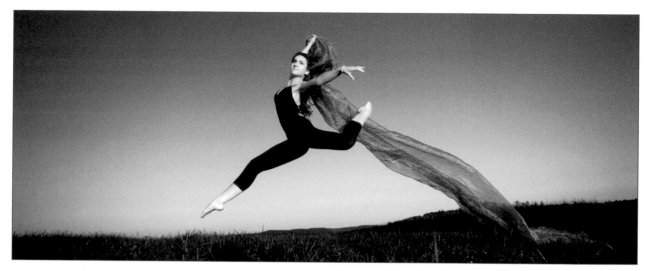

Figure 12.7

When the Black & White Conversion layer is applied, the image appears black and white, although the Background layer has not *actually* changed—just its appearance.

Figure 12.8

A black-and-white adjustment layer has been created above the Background layer. By default, its layer mask to the right appears white. (In other words, an effect is applied.)

To understand layer masks, you must first learn, repeat, and memorize the saying

Black conceals; white reveals.

When you apply a layer mask to a layer, a little box (the mask) shows up next to this layer in the Layers palette. This box (a mask) is automatically applied when you create an adjustment layer.

By default, this mask is white, meaning the effect of that layer or adjustment is fully applied. If you take a black paintbrush and paint onto the image (with the mask selected), the effect is removed from the areas you paint. The black conceals the effect. As you can see in Figure 12.9, now the pink/purple hues of the

ribbon have been revealed, while leaving the rest of the image in black and white. If you look carefully at Figure 12.10, you can see the black painted on the white of the layer mask. The black is in the shape of the ribbon, because that is where I have painted black to conceal the black-and-white effect, thus letting the color through.

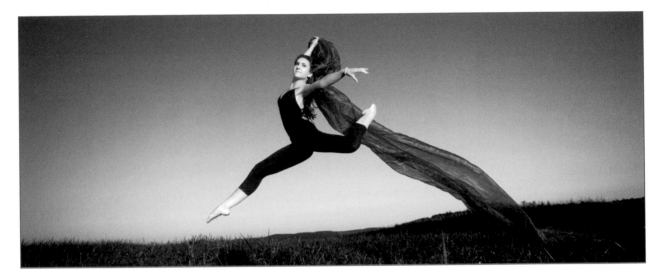

Figure 12.9

By painting black on specific areas of the layer mask, I am able to bring back the original purple color of the ribbon the subject is dancing with.

Figure 12.10

You can see where black has been painted on the layer mask to conceal the black-and-white effect, thus allowing color to show through.

If you painted too much black (removed too much of the effect), simply switch back to the white and paint again to reveal the effect.

> **NOTE**
>
> You can paint black or white at different opacities. In other words, if you paint at 50 percent gray opacity, the adjustment is only being revealed/concealed by 50 percent. So if, on this black-and-white example, you paint black at 50 percent, you will bring back the color to 50 percent of its original strength in the areas you paint.

This seems a bit complicated at first, but if you practice using the black-and-white example, it will make sense after a bit of fiddling. Select the layer mask, paint white, and the black-and-white effect is applied. Paint black to have the color show back through. This works with any adjustment layer!

> **NOTE**
>
> You can apply layer masks to regular layers, too. Let's say that you retouch the skin on a layer so that it is completely smooth and blemish free. If this effect looks too fake, you can add a layer mask. From there you can paint black to eliminate this effect from certain areas of the face to bring back some realistic wrinkles and textures. You can paint at different opacities (like transparency) so that some of the original skin shows through but the general retouch mostly remains.

Why is this so important? When you are adding or removing the effect, you are not degrading the quality of your image. If you were using an Eraser tool to remove the effect of a layer, you could only go back so many steps to correct an error. You lose control.

Furthermore, you can continue to create multiple adjustment layers with masks and pile them on top of one another without harming the layers below.

Layer masks give you complete control of your image adjustments and allow you to go back and change your mind if necessary. I use layer masks in every Photoshop retouch and effect I do!

In the "Rough, Worn Textures" section of this chapter, I will discuss the use of layer masks as applied to actual layers (not just adjustment layers). I will demonstrate how to add a layer mask to a texture or even a retouching layer.

Once you understand adjustment layers and layer masks, you open up a realm of possibilities for yourself.

Porcelain Skin

In many of my images, I make the subject's skin completely smooth and porcelain looking. I do not use this effect when I want a realistic look, but when I am going for a more surreal skin effect.

In this demonstration, I'll use Figure 12.11 of the girl against the graffiti wall. You may prefer her skin at its original color and vibrance, but I'm just using this image as a demonstration of the technique.

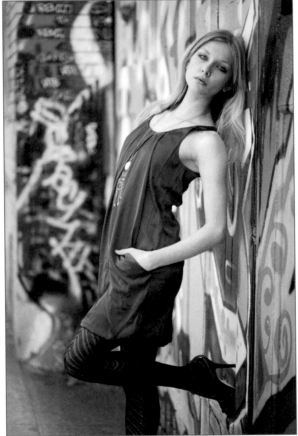

Figure 12.11

In the original portrait, the image is dull and lacks contrast.

As you can see, the original unretouched image is bland and unappealing. The contrast is too low, and the viewer's eye is confused. It's not clear where to look within the image.

First I go in and drastically retouch the subject's skin and body. I get rid of blacks under her eyes and smooth out her skin. Next, using Liquify, I give her a more defined shape. When doing porcelain skin, I take my retouching to a more extreme level: I remove every blemish, every wrinkle, and any moles or

freckles. When I utilize retouching software, I use one of the highest smoothing settings (avoiding softness but increasing smoothness). In other words, I retouch the skin until the point of complete smoothness.

For this particular image, I wanted to make the scene pop, so I increased the contrast and saturation to enhance all the tones in the scene, as demonstrated in the version of the photo in Figure 12.12. As a result, the subject's skin looked a bit yellow and discolored. In this instance, I tried removing the saturation from her face, but I still didn't like the color. That's when I decided to give her porcelain skin by creating an adjustment layer.

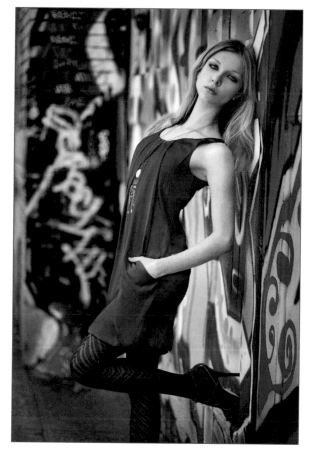

Figure 12.12

After my basic retouching, the skin is a bit too yellow and not necessarily flattering in the image.

Next, I create a Vibrance adjustment layer (by clicking on the half-moon cookie button), as seen Figure 12.13. Here I decrease the vibrance, which makes the skin a light, milky color. There is no exact formula for the "right" setting. Basically I just play around with decreasing/increasing both vibrance and saturation until

I get the desired effect. In Figure 12.14, you see a sample of how I might adjust the vibrance and saturation to get the paleness I want for her skin. In general, decreasing vibrance has a pleasant effect on the skin and is great for the porcelain look.

Figure 12.13

To get the correct coloration in the skin, I utilize a Vibrance adjustment layer.

Figure 12.14

There is no "right" formula for decreasing vibrance or saturation to get pale skin. Each image requires experimentation to get the desired visual effect.

NOTE

Decreasing vibrance often makes the skin look a bit dull, so I add a Levels adjustment layer and increase contrast by adjusting the white points and black points. (Drag black points and white points toward the center.) You can re-add contrast in whatever way you are comfortable.

To make the effect on the skin even more noticeable, I use a black paintbrush to paint the vibrance effect off of other areas of the photo. I remove the effect from the clothing and background, leaving everything else normal coloration while the skin goes completely white. In this scene, it allows the rich colors of the graffiti to stand out, as seen in Figure 12.15.

NOTE

Another way to handle selective vibrance is to paint the effect onto the areas of the photo where you want it. To do this, fill the entire layer mask with black (removes effect) using the paintbrush or select Edit, Fill, Black. From there, simply paint white in areas to add the effect. It's the same technique, just in reverse.

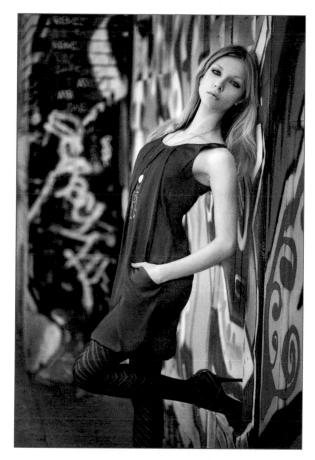

Figure 12.15

I decrease vibrance using a Vibrance adjustment layer and remove this effect from the surrounding environment so the graffiti can stay richly colored.

In the most extreme cases, I completely remove saturation from the skin, leaving it completely white. For my high-fashion images, this adds a unique touch and firmly anchors the image as surreal.

NOTE

If you want the skin to be completely white, you might try this same effect using a black-and-white conversion layer and then removing the effect off the environment. Playing with vibrance works with most portraits, and I only utilize the black-and-white conversion effect when doing conceptual fashion imagery.

Rough, Worn Textures

Look for interesting textures when you are out photographing. Look for old walls, old papers, rusty car hoods, or anything that might help give a worn look. Remember to shoot these straight on (there should be no depth in the photo); otherwise, this will not work as an ideal overlaying texture.

Here are the steps to add textures to your images or give them an aged effect:

1. Open your main photo in Photoshop. In this instance, I have used a portrait of a local singer, as seen in Figure 12.16.

2. Find interesting textures that might look good on your image. You can take photographs of textures or search for texture packs online. You will find hundreds of free images or packs for sale. Check stock photo agencies for hundreds of inexpensive textures. For this example, I have chosen the texture shown in Figure 12.17.

3. Open the texture in Photoshop.

4. Resize the original file and the texture to be approximately the same size. They should have the same number of pixels for the width and height so that the texture covers the entire image. You do not want to have to stretch your texture to fit onto the image. This degrades the quality of the textured photo and will be obvious in the final image.

> **TIP**
>
> You can view and adjust sizes by going to Image, Image Size and viewing the pixels of each image.

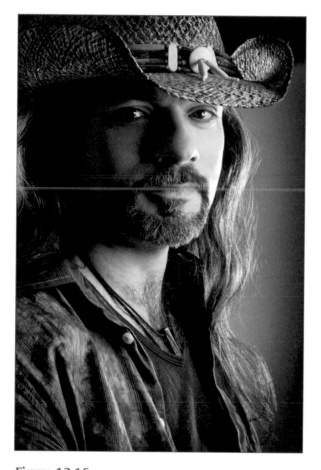

Figure 12.16

This is the portrait of a local singer after some initial retouching but before adding textures.

Figure 12.17

I found this texture online and made sure it was of large enough resolution to be used as a texture on the main portrait.

5. Once you've resized the images, hold the Shift key and drag the texture on top of the original file. This centers the texture, which will now be the top layer in that Photoshop file. When you drag and drop this texture, it will now be the only thing you can see on the original file.

6. Next in the Layers palette, go to the Layer Blending Mode options. By default it reads Normal, as seen in Figure 12.18. You will want to try Overlay, Soft Light, or Hard Light, as seen in Figure 12.19. The correct blending mode depends on the look you are trying to achieve. With hard light, seen in Figure 12.20, the texture becomes more much prominent and visible. In the Soft Light option, Figure 12.21, the texture is less pronounced.

Figure 12.18

To add a texture effect, adjust the blend mode options, which are set to Normal by default.

Figure 12.19

You need to test the blend mode at Overlay, Soft Light, and Hard Light to see which effect best fits your needs.

TIP

Using blending modes affects how your Texture layer interacts with the layers below it. When using certain blending modes, your bottom image picks up some of the color qualities of the top layer. For some creative effects this may be desirable (perhaps it adds a warm, antique coloration), but in many instances you will want to desaturate your texture layer so that only the texture (and not the color) is added.

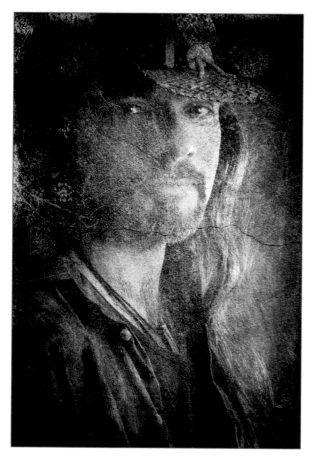

Figure 12.20

When you apply the Hard Light effect, the texture is much more defined and crisp.

Figure 12.21

When you apply the Soft Light effect, the texture is subtle.

7. After you've selected your blending mode, apply a layer mask to your image. Earlier in this chapter we discussed adding layer masks to adjustment layers. You can utilize layer masks for any layers you create, including Texture. To do so, click the symbol on the Layers palette that looks like rectangle with a circle within it, as seen in Figure 12.22. This adds a layer mask to this layer, so now you can paint black on the layer mask to begin removing the texture effect. This works for any texture or any layer you create, whether it's a texture, a retouching layer, or any other adjustment you apply to a layer.

Figure 12.22

This symbol (rectangle with a circle inside) is the Add Layer Mask symbol.

8. Using the black paintbrush, paint in the layer mask to remove textures from areas of the photo that shouldn't have a texture, such as the face. To add textures back in, paint white. In Figure 12.23, I have removed the textures from his face, so now the worn texture is really just on the background and parts of the clothing. In Figure 12.24, the black areas of the mask represent where the texture has been removed.

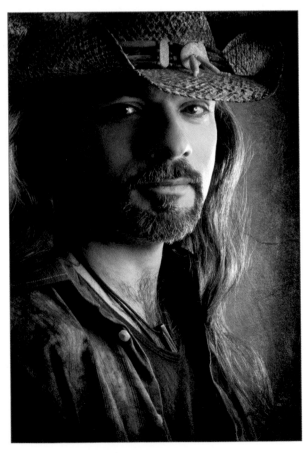

Figure 12.23

I chose the hard light effect and removed the textures off the face and skin using a layer mask added to the Texture layer.

Figure 12.24

I have removed texture from the face and skin by painting black on the adjustment layer.

> **TIP**
>
> If a texture is too extreme, try reducing the opacity of the layer to make it more subtle.

9. Add additional texture layers or textures to specific areas of the photo where needed.

> **TIP**
>
> Sometimes I work with five or six texture layers. My main layer gives the overall texture to the image (perhaps a linen paper look). Then subsequent layers add specific worn textures like a torn edge, or ripped or burned edges.

Faux HDR

Currently the HDR effect is extremely popular not only in landscapes but in portraiture. True HDR portraits require combining frames of different exposures into a single portrait. Because people move, this is simply not practical, and there isn't readily available technology to create true HDR portraiture (although it may be coming soon).

Instead, I suggest a number of faux HDR techniques. The resulting picture will have the aesthetic appearance of HDR without actually being HDR.

> **NOTE**
>
> HDR in photography means high-dynamic range. As mentioned previously in this book, this means you have both detail in extreme highlights and detail in extreme shadows, creating a wide tonal range. Typically, you achieve this by combining images of multiple exposure values into a single frame. Because all images must be 100% identical, achieving this effect with moving subjects such as people and portraits is extremely difficult.

You have to get the lighting right. Faux HDR looks most realistic if you have many highlights. In Chapter 9, "Studio Light: Complete Control," you can find an example of an HDR lighting setup in Figure 9.8. Put highlights on the hair, either side of the face, and other places.

You do not want to light in a way that creates extremely deep shadows. If the shadows are too deep, you will not be able to fill them in enough to fake HDR.

> **TIP**
>
> A true HDR image has detail in the shadow and highlight areas of the image and a much greater range of tones than would typically be possible.

You can achieve much of te HDR effect right in Adobe Camera RAW (ACR). This example uses the steam punk–inspired portrait from earlier in the book.

Once the RAW photo is brought into ACR or Lightroom/Aperture, you need to make a few adjustments.

Take a look at Figure 12.25. These are the default settings for this image in ACR. It looks nothing like an HDR image.

After a few changes in ACR, you can achieve the HDR appearance you see in Figure 12.26. Observe the sliders to see the changes I have made.

First, you want to add a lot of fill light and recovery to your image. This starts the HDR feel by returning detail to the shadows and highlights area. By doing this, however, your image now appears flat. To remedy this, you need to increase contrast in the image. I like to increase the exposure and adjust the black point. By giving myself distinct black points and white points within the image, I remove the muddy appearance.

Figure 12.25

The original image does not innately have an HDR look; instead, you must work in ACR to help the image take on wider tonal ranges.

Figure 12.26

You can see the adjustments done in ACR to achieve a faux HDR effect, including adjustments to fill light, recovery, black point, clarity, and vibrance.

Next, I adjust the saturation and vibrance levels. I want to decrease these values so that I have more muted images with more subtle tones. (It helps pick up on grittier detail.) You will decrease the vibrance, making the tones look a bit more dull or metallic. You may need to add some additional contrast to the image (using levels or curves) to make the existing image pop. You can do this step in Photoshop, but I often like the results better when I adjust them in ACR.

Before leaving ACR, I often increase the clarity in the image. Typically, you do not want to add clarity in a portrait because it emphasizes blemishes and pores. However, HDR portraits typically are more grungy, so emphasizing textures in skin and location is desirable.

After adjusting the preceding settings, you are much closer to achieving the HDR effect. The image is still a bit flat and needs some selective contrast, but you have achieved the general look.

NOTE

Clarity is a way to add contrast to the midtones. It helps make your image pop and improves apparent sharpness.

Now open the image in Photoshop. At this point you need to determine if you've achieved the HDR look. If you do not feel that the look has gone far enough, play with the Shadow Highlights tool.

To apply this effect, go to Image, Adjustments, Shadow/Highlights, as seen in Figure 12.27. From there, you can adjust both the Shadows and Highlights sliders (Figure 12.28) to achieve the desired effect.

NOTE

The Shadows and Highlights tool allows you to pull detail out of the shadows and restore detail in the highlights. Before fill light in HDR, this was one of the main ways of filling in shadow areas.

By playing around with shadows and highlights, you will be able to fill in the shadows and recover the highlights. This will allow you to go even further with the HDR look. If you utilize this tool, use it sparingly. Apply a layer mask, and only use the effect in the darker shadows or areas on the image you've selected. It is easy to overdo this effect, so use it with caution.

Figure 12.27

To bring out detail in the highlights and shadows of an image, you may utilize the Shadows and Highlights adjustment effect.

Figure 12.28

To bring detail out of the shadows, you will primarily adjust the Shadows slider. The values for adjustment vary for each image.

TIP

Remember that you can selectively apply shadows and highlights by using layer masks. Apply shadow and highlight effects, and then only have them show through on the exact areas where the effect is required to achieve the desired effect.

In this image in particular, I used shadows and highlights to bring back some detail in the shadow areas of the skin and jacket, as seen in Figures 12.29 and 12.30.

Figures 12.29 and 12.30 show the results of the shadows and highlight effect. If I wanted more detail in the shadows on the jacket, I could use Shadows and Highlights to extract this detail (Figure 12.30).

Figure 12.29

The detail in the jacket is listed in the original image.

Figure 12.30

By applying shadows and highlights, you can pull detail out of the shadows and give the jacket more defined textures.

If you need to make any other adjustments to retouching, you can do so at this point on duplicate layers. You may want to remove major blemishes or reduce some more extreme skin textures that may have been revealed through this effect. A skin softener (used in a small amount) may help take the roughness down a notch and make the skin a bit more appealing.

For the sample image, my other main adjustments were in playing with shadows and highlights and then adding selective areas of increased contrast. I had nearly a half dozen levels and curves layers that adjust the exposure and contrast in specific areas of the image. I was able to bring out detail in shadows but then re-add contrast to look believable. I added contrast into the beard to make the texture of the hair more visible. I also added a vignette (using levels and a layer mask) around the image to help focus the eye.

The final image is shown in Figure 12.31. A majority of the special effects were achieved in ACR.

Figure 12.31

Although I've applied many additional layers to this final image, I achieved most of the faux HDR effect by making ACR adjustments.

Here are the points you need to remember from this section:

- Increase fill light and recovery.
- Increase contrast by adjusting contrast and exposure.
- Add texture and depth using clarity for increased sharpness.
- Adjust vibrance and saturation to give a muted, metallic look.

Each image varies drastically on the exact values and changes required, but this is a template to start with.

NOTE

Because HDR is grungy and edgy, you might consider adding a texture at this point. You can use this effect on men or women, but it is most successful in tough male portraits.

Part V

Make Flair Your Business

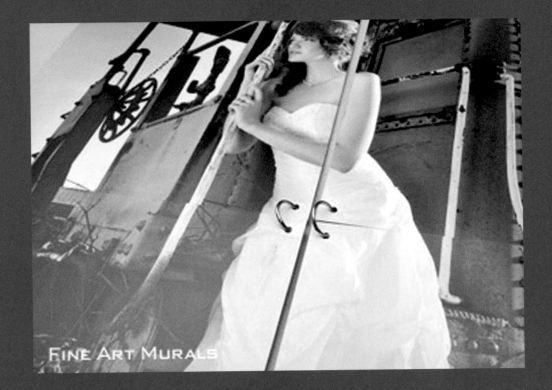

FINE ART MURALS

13

Flair Products and Services

*I*f you market yourself as a fashion flair photographer, you need to have some unique products and services that fit the needs of your clientele. If you are marketing to this wealthier audience or an audience with more refined visual tastes, you need to offer services that address the desire for exclusivity and quality.

On their wedding day, my clients stay at exclusive hotels, get primped at high-end salons, and have purposefully selected every aspect of their day. My photographic products and services should reflective this same exclusivity and attention for detail.

Offer services that pamper the client or include photo session packages that people cannot find elsewhere. Include products that honor your images as pieces of art. It would behoove you to go beyond a basic portrait sitting option and beyond basic print and album packages.

This chapter covers various products and services for your consideration. You don't need *all* these options. Figure out what appeals to you and how you can be unique in your market.

Be an Experience

Your photographic products and services should be a unique experience that clients remember. I'll mention this throughout the chapter. You not only photograph and capture memories; you create experiences.

If you are aiming to be a couture photo studio, your promo materials and internal paperwork should reflect this. For example, instead of just having a price sheet, consider having a beautiful package menu on nice paper with images and boutique packaging. You can offer client welcome packages, which include giveaways, samples of your work, your package menu, and more. Demonstrate to clients that you're investing in them, not just the other way around.

Find ways to make the clients feel special. Send them birthday or holiday cards. Send them announcements about exclusive specials. Send them samples of your personal work to establish yourself as a working artist. Find ways to be memorable.

Create One-of-a-Kind Sessions

As a fashion flair photographer, you may consider offering specialty photo sessions with precise styling and conceptual imagery. This can be for weddings, engagement sessions, or just for fun.

Fashion Flair Session

If you develop a distinctive fashion-oriented style, every shoot can be a fashion flair shoot. Consider creating special sessions for clients who want more sophisticated and developed fashion flair imagery. You can continue to offer your usual sessions such as headshots and family portraits without having to raise prices to accommodate the extra time and costs of fashion flair.

Fashion flair sessions can be as basic or elaborate as you want. They can include hair, makeup, and wardrobe. They can include a morning at the spa followed by a trip to the salon. Or they can just include a concept consultation to make the most of your shoot.

Figure 13.1 was a fashion flair portrait for a local artist. She needed a way to display her installation artwork (shown on the wall) and to integrate that artwork in a portrait of herself. Together we created this image. This portrait session did not include elaborate hair, makeup, or wardrobe. She created wings as props for herself, and we focused more upon concept and communication.

Figure 13.1

This artist wanted to integrate pieces of her work into a scene and portrait of herself. We didn't concentrate on pampering her, but on communicating a message.

Some subjects do want pampering, though, so consider offering an ultimate package that really pampers your client. These types of sessions make for great gifts and become an experience. If you create a package that includes a spa facial, then makeup and hair at a salon and clothing from a boutique, you have not just created a portrait package. You have created an amazing experience for any woman.

Typically when I do fashion flair shoots, I block additional time for photography, hair and makeup, and wardrobe selection. And I have a hair/makeup person onsite at all times for touch-ups. I charge extra for these services, but I market them appropriately.

Figure 13.2 is an example of a typical fashion flair session. I purchased the wardrobe and had a hair and makeup artist on hand to handle the subject's look. I scouted the location beforehand. Although there is no major conceptual element to this shoot, the styling and shooting create a distinct fashionable feel.

Figure 13.2

This fashion flair shoot had no overarching concept. Instead, the fashion flair was expressed through specific styling of hair, makeup, and wardrobe.

Bridal Fashion Shoots

On a couple's wedding day, there is never enough time to capture great fashion portraits of the bride and groom. Everyone is usually busy and pressed for time. As a photographer, I am often not allotted the time and flexibility I want to capture the high-fashion images I imagine.

My clients have still hired me to create stunning fashion images, but I often don't seem to leave enough time to achieve them. They want the amazing photos with the amazing light and amazing locations that they see hanging on my walls, but they don't give me the flexibility to shoot at the right time for the light or to go to the location. On the wedding day, so many events are taking place, weather doesn't always cooperate, and I don't have enough time to travel between locations. Plus, the bride and groom are often preoccupied and not willing to get as creative as I want.

If you do a fashion bridal shoot on another day, usually after the wedding, the bride and groom are relaxed and eager to make stunning images.

I took Figure 13.3 in the studio after the wedding day. This bridal fashion shoot allowed me to use a more couture headpiece and create a stunning bridal portrait of the subject. I was able to create different hair, makeup, and styling than the bride had on her actual wedding day.

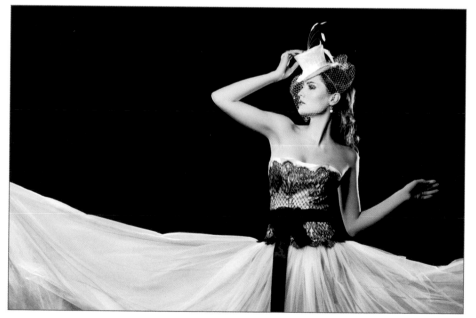

Figure 13.3

This bridal session done after the wedding allowed me to use a couture headpiece to create a stunning beauty shot.

With every wedding I photograph, I offer the bride and groom a free wedding fashion session either before or after the wedding. This session is often 3 to 5 hours long, and we turn it into a fashion event. We usually pick three locations to photograph and take our time at each location. On the bridal fashion shoot day, I have one or two photography assistants to handle lighting, reflectors, and equipment, as well as a person for hair and makeup. The bride gets her hair and makeup professionally done before the shoot (usually at my studio or at the local salon), and then I have the hair/makeup person onsite for touch-ups.

I offer these shoots free of charge because I want to be able to use these images for the final album and sell them as large prints. Obviously, these shoots are not actually free, but I work them into the price of my premiere bridal packages. The more "must have" images I have to work with, the bigger the album I can sell and the more money I can make. These images are often the most treasured and are often purchased as large canvases or prints. I'd rather forego extra sitting fees and instead be able to sell stunning images. Also, because the bride knows that I set aside another day for high-fashion portraits, it relieves some stress on her wedding day. If someone is late or the weather is bad, it is not a crisis. I still have another day to focus my fashion shoots on the bride and groom.

Figure 13.4 is another sample of a bridal fashion session. Without the pressure of time and limitations on hair and makeup, I can create a striking image that is intimate and high fashion.

If I choose a day other than Friday or Saturday for the bridal fashion shoot, I often have access to more extravagant locations that may have been too crowded on a weekend or were previously rented for a wedding. The fashion day gives us plenty of time to discuss location, concepts, and more.

Fashion Engagement Sessions

An engagement session is the absolute perfect time to work on fashion flair. You have two people eager to make memorable images with few time restrictions. When people have engagement sessions, they generally want to create unusual, beautiful imagery, and that gives you the flexibility you need to work on fashion flair.

Figure 13.4

When photographing a bridal shoot after the wedding, I have more flexibility to create well-styled and intimate imagery.

Because not every couple (particularly the men) is always comfortable with high-fashion poses, intimate images, or dressing up, I usually start with a more basic look to help build the momentum of the shoot. I help everyone get comfortable behind the camera and start with beautiful but more traditional engagement shots, as seen in Figure 13.5.

Figure 13.5

Even when I do a fashion flair engagement, I usually start with more basic and traditional looks and build in excitement to help the couple get comfortable in front of the camera.

I usually create two or three different looks for engagement sessions.

Look 1. This is the more traditional look. The point of this shot is to capture the essence of this couple. Are they serious and romantic? Or are they goofy and playful? What shared interests do they have? Typically, this image is cleaner and more focused on the couple's emotions and connection.

Looks 2, 3. This is the fashion flair look. I coordinate with the couple to come up with an interesting concept or style to express through this image. The image may be based on an interesting location, an era of styling, or an interesting prop. Although I can still convey the essence of the couple's relationship, now I can add in more visually appealing features to tell the story.

A couple might want to dress like bikers or do punk style in a grungy location. Another might want to dress up in formal Victorian clothing at an old hotel. Get creative and have fun!

Photograph Pretty People

If you are just starting out building a portfolio to promote yourself as a photographer, seek out pretty people to photograph. This may seem a bit blunt, but photographing attractive people in a beautiful way will help you promote yourself. Potential clients interested in fashion flair are interested in creating a fantasy. They are interested in feeling beautiful, looking beautiful, and creating art starring themselves. If you have attractive people in images to demonstrate your skill, it will be visually appealing and eye catching to future clients.

I am in no way suggesting you *ever* turn down a less-than-attractive client. Instead, I'm saying when you are first starting out you should actively seek out people to practice on and to build content for promotional pieces. I talk about this in Chapter 14, "Making Fashion Flair Work for You." You can seek out "models" from sites like Model Mayhem, friends of friends, and even model agencies. You cannot market yourself for your fashion flair and your high-end imagery if you don't have images that reflect your desired style.

Trash-the-Dress Session

Trash-the-dress sessions have become increasingly popular in recent years, showing our market's desire for distinct images that are eye catching and tell a story. Think about offering this service to your wedding clients. Trash-the-dress sessions are what fashion flair is all about: telling stories, finding cool locations, and making memories.

After the big day, a bride's wedding dress normally sits in a closet or in an attic, never seeing the light of day and never being appreciated. Once it's been worn, it holds no purpose. People spend a lot of money on wedding dress preservation services, so why not spend your money on a session that better helps you appreciate the dress through one-of-a-kind images?

The point of a trash-the-dress session isn't to ruin the dress, but to achieve images that the couple would not have been willing to try on their wedding day. For example, now that the dress doesn't have to remain pristine, the bride can sit in the sand on the beach or wander through a field of sunflowers. A bride and groom can stand in a gentle waterfall or simply cuddle in the grass in the park. The images can be more playful and take place in more unique, visually striking locations. These images are timeless and convey a great deal of emotion. Brides and grooms are a lot more daring when there is no fear of ruining their clothing on the day of the wedding.

Trash-the-dress sessions are a great way to end an album. High-impact images symbolizing the start of a new relationship can be a great way to conclude the work you put into creating an album.

The most common trash-the-dress shoot, in my experience, has been the model submerging her dress in water. She stands in a pond, lake, ocean, or by a waterfall. In this case the dress is really trashed, but the images are unforgettable.

Try something unique. Figure out what type of trash-the-dress session would best represent your clients.

The couple in Figure 13.6 was playful, fun-loving, and daring. They wanted a trash-the-dress session that was bold and conveyed the playful nature of their relationship. They decided to have a bride and groom paintball war—winner take all. By creating this playful image, I was able to capture their relationship and preserve memories.

Figure 13.6

Try trash-the-dress sessions that best represent your couple. This paintball shoot conveyed the playful and adventurous nature of this fun-loving pair.

Offer Unique Products

Your products are another part of your branding. What unique products do you offer that make you stand out from the competition? How do you continue the experience of your brand even after clients leave the studio?

In short, go beyond basic prints. Consider having small prints mounted and put in custom image proof boxes. Instead of just offering large prints or canvases, try offering more dramatic wall hangings, such as fine art acrylic or metal.

Figure 13.7 in an example of a fine art metal wall hanging. The image is divided and printed on metal plates. When hung on a wall, it becomes a beautiful piece of modern art.

Figure 13.7

Fine art metal wall hangings offer unique ways to present your images as pieces of fine art.

For more in-depth or longer shoots, you might offer books or albums. For example, you might do a fashion flair shoot for an entire family and turn the images and experience into a flush mount book that tells a story. Each family member could have a section of the book, and there could be a group shot at the end. Albums are popular for senior portrait sessions as well.

My lab is Miller's Professional Imaging, and I got a lot of ideas for my products just by looking at the range of items offered there. Whether providing Miller's unique Luxe Cards, fine art metals, or accordion fold books, I know I can offer my clients something unique.

If my clients feel as if they can go online and get the same products themselves, I am not doing my job to stand out as a professional with the knowledge base and professional lab to offer superior products.

TIP

Check out my lab at http://www.millerslab.com. Browse Miller's products for ideas of how to offer unique products to your clients.

Also, many of my clients get DVDs of their images. For example, my wedding clients get self-playing DVDs of their album in digital format and their favorite images of the day. To convey the value of these images (and to make the clients feel they got their money's worth), my DVDs are delivered in thick, custom-designed DVD cases. The image wraps around the case with an image-imprinted DVD inside. Figure 13.8 is one example of a high-end case.

Figure 13.8

When I give my clients a DVD of their images (or digital versions of their album), I present the DVD in a beautiful, custom-made case that is thick and durable and features some of the client's favorite images wrapping around the exterior.

Engagement Session Products

If you shoot enough storytelling and fashion flair images during an engagement session, you are affording yourself more flexibility to sell intriguing photo products to your clients. Here are just a few ideas of how fashion flair images have been utilized in the past:

- **Wall prints to sign as a guest book.** Instead of signing a guest book, the guests sign a large white matte around a print. Consider having a large matte with three or four images that tell a story from your fashion flair shoot. For example, on the left you could have an image of the bride, on the right an image of the groom, and in the center a large image of the couple. This becomes a conversation piece and something cherished to put on their wall.

■ **Custom storytelling invitations, save the date.** Help make wedding invitations more personal by offering custom photo invitations and announcements. These cards can have multiple folds with multiple images and be printed on thick linen paper. You can also offer photo magnets for save the date cards. Encourage clients to buy modern and unique products by having these one-of-a-kind cards to send to their guests. Photo thank-you cards are popular, too. Imagine a thank-you card with an amazing trash-the-dress session image on it—it truly makes for a memorable thank-you and gets the couple's friends talking about the image and your photography.

TIP

Think outside of the box for how these services might appeal to your other clients. For example, a senior portrait fashion flair session on DVD might make for a great graduation announcement and party invitation. Figure 13.9 is one such example of utilizing a DVD card. The concept also works for birth announcements.

Figure 13.9

This high school senior graduation announcement card is fully customized with a DVD of fashion flair images.

TIP *(continued)*

- **Fashion flair guest books.** Instead of having a guest book for guests to sign, you can create a custom-designed album filled with images from a fashion flair engagement session. As you page through the album, there are beautiful images of the couple filled with uplifting messages from wedding guests. If you think about it, typical guest books are signed and then put into storage never to be seen again. If the guest book is a beautiful album, it becomes something to be shared and cherished.

- **DVD wedding invitation.** Miller's (and I'm sure other labs) offers cards with hubs for holding DVDs and CDs. Instead of a typical wedding invitation, you can provide this card with a DVD containing a video of the couple or a slideshow of engagement session images. Chances are that no other photographers offer products like this in your market, which you can use as a unique selling point to clients. I'll talk more about video-related products next.

Video as Value-Added

As portrait and wedding photographers, we are constantly seeking ways to improve our work and to differentiate ourselves from the competition. Utilizing my camera's HDSLR video capabilities is one way that I push the limits of my creativity and offer my clients products they cannot find elsewhere.

Few photographers are taking the time to learn about video because they don't realize the profit potential that video creates. You don't need to drop photography and become a videographer. You need to broaden your thinking and imagine the many high-end video products you can offer your clients.

I have found a number of ways to offer video as a value-added service to my wedding clients, and they have fallen in love with these unique products.

Many photographers are referring to this as *fusion* video—including both photography and video services.

I do not think that video should replace your photographic services or even become a focus of your business. Instead, I am discussing it here because not many photographers have considered it. If you are still developing your business, you may not want to complicate things with video. On the other hand, video might be the perfect thing to help you stand out. Here are a few things to consider.

NOTE

Check my blog at http://blog.lindsayadlerphotography.com for an article I wrote titled "10 Beginner Tips for HDSLR Video."

Video Engagement Sessions

In addition to the usual photo engagement session, I offer clients the ability to shoot engagement video shorts. Together we brainstorm ideas of how to best record the couple's relationship on video.

We work together to create video shorts that allow the bride and groom to star in their own mini-film. They come up with the story line that reveals something about their relationship, and we collaborate to create a strong piece of storytelling. It is helpful to think of the piece as an engagement music video: short, fun story line that's filled with high-impact visuals.

For the final product, the couple receives a laser-engraved DVD in a leather case. I also put the video on my YouTube channel and Facebook page so my clients can share the links with family and friends. This use of social networking sites helps me promote my studio and gives clients a way to easily share this unique product.

The couple can also project their engagement photos and video at the reception as a romantic and personalized way to introduce themselves. This idea has become extremely popular.

TIP

You can use video sessions and storytelling for any of your clients. I can easily see how it would be applicable to shoot video of high school seniors and dancers. Consider shooting a few pieces "on spec" to propose to clients later.

Video Wedding Invitation

You can also create personalized video wedding invitations instead of traditional cards. As part of an engagement video, you can shoot a segment in which the couple invites the audience to share their special day. This greeting is integrated into the engagement session piece and sent in customized DVD greeting cards.

I use the 5×5 folded or accordion cards offered by Miller's Professional Imaging. I can design stunning greeting cards using images from the engagement session and include the DVD attached with a small DVD hub. Several companies offer more traditional invitation packaging specifically designed to incorporate DVDs.

You can keep the video wedding invitation as simple or as in depth as you want. On the DVD, you can include key information for the day, directions to the church and reception, introductions to the wedding party, hotel recommendations, images from the engagement session, and whatever other information the couple wants to include. It is the ultimate in personalization, and I can almost guarantee that guests have never received anything like it before.

You don't have to stop at engagement sessions or video invitations. Get creative! You can even send video thank-you cards with a slideshow of favorite images from the wedding day.

Video Content

If you have never offered video to your clients before, here are a few suggestions of the content you can offer brides and grooms. You can just do a few seconds' clip of them interacting, or you can make it a much bigger production.

Poems, verses. The couple can read a personalized poem or a religious verse of significance while overlaying this audio on top of images and video from the engagement session. Have them each read the words, taking turns, so their voices weave together.

Interviews. Interviewing the couple about one another is a great way to communicate their love. I ask the bride and groom a variety of questions about their relationship and later set the interviews to music to create a romantic story. When asking questions, be sure to encourage emotion, and avoid questions that can be answered with a yes or no answer. Keep it light and like a conversation, not an interrogation. Also, don't be afraid to interview the maid of honor, best man, or other people of significance in the couple's lives to add another dimension to the piece. You can come up with your own questions, but here are a few I have found particularly effective:

- How did you meet?
- How would you describe your husband-/wife-to-be?
- When did you know that he or she was "the one"?
- What are your favorite qualities of your significant other?
- What are some of your happiest or funniest memories together?
- If you could have one wish for the future, what would it be?

Storytelling. It is your job to tell the story of the couple's relationship. If they are a serious and deeply romantic couple, convey this. If they are a playful and giggly couple, show that. Your clients can play a role in their own mini-movie. If you want to keep it simple, consider using locations of significance to their relationship (where they first met) or symbolic locations (like merging roads or rivers) as a visual backdrop to your interviews.

Music. Music is a key part of establishing the tone of your video. If you'd rather just let the images and video tell the story of their relationship, you can overlay music as the primary audio, or you can mix the interviews and music together. Companies such as Triple Scoop Music specialize in providing royalty-free music to photographers.

CAUTION

Music must be royalty free. Legally, you cannot simply put today's hottest music as the background of your slideshows because it breaks copyright. Instead, you need to use music that has been licensed for your purposes.

TIP

If you live in a city or near a metropolitan area, you can likely find students or aspiring professionals willing to help you with shooting or editing the project. I seldom do editing or shooting on my own. Video can be a big production, and it is often wise to delegate different parts of the project.

14

Making Fashion Flair Work for You

How you choose to utilize the information in this book depends on your business model and your style of photography. Every successful photographer has a formula for success. Pick and choose what works for you and where you envision the growth of your company.

By embracing fashion flair (or whatever you choose to call it), you can expand your creativity and target a more exclusive, high-end clientele. That enables you to focus your efforts on big, expressive projects. To accomplish this, you must focus on marketing to the right audience and conveying your brand clearly.

When I teach marketing, I urge photographers to break it down into three questions:

- **What do you want to say?** What are the main attributes of yourself, your business, and your photography that you want to convey? What is your central message in one sentence? I suggest that you write it out to come to a concise and powerful summary of what you need to convey through your marketing and advertising.

- **Who do you want to say it to?** Who is your target audience? You may need to segment this into three or four groups. Get as specific as you can so that you can more directly target this audience and have marketing and advertising that are effective for each group.

For example, one audience may be engaged women and couples living in my market in a certain income bracket with creative, artistic tastes.

Another audience might be high school seniors attending exclusive private and public schools who have a desire for exclusive treatment.

- **How and where can you get their attention?** Once you've segmented your audience, where can you get the attention of these individuals? Do they read certain publications or listen to certain radio stations? What social networks are they most active on? Whose opinions do they most respect and admire?

Answering these three questions can give you an idea of where to start your marketing efforts and what message you need to communicate.

Exclusivity

Your services as a fashion flair photographer should look and feel exclusive. I like to convey the feeling that I am a busy, high-end fashion photographer who offers limited portrait and weddings sessions to a few lucky clients.

In an ideal situation, your services should feel exclusive as well. Although your business can be extremely accommodating and focus on client comfort, it can also feel like a privilege to be at your studio for a fashion flair session. You don't need to create an air of snobbishness to have an air of exclusivity.

The exclusivity should be reflected in your prices, your products and packages, and the quality of your work.

If you are just starting a studio, your business, or photography in general, you can take a more subtle approach. Convey that, when clients come to you, they get to star in their own fashion shoot. You don't just take a portrait; you create and capture an experience. Each client can live out a gorgeous fantasy through your images—and this is an experience and product they cannot get elsewhere. Emphasize that you take a unique and artistic approach to imagery that is exclusive to your studio.

Even without large fashion flair productions, you should emphasize the one-of-a-kind nature of your imagery. You want people to come to you because you are not average or ordinary; you are extraordinary.

Price Determination

Price determination is one of the most common questions I get from fellow photographers and photography students: "How do you set your prices, and how should I set mine?" Unfortunately, there is no right answer.

When I was a freshman in college, I worked for the successful photographer John Harrington, based in Washington, DC. Author of *Best Business Practices for Photographers*, he was a wealth of knowledge on how to run a business, handle clients, retain clients, determine pricing and licensing, and much more. I highly recommend his book to anyone serious about their business as a photographer.

One of the things that Harrington taught me early on is that people often see prices as directly correlating to talent and value. For example, the highest priced photographer in an area is often regarded by customers as the best and most high-end. His prices are the most expensive, so it *must* be for a reason! That's what most customers believe. Similarly, if your prices are the cheapest in your market, customers assume this is because you are not experienced enough or your final products are less valuable. You must price to represent your worth.

When I started in the wedding photography business, I was only charging about a grand for a wedding in rural upstate New York. After working for Harrington, I went home and tripled my prices. With the tripling of my prices, I shortly tripled my business. I was no longer at the bottom of the pile for the least expensive (and seemingly least experienced photographer). Now my work was among the best photographers in that market, and clients compared my work to those photographers in a similar price range. Tripling my prices was the best thing I ever did for my early career. It helped people take me more seriously.

You want to be the Tiffany & Co. of photography: low volume, high value, and exclusive. When you are exclusive, you can devote more time and effort to each client and produce a higher quality of work that's worth the value of your prices.

The way you choose to market fashion flair depends on your market and goals as a photo studio. You may want to make fashion flair your sole focus and promote your studio and business just for its fashion flair approach. On the other hand, you might want to promote fashion flair as an additional service available to your most discerning and creative clients.

Either way, fashion flair services require premium prices. As you know, fashion flair often requires more effort. It might require location scouting, hair and makeup, a wardrobe stylist (or wardrobe rental), and extra post-processing.

Figure out how much time and effort goes into producing a single fashion flair shoot. From there, you can decide how much your time is worth as well as how much the premium service is worth. If you decide that at minimum you need $500 to make the shoot worth your time, start packages or sitting fees at $500. Or if you decide that your service is one of a kind and want to cater only to extremely high-end clients, start packages at $2,500. It all depends on your market, goals, and so on.

Regardless, your fashion flair services need a higher price tag to signal to customers that these services are unique, high end, and customized.

> **TIP**
>
> Use high-end terminology when talking about your packages and services. For example, when clients come in to review their images, it is not an "image viewing session" or "review session." Instead, try terms like "investment session" or "image investment consultation."

When writing this book, I had a specific request to cover pricing in more depth. Unfortunately, I cannot tell you how to set your prices and marketing. All I can do is urge you to truly look at the time and expenses that go into producing a high-quality production. If you really break it down, that can help you decide how much you need to charge. From there, consider your clientele and market. Here is an example of how I might price a shoot near New York City with one styling look. I do not bill this breakdown to clients, but this is what I have in mind when I set my starting prices and sitting fees:

Hair and makeup: $100

Wardrobe: $50 (per look)

Assistant: $50

Location scouting: 1 hour

Concept development (phone time, email time, and so on): 1 hour

Gathering creative team, concept coordination: 1 hour

Shoot time: 2–3 hours

Post time and retouching time: 3 hours

Other equipment costs, rentals, parking: $25

Props or location rental: $50

If I value my time at $50 an hour, I am looking at a starting sitting fee around $800. This is where (in the greater New York City metropolitan area) I might start my prices for a fashion flair session. This is certainly not a rule for anyone, but it's an idea of how I might break down my basic costs to start building my pricing around. At a minimum, I know I need to start around $600 for a basic package (with or without sitting fee) to make the shoot even worth my time. I might also charge much more than this once I've established a more prestigious clientele. Whatever your price, be sure you are accounting for all the effort and time you must invest.

NOTE

Whenever you set your prices, don't forget to consider all the hidden costs of doing business, including equipment, insurance, rent, depreciation, membership to professional organizations, utilities, lab fees, taxes, retirement fund contributions, and health insurance. You want to be sure that you are charging enough to cover these costs that may not be readily apparently in the list of costs for each shoot but are costs of doing business nonetheless.

CAUTION

If you live in a more rural area or an area with small budgets, don't think you need to start your prices at $800 per session. For some markets this is simply out of the question. In some places, $300 is out of the question. Know your goals, know your market, price what you think is appropriate, but don't undercut yourself. Obviously, rent and fixed costs alone are vastly different when comparing markets.

Collaboration

For your photography studio, you can incorporate the concepts of fashion photography into your everyday work. But if you want to take it a step further and offer specific fashion flair products and services, I suggest you collaborate with other location business.

For example, you might consider reaching out to the area's premier hair and beauty salon and work on copromotional packages. You can display sample images of fashion flair at the salon, featuring the work by the salon's hair stylists and makeup artists. You might pass out 5×7 glossy promo cards at the hair salon and your studio like the one featured in Figure 14.1.

You might also reach out to a local boutique and try the same approach. The more you can work together with other high-end local businesses, the more synergy and copromotion you are likely to attain.

*you are invited to
the photo shoot
of your dreams*

Lindsay Adler Photography and
Jasmine Blair Salon proudly present
fashion flair portrait sessions.

wedding, engagement, or 'just because'

session includes styling of hair, makeup, and
wardrobe plus your exclusive photo shoot

Packages starting at $750

www.coutureportraitphotography.com 607-972-7458

Figure 14.1

Collaboration and copromotion is the way to go. In this sample 5×7 card, I promoted my fashion flair services alongside a local high-end salon. Their clientele represent my target market and vice versa.

Two Bright Lights

There has been a lot of excitement around Two Bright Lights (http://twobright-lights.com/home.php), an image sharing social network for wedding photographers and wedding vendors. This site provides a way for you to share your images with vendors at the weddings you have photographed, thus helping to increase your bookings via vendor referral and to get your gorgeous images in front of more potential clients. Furthermore, this Web site offers a quick and easy way to submit your images to a variety of wedding publications and blogs to increase your chances for publication and exposure. The more publications you have, the more prestige and exposure you attract and the more money you make.

Here are a few interesting features of Two Bright Lights:

- Photographers can upload their images and connect with vendors they've worked with in the past. Like any social network, you can easily connect with colleagues.

■ Vendors log in to the site to access images for all photographers and weddings they have worked on. If vendors choose to use photographer images, photo credit is guaranteed to the right photographer for all image use.

■ Members can create marketing materials directly through the site using images that have been uploaded.

■ Photographers can submit directly to publications, top magazines, and their blog. The site tracks your status with different publications and notifies you if images have been selected.

■ For photographers, the site is free for networking and $15 a month if you want the ability to submit electronically to publications.

If you have been shooting fashion flair weddings, this is a great opportunity to try to get your work showcased in a variety of publications. Furthermore, this is actually a great marketing timesaver. In the past you had to mail CDs of images to vendors you worked with in hopes that they might refer their clients your way. Now it is easy to upload images and tag vendors. The easier it is to get your images in front of their clients, the more likely you'll be to get a referral. If fashion flair is clear in your work, these images will speak for themselves!

The Gatekeepers

High-end weddings usually involve high-end wedding planners. One of the best ways to reach your target market of brides is to make allies with wedding planners. They are the gatekeepers between you and the brides who would most be attracted to your services. Brides hire these wedding planners to help them make decisions and to put the choices in front of them. Help yourself be one of the choices. Network with wedding planners, take them to lunch, offer them special deals, and find ways to show you understand their importance in the business. Consider sending high-end promotional materials of your best work to demonstrate what you can offer their clients. I have included a sample promo card in Figure 14.2. These beautiful cards have a high-end paper stock and unique die-cut shape, and they reflect the luxury of my services. Furthermore, there is a call to action that invites the event planner to get in touch. This is a promotion piece I will be sending out this year to high-end wedding planners.

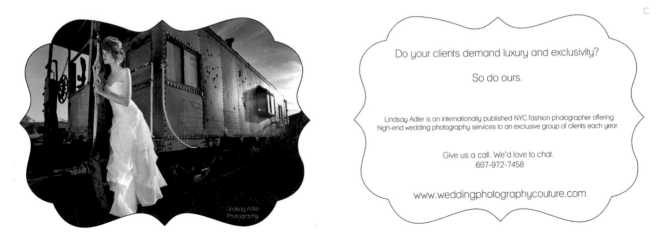

Figure 14.2

My custom Luxe Cards (through Miller's Professional Imaging) show attention to detail and my high-fashion approach, and they include a call to action.

Buzz Creation

Once you've built up a portfolio of images you are confident in sharing as your style, you need to create buzz about your work. You need to let people know you are unique and your images have a distinct fashion flair about them.

There are several ways you create buzz. You can create interesting viral videos to share online. Or you can really push your social networking activities. (See "Social Networking," later in this chapter.) Another idea is to have giveaways and competitions. You can give door prizes at bridal shows or scholarships at local schools. Alternatively, you can create a luxury direct-mail piece. Or consider advertising on the radio or TV.

Each successful photographer I talk to has a different formula for success. Try getting involved in local events or even creating your own local event to generate buzz. For example, you might stage live fashion shoots during a local festival so people come to associate you and your business with fashion photography.

You might also try a local modeling competition theme like "American's Next Top Model" based out of your own town, city, or even local high school. Larger-scale PR and marketing events raise awareness of your business, services, and position in the market.

If you want to quickly become known as a portrait photographer with fashion flair in your area, you might consider holding a contest (with prizes) to draw attention to your business and distinguish yourself from your peers.

Most teens and young adults these days have seen the television program *America's Next Top Model.* It is a reality show hosted by former supermodel Tyra Banks. The program starts with 10 to 14 women hoping to become a top model. Each show, contestants are given different challenges, including a photo shoot. At the end of every show, the images are reviewed by a panel of judges, and one contestant is eliminated. The final contestant is given the title "America's Next Top Model" and wins a number of prestigious prizes, including a model contract.

You can hold a Next Top Model competition in your city, and in doing so you can gain press coverage and an association of your name to high-fashion imagery. For your Next Top Model project, try teaming up with a major local radio or TV station that has young adult viewers.

By teaming up with radio stations or other media outlets, you are getting yourself a great deal of exposure and press coverage. This gets your name out there, regularly mentioned as the area's leading portrait and fashion photographer. The constant promotion not only familiarizes people with your name, but with your unique skills and services.

In the description that follows, I provide guidelines for one way you might approach a competition like this. Obviously, you can modify it to fit your market's needs. You can keep it small or make it huge by having a runway competition in a large hall or live videotaped fashion shoots.

Next Top Model Outline

1. Team up with a local radio station and invite contestants to send in 2–4 images of themselves (ideally unretouched snapshots) to a specialized email address.

2. After a month of promotion, review these images and select the top 15 contestants for the next phase of the process.

 The top 15 contestants can appear in a fashion show put on by the radio station, with clothing provided by a local boutique. This fashion show becomes an event with food, music, runway photography, and more. A panel of judges (perhaps you, a photographer friend, the radio DJs, and the clothing store owner) narrows down the girls to the top 10 contestants.

3. These top 10 contestants then receive a free photo shoot with you and your creative team. Consider teaming up with a local salon to do hair and makeup for each of the finalists. Each contestant gets three shots: one beauty shot (close-up shot) and two full-length fashion shots. Two images for each contestant are then posted on the radio's Web site (or perhaps on your own blog), and people can vote for which model they like best.

4. After these photo shoots are completed and retouched, the contest awards a first, second, and third place prize. The first-place contestant gets a fashion portfolio photo session (aim for high-value, impressive numbers like $1,500+). All the winners are put on the radio's Web site, your blog, Facebook, and many different social networks. This exposes them and your work.

Remember (for prizes in particular) to get as many local businesses involved as possible; the more you have involved, the more you will have promoting the competition. The more prizes, the more hype, and the more local involvement, the more synergy that exists.

Consider having a local salon do the hair and makeup for the shoots and contribute a giveaway toward the final prizes. Also, consider having a local boutique or designer provide clothing for the shoots and contribute some type of gift certificate or prizes. If you are collaborating with a local radio station, the station will be sure to get a variety of extra prizes. The bigger the prizes, the more interest that will develop around the project. Everybody wins.

What do you get for your involvement? You get your name mentioned repeatedly on the radio, and your business becomes associated with high-fashion photography. Furthermore, radio advertising is extremely costly, and you'll get a great deal of radio airtime promotion for free. Finally, if this project becomes a big enough phenomenon, local TV stations and newspapers will cover the event, thus getting you even more exposure.

You might consider ways to include more audience involvement in the competition, including a listener's voting phase. Contestants will urge their friends and family to vote for them, thus making *them* aware of your photography and services. The exposure is great, and you'll get positive responses associated with your work. Not only that, with the first contest being successful, it is easy to turn this into an annual competition that grows bigger each year. Locals will begin to anticipate the competition. Word of mouth spreads, along with the reputation about your business.

Remember the important role that social networking plays in attracting competitors to this competition. Be sure to create a Facebook page for your Next Top Model competition, and consider a separate Web site and Twitter account. The more ways you provide for people to connect with you and your work, the better.

If you want a lot of extra interest, be sure to conduct video interviews of the top 10 contestants during one of their fashion shoots. Interview them about themselves, their interests, and their aspirations, and overlay this with video of them during the shoot. If you have access to an HDSLR camera with video capabilities, that is a great way to drive more traffic to the site and make the project look high end. If you put this video on the Web site, it will show you at work, ingraining the image of you as fashion photographer deep into the minds of potential clients. At a minimum, have behind-the-scenes photographs of the process.

Make Yourself a "Real" Fashion Photographer

One way to market yourself to your clients as a fashion photographer is to become a "real" fashion photographer. In short, attempt to get your fashion flair work published.

I recommend that you shoot some fashion editorials or images that could appear in local or regional fashion, style, and wedding publications. If you are published in local or regional style magazines, you can use this as a promotional tagline or selling point for clients. Not only are clients hiring a photographer to create fashion flair, they are hiring a fashion photographer with work appearing in recognizable publications (even if they are small, local publications). If you keep these publications around the studio or have them displayed on your blog, it will lend you credibility and prestige as a fashion photographer. Clients who want to look like the models in the magazines or who want to live the fantasy will be reassured that you have the capabilities to achieve that for them.

Figure 14.3 is displayed prominently as a large canvas in my studio to act as a conversation piece. This artistic beauty piece has appeared in half a dozen publications in London, Australia, and the United States. When clients comment on or inquire about the piece, I have an opportunity to talk about my work and international publications.

Contact targeted magazines to see upcoming publication themes, submission requirements, or other guidelines for photographers. Often, emails are ignored and ineffective. Instead, I recommend that you call these publications and reach out to the creative director or art director to make real contact about what they are interested in. If you call, you are likely to at minimum get the email address of the correct contact at the publication and usually can get an idea of upcoming themes.

Figure 14.3
This fashion photography piece that's prominently displayed in my studio and has been published in many international magazines gives me an easy introduction to talk about my fashion photography career.

Shoot a Fashion Editorial

If you really enjoy fashion flair and want to pursue it as a foundation of your studio, consider shooting your own fashion editorials and submitting them to fashion magazines.

This may sound intimidating at first, but there are hundreds of online fashion magazines where you can likely find a publication to fit your style and abilities. In fact, if you check my blog (blog.lindsayadlerphotography.com), you can find a list of hundreds of fashion magazines that exist online, both regional and international. Furthermore, if you are published in a foreign magazine, you can then add "internationally published fashion photographer" as part of your promotional tagline. This looks and sounds great in radio advertisements and in literature.

Know the "Rules" of Fashion Editorials

If you want to shoot a fashion editorial, here are a few things you should be aware of.

Theme

Your editorial should have a consistent theme throughout, although it can be anything you imagine. The theme can be girls with big hair in bright colored dresses or a beauty editorial (primarily close-ups) based on using only red and white makeup colors. If you can imagine it, you can do it. Remember that many publications work on a theme for each issue. Research these themes to make your editorial more appealing. In Figure 14.4, the theme of the publication was "ice," so I came up with a beauty editorial themed around "Ice Queen."

Figure 14.4

This image was taken for a magazine with an "ice" theme. The headpiece was made from cellophane and resin, and the image was lit with a softbox as a key light.

> **NOTE**
>
> Remember that magazines are often working 2–6 months in advance of publication. For example, a magazine with a deadline in August would likely not want a swimsuit editorial that would be published in November.

Number of Looks

When shooting a fashion editorial, you are typically expected to have five or six different looks. This can be change of clothing, change of hair or makeup, or any distinct look change. Do your research on a publication to see the types of clothing (brands, styles) that are usually featured in the magazine. Larger publications typically want their biggest advertisers represented, whereas most small publications don't care about the brand of clothing as long as the images are eyecatching and appropriate to the magazine's audience.

Commission Letter, Pull Letter

When you are shooting for a publication, you can request a pull letter or commission letter, which indicates that you are shooting for a particular publication. Because this letter verifies that you are shooting for publication, it often acts as a tool to help you build a better creative team for your fashion shoot.

> **NOTE**
>
> Fashion editorials are unpaid. Do not expect to be compensated for your published fashion editorials. I'm not saying it's right, but it's the way the industry is. Magazines do not compensate photographers for fashion editorials because they view these editorials as advertisements for the photographers; they act to showcase a photographer's work and vision. If your image ends up on the cover of a publication, you have more leeway to request payment because the cover is extremely valuable real estate in a magazine.

Creative Team Compensation

In the fashion world, a tearsheet (publication) is considered extremely valuable and is often treated as payment. For example, if you know an editorial is going to be published, you usually are not required to pay hair, makeup, models, or wardrobe. Instead, their payment is the exposure received through publication and the images you give them for their portfolio. Obviously, this means that your team will be less experienced and consist of people seeking to build their portfolios.

Another term commonly used during shoots is TFCD, or "trade for CD," implying that the creative team's payment is the images that you provide them on CD for their portfolio and personal promotion use. Working for TFCD and tearsheets is completely acceptable when you are not being paid as a photographer. If you are working to be published in a magazine and are not being compensated besides a tearsheet, it is fair to expect the same from your creative team. When I first got into fashion photography, I thought this entire nonpayment setup was bizarre, so hopefully I've prepped you for it!

NOTE

If you are just starting out and have money to spare, you can pay your creative team to get more experienced professionals to help you with your work. If you already have a financially successful business and are just hoping to take your work up a notch with fashion flair, you can consider these editorials an investment in your career and invest in a high-end creative team to help you express your vision.

TIP

I've found that burning and mailing CDs to each team member can be a pain. Instead I use Web sites like http://www.yousendit.com to send the larger finished files via the Web to each person. They are provided a link where they can then download all of the files for their personal and self-promotion use.

Social Networking

You've created a lot of creative buzz around your business. You've spent time finding potential clients and communicating your message. Now you need a way to connect with these clients. You need a place for them to go to learn more about you and to connect with you as a person and as a business. That's where social networking comes in.

If you are serious about utilizing social networking for marketing (which I highly recommend!), check out my book *The Linked Photographers' Guide to Online Marketing and Social Media.* This book aids photographers in getting online quickly and efficiently to build their reputation, find potential clients, and network with colleagues. Particularly if you are new to social networking, this book provides the ins and outs of what you need to know for your photography business.

Assuming you don't own this book (which I'm sure you'll go out and buy now!), I'll give you a quick overview of the must-do's of social networking for fashion flair.

For your fashion flair marketing, it is essential that you have a blog and Facebook page. From there, I also highly recommend a Twitter account and YouTube (or Vimeo) page. Without a blog and Facebook page, you are missing a goldmine of opportunity to share your work and reach potential clients.

Blog

A blog is a place to share your work and your personality. On your blog, you can share images beyond just the limited number in your portfolio. It is a place for you to demonstrate that you consistently produce high-quality work.

For any fashion flair session, you should be creating a blog post with a few of your favorite final images and a backstory about the experience.

Let's take an engagement session blog post, for example. The blog post in Figure 14.5 talks about the charisma of the couple and shares the best images from their session, including a behind-the-scenes video.

Include three or more images from the shoot and a story about the day. To make the posting even more personal and engaging to read, consider adding the story of how the couple met, how they heard about you as a photographer, and how they developed the fashion flair concept you decided upon.

I suggest you create a questionnaire for the couple to fill out that asks essential questions about them, their hopes and dreams, their fears, and their relationship. You can then format their answers into a beautiful post that the couple can eagerly share with friends and family.

In your blog post, you are creating the story of this couple and their excellent experience with you by sharing the beautiful resulting images. By making the blog post more personal, people come to associate you with beautiful images as well as powerful positive emotions.

If you capture video of the shoot or the couple, you can also share that video here.

Through your other blog posts, you can express your personality as well as your prestige. You can show that you are funny, playful, or creative. (You can share some personal work on the blog, too, if you feel it would appeal to your audience.) Your blog is a place to talk about awards you have received, publications your work has been showcased in, or any other updates that establish your reputation as an exceptional photographer.

Your portfolio's purpose is to show the best-of-the-best work. Your blog's purpose is to show that you consistently produce high-quality imagery and have a great personality to go along with that work.

For most online purposes, your images should be sized at 800px on the long side of the image along with your copyright watermark. When you include your watermark, have the year the image was created along with your name or your studio's name. © Year Your Name, or © 2010 Lindsay Adler.

WordPress.org

You can use any blogging platform for your blog, but if you are serious about having a professional-looking blog and maintaining your brand identity, I recommend using WordPress.org.

WordPress.org gives you the most customization options. You host WordPress on your own server and domain (such as http://blog.lindsayadlerphotography.com/ instead of http://lindsayadlerphotography.wordpress.com). From there you can purchase a variety of custom templates or even have a designer create a template to perfectly match your brand identity.

Your blog doesn't have to look like a blog! Instead, it can look much more like a Web site with a blog section to feature your updates.

If you are looking for a custom-made template for photographers, check out Photocrati, ProPhoto Blogs, or Graph Paper Press. All are relatively easy to use and are customizable to fit your needs.

Caution

WordPress.com is different from WordPress.org. WordPress.com is the more limited blog platform site that still offers a free domain and hosting but offers limited customization. WordPress.org is a blog publishing platform that you install on your Web server; it offers complete customization. WordPress.org allows you to change every aspect of the appearance and functionality of the blogsite, while maintaining the content management system at its core.

Facebook

Your clients are on Facebook. Almost everyone is, and as a portrait and wedding photographer, you must have an active Facebook presence.

Individuals have Facebook (personal) profiles, whereas businesses have Facebook pages. You must first have a Facebook account and personal profile

to create your business presence. Two types of pages are appropriate for you as a photography studio or artist.

Local Business Page

This type of page is more appropriate if you have a brick-and-mortar studio. If you are an artist who travels around regularly or has no specific base, this page would not be for you. If you have several people working in your studio, this might be an appropriate presence.

Visual Artist Page

This type of page is more appropriate for a fashion photographer, particularly a person who does not actually have his own studio. Although an extremely well-established and famous photographer may have a visual artist page, it is also appropriate for beginning photographers just establishing their business (and may not have a particular location or geographic region established).

Once you have your Facebook page set up, share all relevant updates on this page. When you do a new shoot, post lower-resolution images of the clients to this page, and then tag the clients so the images show up on their profile. By doing this, your images are displayed on their page (with your copyright) for all their friends and family to see and enjoy. In Figure 14.6, for example, I have tagged the subject in the photo and friends and family have then commented their positive feedback on the work. If visitors like your work, they can easily click on the album link to be redirected to your business page. Albums and tagging are available for both local business pages and visual artist pages.

You must be someone's friend via their personal page to tag them in an image on Facebook. I keep my personal page professional (no lewdness or inappropriateness) so that I can fully utilize Facebook's capabilities. I tell my clients that I am going to add them as a friend so I can tag them in their images, and they can remove me as a friend later if they so choose. Nowadays many people seem to "collect" friends and don't think twice about adding their photographer to their friends list. If you do your job right, they may even consider you a friend when it's all said and done.

CAUTION

Facebook now allows members to upload high-resolution files to their business and personal pages. To protect your images, I still recommend 800px on the long side. If you upload large files, you are making yourself more vulnerable to people stealing your images.

Figure 14.6

When you share images on Facebook from your business page, you can tag clients so that the images show up on their profiles. That makes it easy for friends and family to comment on the photo with their positive praise.

Here are some other things to share on Facebook and your blog:

■ Discounts

■ Gallery showings

■ Publications

■ New shoots, recent work

Facebook is incredible for word of mouth. It is the easiest way to share your work with other potential clients. People's comments on your images make for great testimonials of your work.

Twitter

The easiest way to describe Twitter to a nonuser is that it's like a big Facebook newsfeed where you see everyone's status updates. Twitter is a form of microblogging. In short, people quickly share their ideas, things they've found online, images, and more through these 140-characters-or-less updates.

Twitter provides you a great way to network with clients and colleagues. I am amazed how much I learn every day from the links photographers share on Twitter.

I recommend that fashion flair photographers get on Twitter for three reasons:

- **To learn.** Twitter provides a great way to network with clients and colleagues. If you follow the right people, they provide links to good tutorials, interesting photo-related news, quality publications, and business advice.

- **To network with clients.** Many of your clients may already be on Twitter, whether for their businesses or personal life. By being on Twitter, you give them yet another chance to come across your name and your work. Just like in advertising, the more clients run into your name and your images, the more likely they will be to remember you and call upon you when they need photographic services.

- **To network/follow publications.** As a fashion flair photographer, you can follow a range of fashion, style, and wedding publications. If these publications are local or regional, you can look for opportunities to submit your work or collaborate on projects. You can also learn of upcoming events and activities in the community that might be of interest to your target audience.

YouTube or Vimeo

Video has a high pass-along rate. In other words, people like to share videos. If you shoot behind-the-scenes videos at a fashion flair session and post them online, your clients will be sure to pass on that content to friends and family.

As I discussed in Chapter 13, "Flair Products and Services," you may also begin to offer video profiles or invitations to other clients. You can share these videos online.

Your clients will appreciate the ability to share this content, and you will gain additional exposure for your business.

YouTube is the biggest video-sharing social networking in existence, although admittedly there is a lot of "noise" out there (think laughing babies) to distract potential clients.

Vimeo is a video-sharing social network geared more at creative professionals, including photographers, videographers, and animators.

On either site, you can create your own channel to feature your videos so potential clients can browse other video content. Figure 14.7 is a screen grab of my Vimeo profile, featuring video from a trash-the-dress session. Furthermore, you can feature slideshows from portrait sessions or wedding clients.

Figure 14.7

On Vimeo (and YouTube as well) you can create your own channel to feature video content. Here is a screen grab of my Vimeo channel featuring a recent behind-the-scenes trash-the-dress session.

> **TIP**
>
> Both Vimeo and YouTube are easy to embed on your blog, and it is highly recommended that you share your video content in as many ways as possible (blog, Facebook, Twitter, and so on).

Index